W9-CKU-931

JACOB KAINEN

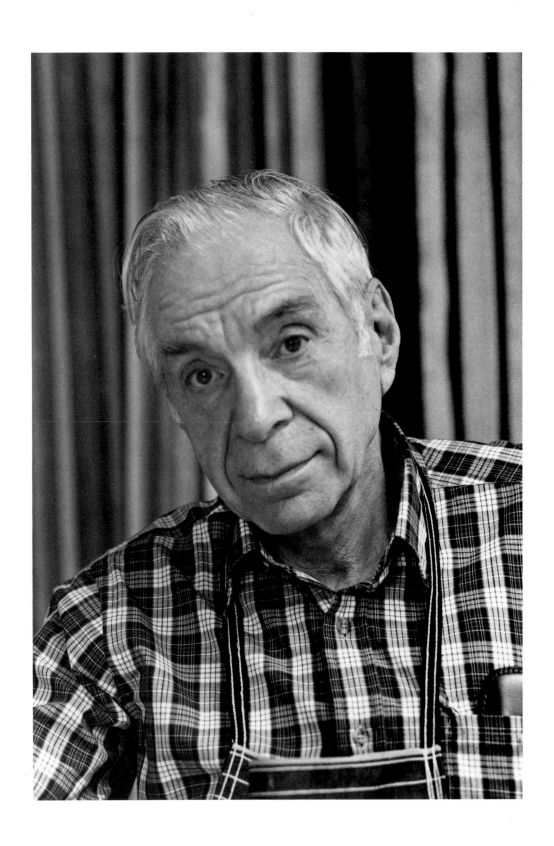

Jacob KAINEN

Curated by Walter Hopps

Essays by Wiliam C. Agee and Avis Berman

Thames and Hudson

National Museum of American Art

Smithsonian Institution, Washington, D.C.

THIS PUBLICATION IS MADE POSSIBLE, IN PART, THROUGH
THE GENEROUS SUPPORT OF THE RICHARD A. FLORSHEIM ART FUND.

Published on the occasion of the exhibition *Jacob Kainen*, organized by the National Museum of
American Art, Smithsonian Institution, Washington, D.C., 10 September 1993 to 2 January 1994.
Project Coordinators: Virginia Mecklenburg and Janet Altic Flint.

The exhibition is also being shown at
Addison Gallery of American Art
Phillips Academy
Andover, Massachusetts
21 January–28 March 1994

The Equitable Gallery
New York, New York
1 July–1 October 1994

In conjunction with the presentation of the show at the National Musuem of American Art, a
companion exhibition, *Jacob Kainen: Seven Paintings and Three Drawings*, has been organized by
the Corcoran Gallery of Art, Washington, D.C., on view from 10 September 1993 to 2 January 1994.

Copyright © 1993 by The National Museum of American Art, Smithsonian Institution

First published in the United States of America in paperback in 1993 by
Thames and Hudson Inc., 500 Fifth Avenue, New York, New York 10110

All rights reserved. No part of this publication may be reproduced or transmitted in any form or by
any means, electronic or mechanical, including photocopy, recording or any other information
storage and retrieval system, without permission in writing from the publisher.

Editor: Janet R. Wilson
Editorial Assistant: Deborah Thomas
Designer: Steve Bell
Curatorial Support: Christine A. Ossolinski
Photo Reproductions: Kimberly Cody
Printed and bound by Balding and Mansell, Great Britain

Front cover: *The Coming of Surprise*, 1951, oil on canvas
Back cover: *Dabrowsky III*, 1985, oil on canvas

ISBN 0-500-27734-6

Library of Congress Catalog Number: 93-60224

The National Museum of American Art, Smithsonian Institution, is dedicated to the preservation,
exhibition, and study of the visual arts in America. The museum, whose publications program also
includes the scholarly journal *American Art*, has extensive research resources: the databases of the
Inventories of American Painting and Sculpture, several image archives, and a variety of fellowships
for scholars. The Renwick Gallery, one of the nation's premier craft museums, is part of NMAA.
For more information or a catalogue of publications, write: Office of Publications, National Museum
of American Art, Smithsonian Institution, Washington, D.C. 20560.

Frontispiece: Jacob Kainen, 1984.

CONTENTS

FOREWORD

It is always a special pleasure for a museum to present the first full retrospective of a major artist's career. In the case of Jacob Kainen, the pleasure is magnified, for his art encompasses more than a half-century of work that expresses an unusually full and rich life. We cannot claim to be introducing his art to the public, for it is already widely known through publications and innumerable exhibitions in New York, Washington, throughout America, and abroad. Yet despite its familiarity, there are surprises in viewing Kainen's career as a whole. We can discover in this retrospective remarkable variations and diversity within an overarching dedication to the fundamentals of painting, especially to abstract qualities of color and form.

Kainen is a committed modernist, yet a true scholar of Old Master traditions; a formalist with a deep knowledge of world literature; a "painter's painter," who also excels in every kind of drawing and printmaking. His art speaks for itself, yet he writes on many subjects with a grace and incisiveness that would be the envy of any author. Alternating between figuration and abstraction, Kainen's works convey his deeply felt humanism and concern for history and social issues. He balances intuition and concept, subject and form, surface and image.

So gifted and seemingly paradoxical an artist is difficult to write about, and I am therefore especially grateful to William Agee and Avis Berman for their insightful discussions of his art and life in this volume. The works in the exhibition were carefully selected after review and reflection by guest curator Walter Hopps, the distinguished former director of the Menil Collection in Houston, who has long been one of Kainen's most enthusiastic advocates. Virginia Mecklenburg, chief curator of the museum, and Janet Flint, curator, coordinated arrangements for the exhibition and the accompanying book. Designer Val Lewton, working with Hopps, brought his own keen painter's eye to the exhibition installation. Alberta Mayo, assistant to Hopps, and Jayne Gribbin and Frances S. Lauriat, assistants to the Kainens, were extremely helpful throughout the project. The companion showing of several recent large-scale Kainen paintings and drawings at the Corcoran Gallery of Art was coordinated by that institution's director, David Levy, and Jack Cowart, deputy director and chief curator.

I especially want to acknowledge the Florsheim Art Fund's generous contribution toward the publication of this book, which will continue to reveal the special joys of Kainen's art long after the exhibition has closed.

Finally, I offer my heartfelt appreciation to Jacob Kainen and to his most ardent supporter, his devoted wife, Ruth, for their confidence in the National Museum of American Art and their generous assistance with every aspect of this retrospective and book. We all thank them for sharing their wonderful art and friendship with us.

ELIZABETH BROUN
Director
National Museum of American Art

Kainen in his Dupont Circle studio, Washington, D.C., ca. 1957–58.

IMAGES FROM A LIFE

AVIS BERMAN

The most difficult problem for an artist, granted technical competence, is to know how to be himself. The strong artist clings to his own identity regardless of the variety of pressures in our society. I have certain images in my mind that won't go away. I begin with the aesthetic balancing of forms, but these psychological ghosts soon take over.

—Jacob Kainen[1]

For well over half a century, Jacob Kainen has asserted and preserved his artistic identity amid a welter of circumstances and events that might have defeated a less resourceful personality. As a young man coming of age during the Great Depression, he watched his opportunities for economic survival shatter and encountered general cultural indifference and a forbidding social climate. Nevertheless, his associations with some of the most advanced painters and important artists' organizations in New York City were formative experiences of incalculable aesthetic and spiritual enrichment. Kainen was an insider, seemingly on the verge of joining that loose coalition of painters and sculptors who would later make up the New York School. However, in 1942, before he had sufficiently established himself as an artist, Kainen moved to Washington, D.C., which essentially removed him from the vanguard milieu and caused him to redirect the nature and course of his art.

As Kainen matured, he often worked in a manner almost willfully contrary to the dominant period style. Such stubbornness virtually ensured years of critical misreading, if not dismissal, of his work. Similarly, because of his long, distinguished, and demanding career as a curator and scholar at the Smithsonian Institution, during which it would have been all too understandable if he had given up his own artistic pursuits, Kainen spent many years as a "promoter of others' talents"[2]—a position that made it ethically difficult for him to make a public case for his own.

Perhaps the predicament of being underrecognized conferred a certain degree of freedom. Independent in thought and character, Kainen explored abstraction and figuration at his own pace, slowly refining and emboldening his gift for color and shape. He stayed clear of the art movements of the moment, which would have been easy for him to join. Like his close friend John Graham, Kainen was not impressed by establishment taste, nor was he willing to accommodate its need for labels.

Kainen retired from the Smithsonian in 1970, and since then he has gained the freedom to work incessantly. The last twenty years have been a special testament to his artistic tenacity and will. He is painting better than ever, attacking large canvases with increasing subtlety and strength. This flowering shows itself formally in the assured composition, the poetic color ensembles, and the minute, sensuous touches that energize the surfaces of these canvases, which seem so serene yet flicker with submerged feelings. It is also apparent in his intense dedication to his task. Acutely conscious of having to make up for lost time, Jacob Kainen continues to wrestle with forms and images,

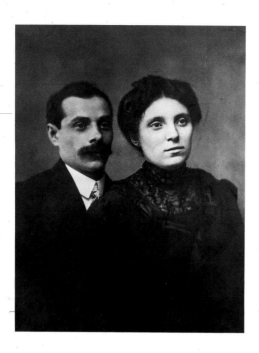

pursuing the problem of reclaiming and being himself.

Jacob Kainen was born on December 7, 1909, in Waterbury, Connecticut. One of three sons of Joseph and Fannie Levin Kainen (fig. 1), who were both Russian immigrants, he grew up in a family in which talent was respected, culture was appreciated, and industry was expected. Joseph Kainen was an inventor and a tool-and-die maker who could do anything with his hands, and his wife had an ardent love of music and literature that she imparted to her children. Jacob "was always interested in art,"[3] and as a young boy he kept a scrapbook of the art reproductions that appeared in the rotogravure section of the *Jewish Daily Forward* every Sunday. By age ten he had filled several sketchbooks with drawings and was making copies of the pictures he had saved from the *Forward*. Jacob's parents were supportive of his efforts and voiced no opposition to his desire to become a painter. They knew, however, that a fine artist was not likely to make a good living and urged him toward the more financially stable vocation of commercial art.

In about 1918 Joseph Kainen agreed to go into business with his brother in New York City, and the family relocated to an Irish-Italian neighborhood in the Bronx. An athletic, energetic boy as well as a precocious one, Jacob was stimulated by his new environment, and in a pattern that was to continue for decades, he crammed as many activities as he could into each hour of the day. While attending school and holding down a part-time job or two, he was also painting, drawing, writing, playing baseball, and competing in track and field meets.[4] At age twelve he entered DeWitt Clinton High School and joined the staff of its literary magazine, to which he contributed articles, cartoons, and other illustrations.

Now that he was in New York, Kainen began to frequent the Metropolitan Museum of Art, studying the Rembrandts and Titians, but he was working from nature as well. He and his schoolmate Jules Halfant, who also became a professional artist, would make trips to the countryside to paint and draw landscapes. Kainen was also writing some poetry at this time, and he formed a literary group that met every Friday or Saturday night at his parents' apartment. Halfant, who was a regular at these sessions, recalled that the Kainens welcomed their son's friends with great tolerance and warmth:

> Jacob's father earned about forty dollars a week, which was an enormous sum to us. His parents were gentle people who would invite us over for a good meal and see that we ate. Even then Jacob was developing an encyclopedic knowledge of literature and art. One evening he handed me a volume of Keats's poetry, and told me to pick any page. He looked at it no more than a minute or two, and then recited the entire poem from memory.[5]

To this day, Kainen often quotes long passages from Shelley, Rossetti, Yeats, and others from memory, and his everyday conversation is interspersed with apposite passages from American, British, French, German, and Russian writers.

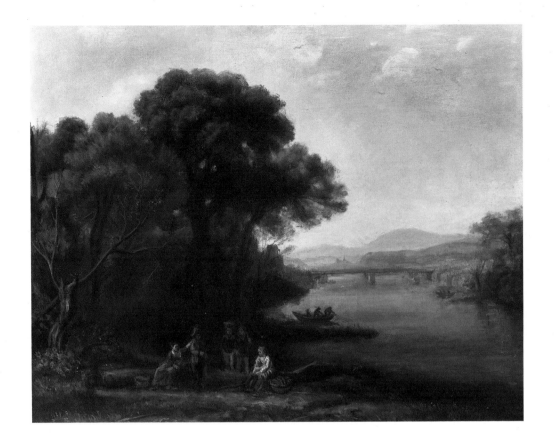

2 The Ford, copy after Claude Lorrain, 1932, oil on canvas, 23 x 29 in. (73.7 x 58.4 cm). Collection of the artist.

Kainen graduated from high school in 1926, too young to attend Pratt Institute in Brooklyn, which required that students be at least seventeen years old. In the interim he enrolled in a life-drawing class at the art school of the Educational Alliance, the settlement house and community center on the Lower East Side.[6] The class was taught by Abbo Ostrowsky, a portraitist, etcher, and eventual director of the school. Although Ostrowsky made a point of using neighborhood residents as models, as opposed to the traditional academic method of having students draw from plaster casts, Kainen still found his teaching too literal and dogmatic to be stimulating.[7]

It did not take Kainen long to realize that his hours with Ostrowsky were not fostering independent thought, and in the fall of 1926 he signed up for night classes at the Art Students League with Kimon Nicolaides, the school's renowned drawing instructor. In retrospect, Kainen believes that the Nicolaides classes were "the best training I ever had."[8] Nicolaides taught his students to draw the model without looking at the paper, to learn to trust the freedom and sureness of their hand. He also advised them "not to take the pencil off the paper, but let it trace the contours and move around in forms to establish a pantographic relationship between the eye and the hand."[9] This practice, which seems analogous to Klee's famous remark that he let his line go for a walk, served Kainen well. His draftsmanship gained in confidence and freedom; his understanding of the relationships among the various parts of the figure increased. In becoming used to letting his hand go without watching it, he was prepared to try the automatist methods of the Surrealists and ready to appreciate the "wizard lines,"[10] as he called them, of his future mentor, Arshile Gorky. During this period Kainen made his first prints by pulling drypoints through the wringer on his ever-indulgent mother's washing machine. And as usual he was busy doing things outside the world of art. He worked in the classics department of Brentano's bookstore, which enabled him to absorb all the art books on the shelves, and he learned to box well enough to become a skilled amateur prizefighter.[11] Kainen's career as a pugilist went on for a year or so, climaxing in a fight with Canada

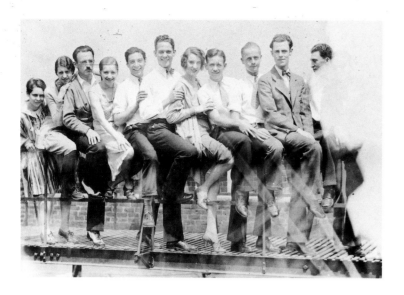

3 Pratt Institute class of 1930, Jacob Kainen fifth from left.

4 Model in Black, 1928, oil on canvas, 29 x 23 in. (73.7 x 58.4 cm). Collection of the artist.

5 Still Life with Apples, Pipe and Hat, 1929, oil on canvas, 16 x 26 7/8 in. (40.6 x 68.3 cm). Collection of the artist.

Lee, the reigning national lightweight titleholder and winner of at least ninety amateur bouts. He lasted two rounds against Lee, who was about to turn pro as a welterweight.

In September 1927 Kainen was old enough to attend Pratt Institute, entering as a painting major. Meanwhile, Jules Halfant had discovered Velázquez and Hals and introduced them to his friend. Entranced by the vigorous brushwork and bravura paint handling, the two young men pursued their studies of the Old Masters more intensely, aided by books from Brentano's and hours of copying works of art at the Metropolitan. From 1928 to 1933, Kainen copied about twelve paintings in the museum and in the New York Public Library, including works by Claude (fig. 2), Constable, Rembrandt, Corot, Hoppner, G. F. Watts, and Inness.

After several years of art training as well as constant work on his own, Kainen was far more advanced and ambitious than the majority of students starting at Pratt, and he quickly fell into the role of learned scapegrace (fig. 3). The painter George McNeil, who met Kainen in the life class at Pratt a few weeks after they had both matriculated, recalled,

> There were only about five students who stood out, and Jacob was one of them. It wasn't long before I realized that he was somebody and gravitated to him. We were at home with each other in a very academic environment. Jacob was very deep into the Old Masters and already had a vast store of knowledge. I was in awe of it.[12]

McNeil also characterized the atmosphere at Pratt in those days as backward and antimodernist.[13] Nevertheless, the school provided grounding in such fundamentals as perspective and anatomy.

Before long, Kainen lost all respect for the faculty and curriculum. He was not so much insubordinate as so serious about what he was doing that he was impatient with any teacher who seemed to know less or care less than he did. He informed Paul Moschowitz, his portrait instructor, that the emerald green paint he advocated contained arsenic and was poisonous, and when another lecturer stated that Holbein was a thirteenth-century artist, he told her that she was off by three hundred years. After the latter teacher tried to commercialize his drawing style, Kainen retaliated. Characteristically, only a person extremely well versed in art history and practice could have pulled off his prank. Kainen was reading a biography of William Merritt Chase that told of the time Chase, as an art student in Munich, repaid an unpleasant housemaster by filling his keyhole with Prussian blue, a "peculiarly virulent pigment [that] . . . will penetrate in all directions for an indefinite period."[14] Kainen, acting on what he had just learned, painted his teacher's keyhole and under the door with Prussian blue. "When she came into class," Kainen says, "her hands and arms were purple from futile scrubbing. She walked in and looked at me. I didn't say anything, but she knew that I was the only one who could have done it."[15]

Occasionally Kainen's erudition met with professorial approval. One day in Moschowitz's portrait class, Kainen noticed that the model had taken the exact pose of Titian's *Man with a Glove*. Another student, Russell Fairbanks, was in the best position

to sketch the pose, and Kainen asked him to move over and make room for him. He refused, whereupon Kainen shoved him out of the way. Fairbanks complained to Moschowitz, who chastised Kainen for his behavior. When Kainen replied, "But this is exactly the pose of the *Man with a Glove*," Moschowitz turned around and said, "Fairbanks, take another position!"[16] At this time, Kainen's portraits were executed in a warm-toned, closely observed, empathetic manner heavily influenced by Rembrandt (fig. 4). Within a year or two he had adopted a brighter, less naturalistic palette, and his brushwork and still-life compositions showed some Cézanne-like touches (fig. 5). These developments could not have been applauded at Pratt, where Kainen heard the director give lectures denouncing Matisse and Rouault.

While Kainen was at Pratt, the fine arts curriculum was revamped as a commercial art program. Kainen refused to take commercial courses; instead, he set up his own class. This, plus other acts of rebellion, was too much of an affront for the administration, and in 1930, three weeks before graduation, he was expelled from Pratt for consistently asserting his independent outlook. Kainen, who did not lack the confidence or idealism of youth, told his oppressors, "Well, Shelley was kicked out of Oxford, and Max Weber was kicked out of Pratt before me. I'm proud to be in their company."[17]

Nearly twenty-one, Kainen began to follow where his curiosity and independent inclinations led him. At the Museum of Modern Art and other institutions he and his friends sought out the avant-garde artists scorned at Pratt. They admired the School of Paris but were wary of falling too heavily under the leviathan shadow of Picasso. For this group, a powerful counterforce was German Expressionist art. Besides Halfant and McNeil, Kainen's circle had grown to include several other young and struggling artists, such as Boris Gorelick, Joseph Solman, and Alice Neel, who were deeply attracted to Expressionism. They identified primarily with the Expressionists' alienation and emotional vehemence but also found the Germans' formal qualities extremely useful. "They [the Expressionists] had flattened patterns, but their subjects were based on the streets, the kind of life we had," Kainen has said,

"whereas Matisse was more luxurious. The colors were more ingratiating."[18] These aspects of Expressionism—the rawness of the artist's inner vision, the sense of spiritual crisis, the heightened color, and loose, often turbulent brushwork—were embraced in varying degrees in the mid-1930s by Kainen and the artists closest to him, who were attempting to combine modernist facture with social concern.

Kainen's admiration for the great Expressionist artists has been a constant throughout his life. His attachment, which has developed and blossomed beyond a youthful search for direction, appears to have a strong psychological component, making it intriguing to speculate on the dynamics of the bond. Kainen has always been a circumspect, upstanding man who keeps his anxieties to himself and honors his obligations to others, no matter how much the single-mindedness practiced by artists would have served him better. Expressionism, too, finds its practitioners caught between the extremes of individual freedom and social responsibility, probing the tension between the necessary selfishness of the artist and the pressure of events on him, between mental and social integration and compartmentalization. These conflicts have long shaped Kainen's personal and artistic life. The Germans' struggle to stay true to their feelings and avoid being ensnared by the horrors enveloping their country might well have elicited a response in Kainen, first as a young artist caught between social relevance and formal rigor, and then as an older man trying to remain a creative artist while meeting the demands of a full-time job and a growing family.

In the 1930s Expressionist art could be seen in New York on a fairly regular basis. J. B. Neumann, whom Kainen remembers as one of the friendliest and most accessible of dealers, showed Barlach, Beckmann, Feininger, Heckel, Klee, Kokoschka, Munch, Nolde, and Soutine in his gallery, the New Art Circle. Two other emigré dealers, Curt Valentin (who ran the Buchholz Gallery) and Carl Nierendorf, also had important shows of Expressionist work. At the Buchholz Gallery in 1937 Kainen particularly remembers seeing Max Beckmann's great triptych *Departure*,[19] which had been smuggled out of Germany; that same year the gallery presented a big Kirchner show. In addition, certain American artists of the preceding generation—most notably Marin, Dove, Hartley, Walkowitz, and Weber—were considered to have an Expressionist outlook and generated admiration and debate among these younger painters.

The lure of Expressionism for Kainen's coterie, as his earlier comment suggests, was the movement's association with rebellion and political agitation. Kainen was one of many artists whose compassion and indignation manifested themselves in social activism. In 1929, even before the Depression began, he was concerned about the welfare of the people around him. Observing the eviction of dozens of people in entire city blocks, he often used his spare time to move destitute tenants' belongings back into their apartments after the police had departed. His involvement in left-wing causes and groups, which he saw as the only plausible opposition to the rise of fascism, escalated as the Depression deepened, human misery increased, and the Hoover administration did nothing to alleviate it. Privation was hardly an abstraction to Kainen. As a young and uncredentialed painter, unable to make a living from his art, he juggled part-time jobs as a sign painter, medical illustrator, and greeting-card designer. But within a year or two of the Crash, these jobs had dried up. From then on, he was one of the indigent. In this moribund economy art galleries were failing and sales evaporating. The majority of painters and sculptors had no work, no supplies, no patrons, no clients, and no hope. In Kainen's words, "We were poor, footloose, had never been anywhere, and had no prospects of going. The Depression had driven us to think of social change; in such an atmosphere a more than passing concern with aesthetics was tantamount to frivolity."[20]

In the early 1930s Kainen joined the John Reed Club, the Marxist literary organiza-

tion. Artists and writers gathered for lectures and discussions on the place of propaganda in art, the future of the Soviet Union, and less heavily political topics. For Kainen, the club was both a cultural and a political nexus. He often went to meetings with Philip Rahv and Alfred Hayes, who lived near him in the Bronx,[21] and it was out of the John Reed Club that the *Partisan Review* was born. At one meeting Diego Rivera spoke, at another, Malcolm Cowley. After spending an evening at the club, Kainen accompanied Henry Glintenkamp to a Village café, where the older painter introduced him to his friend Stuart Davis.[22] From then on, Kainen often dropped by the Jumble Shop and Romany Marie's, two of Davis's favorite haunts, to talk with him. As Davis was often in the company of George Ault or Hilaire Hiler, Kainen also got to know these men. Under the auspices of the club, Kainen went to western Pennsylvania to record the effects of a miners' strike. He also visited the Chicago branch, where he was taken

6 Arshile Gorky, **Portrait of Jacob Kainen**, 1934–37. Collection Arshile Gorky Estate.

around by Mitchell Siporin and Richard Wright.[23] Finally, Kainen's political affiliations provided him with his first chance to exhibit. In 1934 he participated in a group show at the American Artists School, another organization sponsored by the John Reed Club, submitting *Tenement Fire* (pl. 1), a painting whose grim subject matter allowed pointed conclusions to be drawn about current social conditions and human suffering.

The two main currents of Kainen's interest—the Expressionist and the social—began to merge in his work around 1934. The paintings of the next few years, such as *Tenement Fire*, *Disaster at Sea* (pl. 2), *Invasion* (pl. 3), and *Flood* (pl. 4), depict human tragedies analogous to the economic devastation he was witnessing. The impulses behind these canvases are rooted in the tumult of the times, but their style is indebted to Expressionist ideas and devices. First of all, Kainen saw none of the scenes he painted; they were all done from his imagination, and the emphasis was interpretation rather than description.

In 1934 Kainen took a studio in a building on the corner of Fourteenth Street and University Place, a location that led to two enduringly magical relationships. On the northern border of Greenwich Village and close to Union Square, "a walk along the street or a break for coffee always had lively possibilities."[24] So did a visit to the downtown cafeterias favored by artists as cheap and convenient meeting places. "Any night," Kainen says, "you could see a group of artists around these white-topped tables, and always talking about art—the importance of color, what composition was. We talked about older artists or contemporary European masters. We never talked about ourselves or our contemporaries—it was amazing."[25]

One of the pivotal links to the European tradition was Arshile Gorky, who had attained legendary status among his peers. With his long black hair and burning eyes, "no other artist in New York matched him in intensity of desire, in contempt for half-heartedness, in force as a personality."[26] Kainen, then twenty-four, would not have

dared approach Gorky on his own. But one evening in a cafeteria when Gorky was declaring that the best way to learn about art was to haunt the museums, Kainen, sitting nearby, piped up, "And copying paintings is even better."[27] Gorky, who was himself a dedicated copyist, looked pleased and asked him what he had done. Conversation led to an acquaintance that ripened into a rich and instructive friendship when it turned out that Gorky's studio on Union Square was diagonally across from Kainen's; Gorky then asked Kainen to pose for a portrait (fig. 6).[28] During these sessions and on long walks together, Gorky guided Kainen toward reevaluating his work. He advised him to think in terms of shapes and to flatten his forms while retaining solidity and texture. Above all, he counseled, Kainen should trust his subconscious and work more freely. Painting, Gorky often said, was "making confession."[29]

Through Gorky, Kainen was admitted to the tutelage of John Graham, another catalytic figure esteemed by the vanguard as a painter, connoisseur, and intellectual influence.[30] Born Ivan Dombrowski, the scion of a noble Polish family living in Russia, Graham was generous with his time and encouraging to up-and-coming artists, but he was not a man who indulged in small talk. His manner was professorial, and Kainen gladly assumed the role of pupil to such an authoritative teacher. Despite their differences in age, background, and life experiences, Graham and Kainen shared a Russian heritage, a ceaseless appetite for information, and a commitment to the seriousness of art. Graham's good opinion was not easily won, and Kainen's erudition, intuition, and taste were often put to the test with sharp darts of argument and aphorism. Kainen passed this trial by intellectual fire at some point in 1936, when Graham showed him the manuscript of his book, *System and Dialectics of Art*, and asked for his opinion of it. A year later the book was published in Paris. In his discussion of great art critics, Graham placed Kainen in the company of Apollinaire, Georg Brandes, Waldemar George, and a few others as possessing "a profound understanding of art."[31]

This extraordinary compliment notwithstanding, Kainen, by his own admission, had much to learn. He still did not fully understand what went into the composition of a real work of art. Furthermore, he was not as formally liberated as he might have been because of his desire to incorporate proletarian subject matter into his canvases. Graham rejected such themes as vulgar and obvious and tried to dissuade Kainen from using them.[32] (Gorky made it clear to Kainen that he, too, had a negative opinion of art that was dependent on social zeal.)[33] Graham and Gorky made a far greater impact on their protégé when the three of them went to Durlacher Brothers, a Fifty-seventh Street gallery, to see a Poussin show that included the artist's *Triumph of Bacchus*.[34] Kainen's two mentors "took that painting apart in detail . . . relat[ing] all the spaces, shapes, colors, and their cunning echoes." The "analysis was a revelation" to Kainen. "Such organizational niceties," he marveled, "could be learned only by going to galleries with artists advanced in their art."[35]

While continuing his informal education in the company of artists who kept themselves aloof from the political fray, Kainen plunged more deeply into causes. In 1935 he joined the Artists' Union, participating in demonstrations and attending weekly meetings. George McNeil, who expected to run into Kainen, as well as most of the other people he knew, at the union every week, said that these gatherings were populated "by hundreds of wild men and women. They were not well-mannered. People would shout and interrupt each other because we were remaking the world. At one meeting, Jacob got up and began speaking in his slow, quiet way. For once there was intense quiet as Jacob explained the whole Dred Scott decision, going through it point by point. Everyone in the room was impressed."[36]

Kainen's membership in the Artists' Union led to a growing friendship with Stuart Davis, who was also extremely active in art politics. (Davis later recruited him for the

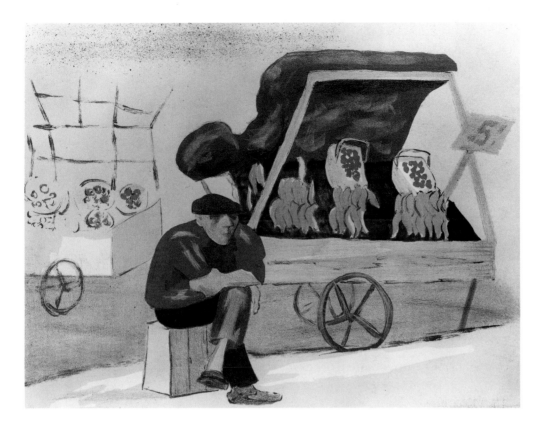

7 Banana Man, 1938, color lithograph, 10 15/16 x 13 3/8 in. (27.6 x 33.9 cm). National Museum of American Art; gift of the artist.

American Artists' Congress, for which Kainen arranged exhibitions and directed publicity.) When the Works Progress Administration's (WPA) Federal Art Project, the third New Deal program to employ artists, was inaugurated in August 1935, Kainen was in a quandary about whether to apply for the easel or the graphic arts division and asked Davis for advice. The answer had enormous bearing on Kainen's future. "Don't be a fool," Davis said. "If you go on the easel project, you'll work at your paintings during the daytime, they'll disappear forever into some veterans' hospital in Utah. Go on the graphic project, learn about etching, lithography, and all the media. You can do the graphic work at night, paint during the day, and keep your paintings."[37] Kainen immediately saw the wisdom of what Davis said and registered for the graphics project.[38]

Perhaps because of his unfamiliarity with printing techniques and his perceived need to hoard time for painting, Kainen initially took a rather thrifty approach to lithography. Several of the earliest works are close distillations of his canvases. But as his enthusiasm and confidence increased, he began to enjoy printmaking for its own sake and took pleasure in bringing his painterly skills to bear on the medium. He "explored lithography as a painter might," Janet Flint writes, "working freely, expressively, and seeking new means of introducing textures and tonal nuances."[39] As with his paintings, Kainen's subject was New York people and places. His scenes were imaginary, but the details were based on his observations of the day-to-day realities of the Depression. Whereas the paintings tended to be melancholy or despairing in outlook, the works on paper were occasionally leavened with satire. Kainen's humor was in the tradition of Daumier—gentle with the powerless and harsher as his targets ascended the financial and social ladder. And as would be expected, Kainen found it easier to take expressive formal liberties as he acquired greater knowledge of drypoint, etching, woodcut, lithographic, and silkscreen techniques and processes. He learned color printing, and two of his finest prints, *Banana Man* (1938; fig. 7) and *Snowfall* (1939), are complex experiments that would have been beyond him at the beginning of the project.

In 1935 Kainen became a contributor to *Art Front* (fig. 8), the journal of the Artists'

Union, and two years later he joined its editorial board. Kainen doesn't remember how this affiliation came about, perhaps because it happened so naturally. An occasional cartoonist and reviewer for *The Daily Worker* and *The New Masses*, he had recent—and politically sympathetic—writing experience to his credit. Furthermore, Davis, another acquaintance writer Clarence Weinstock, and later Solman were on the editorial board. All but one of the essays Kainen wrote between May 1935 and December 1937, when the magazine folded, were reviews of current books or exhibitions. *Art Front* not only gave Kainen's name and opinions some prominence in art circles but also afforded him the opportunity to define and evaluate what constituted meaningful art. He sometimes slid excessively into Marxist rhetoric, which was in line with Weinstock's editorial preferences, but especially in his longer and more thoughtful essays Kainen's astuteness as a critic and honesty as an artist led him to ponder the limitations as well as the possibilities of a socially conscious art. When a choice had to be made, he placed tolerance and aesthetic vitality above ideology. Criticizing the Whitney Biennial in the December 1936 issue, Kainen advocated "new approaches to questions plastic and social,"[40] and named Expressionism as his primary solution to the old, dead painting he saw. He went further a few months later. Writing in the spring of 1937, he applauded the formation of the American Abstract Artists (a group and an outlook considered decadent by the orthodox left wing), decried the "general opposition" to abstract painters, and commended nonrepresentational art without reservation.[41] He said that the relationship of color, shape, line, and space could give a work of art aesthetic meaning. "The fact remains that the *associations* of their [the artists'] abstract values are anchored in emotional experience,"[42] he concluded, singling out for praise Balcomb Greene, Werner Drewes, Josef Albers, Carl Holty, George McNeil, Louis Schanker, and Gertrude Greene.

But intrigues were integral to *Art Front*, and Kainen was drawn into them on at least one occasion. Shortly after he began writing for the periodical, Davis and Ben Shahn, who were both on the editorial board, asked Kainen what he thought of Alexander Brook, an established and then famous painter. When Kainen replied that he was a terrible artist, Shahn and Davis pressured him into reviewing Brook's latest show at the Downtown Gallery (where Shahn and Davis also happened to exhibit). In February 1936 Kainen published a devastating indictment entitled "Brook and His Tradition," in which he stated:

> The path he [Brook] follows has been so well cleared by his predecessors; the problems he encounters have been so thoroughly solved that his familiar manner provokes no one. Every contemporary problem is side-stepped; every conviction is left outside the door of the studio.[43]

Davis and Shahn must have been beside themselves with glee after reading this elegantly written blast, but its author quickly learned that merciless invective could have unforeseen consequences. Niles Spencer, whom Kainen liked and admired, was a loyal friend of Alexander Brook's, and he broke with Kainen over the article.[44] Kainen's disposition made him loath to gore others in print; he continued to express his likes and dislikes firmly in his critical writings, but he never again penned such a cutting attack.

As Spencer's reaction indicates, artists of every aesthetic and political persuasion paid attention to *Art Front* and its reviews. Kainen's critiques were read and noticed, and they continue to be. To this day, many art historians are more familiar with his journalism of the 1930s than with the painting he did then, and a number of exhibition catalogues and articles dealing with the period treat him solely as a writer.[45]

The most important piece Kainen wrote for *Art Front* was constructive: he used his

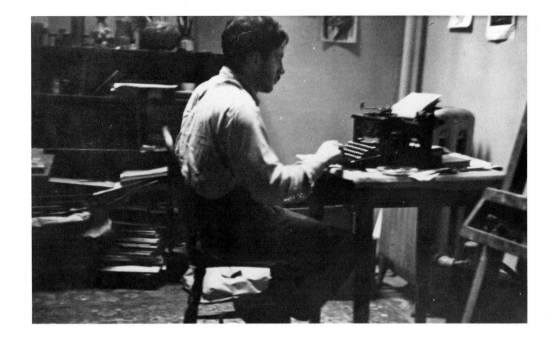

8 Kainen at his typewriter, University Place studio, New York, ca. 1935.

pulpit to deploy his knowledge and stir up interest in what he believed in. "Our Expressionists,"[46] published in February 1937, which built on an earlier essay by Charmion von Wiegand,[47] called attention to the then unacknowledged impact of Expressionism on the burgeoning American avant-garde. After enumerating the characteristics of Expressionism and the historical reasons for its appeal, Kainen discussed its current practitioners. He cited The Ten as the "best organized young Expressionists functioning in New York"[48] and reviewed their exhibition. The Ten, founded in 1935 by Solman, Mark Rothko (then Marcus Rothkowitz), and Adolph Gottlieb, were a group of modernist painters predominantly Expressionist in tendency and without gallery representation. They, plus the other original members of The Ten—Ben-Zion, Ilya Bolotowsky, Louis Harris, Yankel Kufeld, Louis Schanker, and Nahum Tschacbasov—banded together to hold their own shows and perforce get critics to notice them. The more conservative art critics had ignored The Ten or categorized them as crude and difficult. Kainen, however, understood and illuminated their ambitions; his review was the first lengthy appraisal of their work. "Our Expressionists" was prophetic as well as cogent: Kainen predicted a shakeup in American art. That is, in their struggle to overcome the limitations of conventional realism, more and more artists would adopt an Expressionist approach. Given the histories of Rothko and Gottlieb, along with those of Pollock, de Kooning, Kline, and Pousette-Dart, Kainen had identified a key development in the making.

Between 1937 and 1939, Kainen also wrote for *The Daily Worker*. These pieces carry the obligatory (considering the publication) references to a correct social orientation—in one story Frans Hals scores by "show[ing] a series of working class subjects"[49]—but Kainen's discernment and prescience are what ultimately impress. He supported succeeding exhibitions of The Ten (whom he approvingly called "intransigent moderns")[50] and the American Abstract Artists, although he worried about the latter organization's "anarchic political views"[51] and apparent lack of interest in human emotion and associations. Within the AAA show, Kainen pinpointed "David Smith's forged steel sculpture [a]s perhaps the most original and rewarding work on exhibition."[52] Kainen was close to many of the artists he reviewed, but he did not flinch from noting their weaknesses. At various times he criticized Rothko, Harris, Schanker, McNeil, and Graham.

This confluence of vital and provocative forces—Gorky, Graham, Davis, the Federal

Art Project, and The Ten—could not help but affect Kainen's artistic growth. Between 1936 and 1941, his painting was evolving continuously, achieving a sense of greater control and a more judicious placement and apportionment of shapes. Modeling and details were abbreviated, but weight and mass were retained. These changes can be seen as early as 1936 in *Invasion*, with its compressed forms, broken planes, and wide-angled view, but they come to the fore in 1937 in *Cafeteria* (pl. 6). In this depiction of a place that was almost a second home to Kainen, there is no trace of sentimentality. Space is carefully disciplined by the horizontals and verticals of the arches and checkerboard floor. The figures avoid being illustrative by a consciously naive, almost awkward way of drawing that is reminiscent of Milton Avery, another important model for Kainen and his generation. Unlike the contemporaneous cafeteria scenes of the Fourteenth Street School, which focus on the human hurly-burly, Kainen's quieter version highlights pattern, design, and the setting of shape against shape.

Hot Dog Cart (pl. 7), also painted in 1937, demonstrates a change in Kainen's approach to a street scene. The space is shallower, the forms flatter, and he has become intrigued with facades, shopfronts, signs (such as the sandwich board on the man in the middle distance) and symbols of popular culture. He liked the "symbolic character" and "cryptic suggestion" of street signs, which "indicated that there is a life beneath life."[53] (Both Davis and Solman were using commercial signs and lettering in their canvases, but Kainen had worked as a sign painter in the early 1930s and studied architectural history at New York University from 1936 to 1938, so these sources of imagery also came out of his own experience.) There is an enigmatic touch to the ghostly frieze of figures in the background; it might be a breadline or a row of phantoms from a Surrealist dream. Within two years, Kainen's interest in simplification—and abstraction—was even more pronounced. Patterning and shapes, as opposed to documentary detail, predominate in *Tin Warrior* (1939), and the gigantic advertising figure imbues the picture with Surrealist disquiet. *Bronx El* (1941; see p. 42) makes even better use of economies: broad, flat areas, all confidently worked, are placed solidly against each other to convey an effect of architectural weight. Soft grays, greens, and blues blur and mingle; their muted harmonies produce an atmosphere of stillness and quiet.

Kainen's exhibition opportunities were sporadic until 1937 when he joined the A.C.A. Gallery and participated in two group shows triggered by mass dismissals from the WPA. Revolving-door hirings, firings, and rehirings had been instituted, and artists were not assured of being returned to their old jobs. A victim of these churnings, Kainen was unemployed between July and September of 1937. His next two appearances in A.C.A. shows were more carefully shaped. Following the precedent of The Ten, he could see the advantages of organizing an attention-getting group. In 1938 he enlisted Halfant and Herbert Kruckman to form their own exhibiting body, which they named the New York Group. Five other artists were invited to join: Alice Neel, Louis Nisonoff, Herman Rose, Max Schnitzler, and Joseph Vogel. To introduce the first show, which was held at the A.C.A. from May 23 to June 4, 1938, the checklist was accompanied by a statement of principles written by Kainen:

> The New York Group is interested in those aspects of contemporary life
> which reflect the deepest feelings of the people; their poverty, their surround-
> ings, their desire for peace, their fight for life. However . . . [t]here must be
> no talking down to the people; we number ourselves among them. Pictures
> must appeal as aesthetic images which are social judgments at the same time.[54]

Thus Kainen's continuing dilemma was extended to the entire group: how to reconcile aesthetic views with social convictions. He later said of that time, "I think my interest

in left-wing causes prevented me from being more daring in the work because no matter how I patterned and so forth, I had still a proletarian angle."[55] Of the twenty-eight works in the exhibition, Kainen showed three—*Times Square*, *Coffee Pot*, and *Future Subway*—all of which are now lost.

The New York Group had a second exhibition at the A.C.A. from February 5 to 18, 1939, with a catalogue foreword written by the poet Kenneth Fearing. Interested in examining the artist's connection to social problems, the gallery's director, Herman Baron, wanted to hold a symposium on "Social Painting and the Modern Tradition" during the run of the show. Kainen, the panelist representing the New York Group, was responsible for finding other participants. He enlisted Philip Evergood and John Graham, which ensured a huge audience. The event took place on February 10, 1939, with Graham creating an uproar by denouncing "proletarian art" and saying that the real revolutionary art was abstraction. Evergood quieted things down a bit by stressing the importance of using the imagination in any work of art.[56] In giving his view of the social nature of modern art, Kainen traced the history of the "truth-seeking" artist's alienation and stated that in an increasingly "predatory" society, "[s]ubject matter as such is of little importance since the world is hostile—what is important are the textures, shapes and colors of the external world or the mental world."[57] Kainen was, in effect, formulating an attitude toward abstraction that he holds to this day. That is, art has to have some quality of human experience, or else it is just tastefully arranged design. In 1973 he reiterated his position by saying, "However abstract the forms and colors seem, they should somehow give off an aura of human experience."[58] Despite this lively start, the New York Group ceased to exist after these exhibitions, principally because they were not as well organized as The Ten and lacked the momentum to keep going.

In the fall of 1940 Baron gave Kainen his first solo show. Twenty canvases were exhibited, to positive reviews that marked him as an artist of promise. All the critics commented on Kainen's individualistic outlook, subtle and rich color, vigorous approach, and poetic sensibility. Several of them pegged the work as transitional but were curious about what he would do next. Kainen, it would seem, was about to emerge as a worthy artist of the coming generation.

In August 1938 Kainen married Bertha Friedman, a young woman he had known for about three years. The couple rented an apartment in the Bronx, and Kainen moved out of his Manhattan studio and started painting at home. Bertha Kainen had a part-time job in a doctor's office and agreed to work after their marriage for five years—the time Kainen thought it would take to establish himself as an artist—but within six months of their wedding she began to have health problems that left her too weak to hold a job. The two were living on Kainen's WPA salary, and that meager amount (which ranged from $87.60 to $91.20 a month)[59] was jeopardized by repeated firings and rehirings. Kainen was terminated from and then rejoined the FAP three times, which made existence frightening and tentative and, Kainen later realized, was detrimental to his printmaking. The couple's financial burden increased when Bertha's mother died; then her father and brother came to live with them. In 1940 Kainen expressed his fears in a blatantly autobiographical painting called *Young and Old*, which depicts a young man numbly scaling a high mountain while carrying an old man on his back, nearly strangled by the exertion. The subject alludes specifically to Kainen's marital situation, but it also seems related to worries about cultivating his talents. He was having trouble forging ahead on the WPA, he felt, because his uncertain employment undermined his concentration, and his ability to advance as a painter was kept in check by his commitment to expressing humanitarian concerns. The figure is carrying not only the dead weight of the past on his shoulders but also the baggage of art inhibitions and obligations that he was fighting to jettison.

With these financial pressures on his mind, Kainen applied for a job as an aide in the Division of Graphic Arts at the U.S. National Museum (now the National Museum of American History) in Washington, D.C. Although he received the second highest score in the country on the test, which required a knowledge of photomechanical processes and a thorough grounding in the fine arts, the post was given to a succession of other candidates before being offered to Kainen in 1942. In May of that year he and his wife moved to Washington.

With hindsight, knowing that Gorky, Rothko, Gottlieb, and other artists in Kainen's circle were on the threshold of attaining a breakthrough in their art and that exposure to such discoveries would have immensely stimulated his own work, one tends to wonder about the road not taken by Kainen. But in 1942 no such questions loomed. His move seemed practical and wise, as few other options were available. The WPA was disintegrating, and his draft status was uncertain. The Smithsonian offered steady employment in an art environment not too far away from New York, and Kainen assumed he would be returning there in the near future.

As a newcomer to Washington, Kainen was not prepared for the embryonic state of the Washington art scene. He had no idea that collectors were conservative to nonexistent, that the critics were retardataire, or that camaraderie among artists was rare and precious, but his eyes were opened soon enough. Within days of his arrival, Leila Mechlin, art critic of the *Washington Star*, devoted her column to excoriating Cézanne for incompetence. Kainen couldn't believe it and immediately wondered, "What have I gotten myself into?"[60] Washington, he discovered, was "a sleepy, spacious, gracious Southern town"[61] whose activities for contemporary artists were meager and old-fashioned. The limited horizons were shocking for someone who was used to an art life in the top echelons of the vanguard. "The activities were confined mainly to the [annual exhibition of] the Society of Washington Artists, which was founded about 1890—and it showed," Kainen recalled. "People did their one painting a year."[62] The two or three other local artists' organizations were only marginally less provincial.

Even the commercial traditions of the city worked against aesthetic ferment or controversy. Because there were no cafés, cafeterias, or other cheap and informal places for kindred spirits to gather, or indeed a district or neighborhood where artists formed a substantial part of the community, it took Kainen a while to discover that some estimable artists were working in the area, such as Pietro Lazzari, James Lesesne Wells, Prentiss Taylor, Robert Gates, and William Calfee. Kainen, however, was grieving not so much for the apparent scarcity of peers but for the permanent absence of those "magus"[63] figures who had inspired and challenged him during the thirties. Gorky, Graham, and Davis were always in Kainen's thoughts, and he found no replacements for them in the nation's capital. In 1988 he would write,

> What I found particularly conspicuous, like a missing front tooth, was the lack of an older generation of ambitious artists, that we, the upcoming generation, could look up to and cross swords with.... We could do without collectors, good commercial galleries and even knowledgeable contemporaries, but it was difficult to start out in Washington like Robinson Crusoes.[64]

Of course, the cultural landscape was not completely unpopulated, as Washington did not lack for art museums. The National Gallery of Art had opened the year before his arrival, the Corcoran Gallery's biennial exhibition drew artists and jurors from all over

the country, the Freer Gallery had its extensive holdings of Asian art and of Whistler, and the National Collection of Fine Arts had its Ryders from the Gellatly gift. The most influential museum for living artists was the Phillips Memorial Gallery (now the Phillips Collection), with its superlative holdings of modern art and its antecedents. Kainen got to know its founder, Duncan Phillips, and savored their sympathetic conversations, but they were not the "intense, shared dialogue"[65] that he had known in New York.

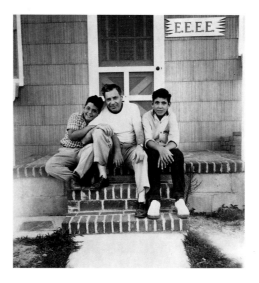

9 Kainen with sons Daniel and Paul, Provincetown, Massachusetts, 1957.

Kainen's disillusionment also extended to his job. "I was in a museum that didn't really specialize in art,"[66] he said, and his superior, Ruel P. Tolman, the curator and acting director of the museum, was ultraconservative in outlook. No real acquiring had been done since the death in 1900 of the founding director of the print collection, Sylvester R. Koehler. The division was "located in the nave and chapel"[67] of the Smithsonian Castle, where visitors looked at prints in the fusty atmosphere of old cases crowded together. The division offices were hung with Old Master prints, and Kainen was stunned to see Dürer's woodcut *Portrait of Ulrich Varnbuler*, which had a green tint block, hung near a window. The green on the paper had faded, one among many examples of prints damaged by exposure to direct light for decades.

Kainen's principal duty was to answer questions from all segments of the public on the identification of prints, but before long he was writing the letters and reports that went out under Tolman's signature. He also examined each work in the collection, recataloguing, rematting, and reattributing as necessary. (For example, in the card files Kainen found separate listings, as if they were four different artists, for Titian, Il Titien, T. Vecellio, and Tiziano.)[68] He rooted out forgeries and identified prints by Delacroix and Ribera that had been listed as anonymous. Tolman appreciated Kainen's industry—and his acceptance of responsibilities beyond what the position required—but two years passed before he received a title (assistant curator) that began to acknowledge his professional status and actual workload.

In October 1942, after six months on the job, Kainen wrote a candid letter to his friend Joseph Solman that documents his efforts to sort out his feelings and ambitions; he is glum but determined, bitter but hopeful. He misses the old tumult and the ongoing discourse about art but is intent on salvaging something from his situation:

> I am learning a hell of a lot about printmaking, printing processes and office procedure, but the stale atmosphere of anti-art is beginning to get on my nerves. Fortunately, my nerves are extremely tough and apply the minimum connotation to certain outrageous standards by which prints are measured in this place. . . .
>
> A while ago I brought eight canvases to the Phillips Gallery and left them with his secretary. She phoned me some time later and told me that Phillips had seen my work and liked it 'very much.' Then she added that he wanted me to bring two particular pictures to a jury show which will be held around Christmas. . . . [69]

10 M Street,
1945, oil on
canvas, 20 x 30
in. (61 x 76 cm).
National Museum
of American Art;
gift of the artist.

Well, Joe, consider yourself lucky that you live in N.Y. I know that it is blacked out to a certain extent, but this town is blacked out intellectually, spiritually and what have you. . . .

I have been able to squeeze in some hours of painting and have done some new things. Rather hasty I admit, but I keep reworking until I get something, even if of small consequence. I have the strange feeling that I am about to reach a new stage where the scales will fall from my eyes and I will see like a Beethoven. I feel greater strength coming. Perhaps it's a reaction to the degradation of my job with its small clerical cares.[70]

With the birth of the Kainens' first son, Paul, in 1943 and Daniel, their second, in 1947 (fig. 9), the job at the Smithsonian became a necessity. But instead of dwelling on his regrets, Kainen had begun to sense the aesthetic possibilities of Washington. A verdant city with a low skyline and clear light, it was filled with eclectically constructed Victorian architecture bristling with turrets, bas-reliefs, cupolas, and peaked roofs. Kainen realized that no one had painted modern street scenes of Washington—"it was a tabula rasa as far as the art community was concerned"[71]—and he resolved to apply what he had learned in New York to what he was seeing around him.

While riding the streetcar to and from work, Kainen sketched the pedestrians, sidewalks, doorways, facades, and rooftops. His line curled along in a continuous rhythm, derived from Nicolaides's method. The calligraphic quality that had occasionally surfaced in the paintings and graphic work of the previous decade became much more pronounced. Recalling the long walks he took with Gorky, who made constant observations about the predatory character of New York rooftops, Kainen let spouts, facades, and gables assume tormented shapes that angled ominously upward. He was

surely the first artist in Washington to tinge his work with Surrealist elements.

Kainen never sought out the monuments or official buildings; he preferred the sturdy Victorian rowhouses whose ornamental arabesques were compatible with his emergent calligraphic style. As these architectural forms became increasingly elaborate, the overt social commentary fell away: Kainen had learned how to communicate life's fears and uncertainties by implication. Another important difference was an onrush of brighter color that was only partly attributable to the local light. Starting in 1944, when he rented his M Street studio, Kainen acted on a tip from Stuart Davis. Instead of using a wooden palette, Davis mixed his colors on a piece of glass placed on top of a white table. After all, he said, "Your canvas is white, isn't it?"[72] When Kainen started doing the same thing, his color became purer and more spectral.

These changes are evinced in *The Walk* (1943; pl. 19) and *M Street* (1945; fig. 10). The vibrant, bold colors and dramatic structure of *The Walk*, leading the eye on the same journey as the figures on the canvas, reveal that Kainen was experimenting quite soon after his relocation. In *M Street*, the blocky shapes of the buildings and cars are about to whirl off the canvas, as if powered by centrifugal force from the circles and spirals scattered across the central band of the picture. Kainen was a painter poised on the brink of abstraction, but he still had a strong interest in manmade and natural objects. This was discerned by Ad Reinhardt, who visited Kainen's studio in 1944 with George McNeil. Two years later, Reinhardt published in *P.M.* his best-known art satire, *How to Look at Modern Art* (fig. 11).[73] Ruthlessly parodying Miguel Covarrubias's tree cartoon on the roots of modern art, which had recently appeared in *Vogue*, Reinhardt drew his own tree, offering a gimlet-eyed view of the panorama of art in America.[74] The four branches on the left side of the tree were healthy and upright, unencumbered by the detritus of big business and official honors. Of these four shoots, the variants of modernism proceeded left to right from the exponents of Neo-Plasticism (Burgoyne Diller, Ilya Bolotowsky, Balcomb Greene) to semi-abstract artists who still made use of symbols and organic forms (William Baziotes, Bradley Walker Tomlin, Pollock, Gorky). Kainen, on the rightmost branch of the approved part of the tree, was placed in the same cluster of leaves as Rothko, Gottlieb, Loren MacIver, Louise Bourgeois, Harry Bertoia, and Morris Graves—distinguished company, and a reminder of what he had given up.

Kainen's isolation began to diminish in 1943 and 1944. The two paintings Duncan Phillips liked were seen in the Phillips Gallery's Christmas sale in late 1942, and in January 1943 he showed one work in the Society of Washington Artists' annual exhibition, which took place at the Corcoran. Kainen joined In Transit, a progressive artists' group that included Lazzari, Laura Douglas, Jane Love, and the photographer

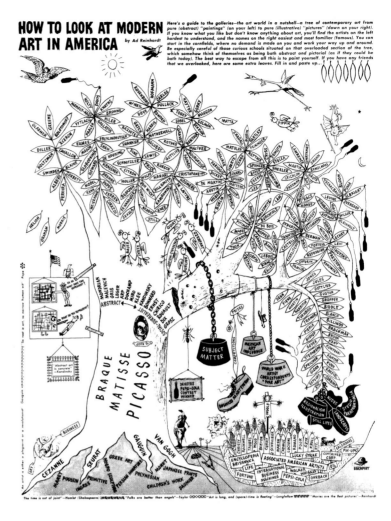

11 Ad Reinhardt, "How to Look at Modern Art," *P.M.*, 2 June 1946.

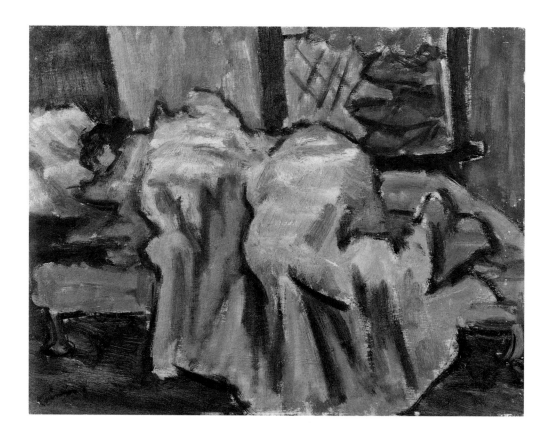

12. Sleep, ca. 1943, oil on cardboard, 12 x 16 in. (30.4 x 40.6 cm). The Phillips Collection, Washington, D.C.

Clarence John Laughlin. About the same time, another organization, the Artists Guild of Washington, was formed, and Kainen became a member, as did Lazzari, William Calfee, and Robert Gates. He would shortly be invited to show with another fledgling—and more lasting—art enterprise, the pioneering Barnett-Aden Gallery, founded by James Herring and Alonzo Aden in 1943. Finally, Kainen met Caresse Crosby, the flamboyant expatriate who had run Black Sun Press in Paris with her late husband, Harry. Crosby, evidently beached in Washington during the war years, rented the building at 916 G Place in partnership with David Porter in 1943 and brought a sense of excitement to the art scene. In her gallery—she had one floor of 916 and Porter had another—Crosby mounted impressive exhibitions of di Chirico and Max Ernst and gave Romare Bearden one of his first shows. At one of Crosby's cocktail parties, Kainen remembers mingling with Thornton Wilder and the literary critic David Daiches.

Kainen's first solo show in Washington was at Porter's G Place Gallery, opening in January 1944. Florence Berryman, Mechlin's successor at the *Star*, reviewed the exhibition positively, though it is apparent that she expected artists to make concessions to their audience. Kainen's statement "that a painted figure is not a real person, that one may improvise to his heart's desire without asking Nature's permission" gave her pause. Berryman reminded the artist that "to a great many people the modern idioms are unknown foreign tongues. Some of the paintings in the present show will baffle the average person." She went on to extol *Tugboat* and *Sleep* (1943; fig. 12) as paintings "every one would enjoy."[75] Berryman's fixation on the lay person was even more fervid when she reviewed a show of Kainen's drawings and lithographs at the Central Public Library in the summer of 1944. After saying that Kainen's WPA lithographs were made while he was living in Waterbury, she reprimanded him for becoming "increasingly experimental and expressionistic. His line is coarser and his subject matter in many instances has become symbolic and full of significance which eludes the average mind." Conceding that Kainen was "not sinking into a rut," Berryman concluded, "One feels sure he is going somewhere, even though his road at present may appear a trifle rocky to the laity."[76]

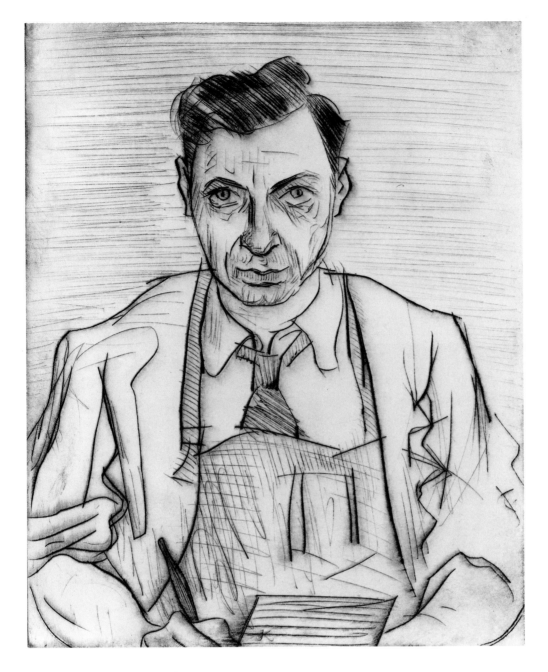

13 Self-Portrait with Drypoint Needle, 1945, drypoint, 9 3/4 x 7 7/8 in. (24.8 x 20 cm). Collection of the artist.

By the time the war ended, Kainen's status at the Smithsonian had changed. As he now recalls, his position was originally a temporary one, but it became permanent in 1944. As a result, he embarked on the process of carving out two careers; he would remain an artist while functioning expertly as a museum person, adjusting himself to his schedule through rigorous discipline. He worked at the museum until 5:15, grabbed a quick supper, and by six o'clock was at his unheated studio at 3140 M Street. He painted until ten or eleven o'clock, then returned home to do some writing or museum research until 2 A.M. because the Smithsonian would not allow him to do scholarly writing on government time. Kainen adhered to this routine for decades.

In 1946 Kainen was appointed curator of the Division of Graphic Arts. Now that he was in charge, he could make decisions, and the way Kainen reshaped the department, heightening its role and impact and adding to the dialogue of contemporary art, would help speed the maturing of the Washington art world. An almost prophetic self-portrait, a drypoint made in 1945 (fig. 13), seems to register the impact of Kainen's new position. The open-eyed, frontal pose communicates a quiet will, as if the sitter is preparing himself for an important transition.[77] He wears a printer's apron and holds a drypoint

needle, emblems of his artistic persona and true vocation. The apron covers but does not hide the necktie and shirt that serve as reminders of his white-collar job. (Kainen used to print his plates at the Smithsonian because he was encouraged to use the presses there. This was the mundane reason for both kinds of attire, but their juxtaposition neatly encapsulates his dual status as artist and art professional.) No conflict or confusion disturbs this portrayal; the image projected is that of a man ably mediating between two worlds.

Kainen took over a program of monthly (later bimonthly) print exhibitions. In general, they were solo shows of living artists who were outstanding printmakers or group shows of historical and contemporary masters of a medium. It is safe to say that the graphic work of S. W. Hayter, Josef Albers, Adja Yunkers, Louis Lozowick, Karl Schrag, José Guerrero, Louis Schanker, Werner Drewes, and Boris Margo would otherwise never have been seen this early in Washington. Nor were local artists neglected. James Wells and Prentiss Taylor, for example, were also given shows. Kainen's budget was so tight that the artists had to pay the shipping charges in one direction, as the Smithsonian would only pay for sending the works back. Nevertheless, the artists were willing to split the costs in order to get exposure in Washington. They were guaranteed everything but sales—a professional installation, a useful press release, a photographic record, and an excellent chance of a review. Often the artists donated a print to the museum in appreciation of Kainen's sensitive handling of their work.

Naturally Kainen wanted to build up his department's collection, which hadn't been added to for half a century. Not one modern master was represented. From the first, he knew he would buy prints rather than drawings, which would cost more, but even the smallest purchases seemed out of reach. Then, in perusing the annual financial reports, he noted a category for equipment. All the money he needed could be requested, provided it was for display cases, storage units, desks, typewriters, and the like. A silly idea dawned:

> I idly asked whether or not the map cases included what was put in the map cases. I thought it was too foolish. [My superior] said, "Of course, it's part of the equipment." I couldn't believe it. So I began buying. I had to write up a memo to my superior explaining why this piece of equipment was necessary. I said, "To fill out the history of this medium, to fill in gaps in the history of the medium."[78]

Kainen had many gaps to fill, as the division didn't even own a Daumier. He also acquired prints by Dürer, Rembrandt (*Landscape with a Flock of Sheep*), Manet (*La Barricade*, for $300), Bonnard, Toulouse-Lautrec, Picasso, the German Expressionists, and Jasper Johns (*Coathanger*, for $75). At the time, Kainen's department at the Smithsonian was the only museum in Washington that dealt systematically with prints. Ironically, while Kainen was making a reputation as an authority on prints and their history, his renown as a graphic artist was slipping away. He was as active as ever in producing etchings, woodcuts, and drypoints, but because he was on a first-name basis with everyone who mattered in the print world, he felt it would be a conflict of interest to exhibit, sell, or otherwise promote his own work. "Even the slightest suggestion of presumption on professional contacts was unthinkable for a man of Kainen's sensibilities," Janet Flint wrote in 1976. "Consequently he dropped out, in a sense, from the national print scene."[79]

Around the time Kainen was promoted, two events made Washington's art landscape more habitable. First, the Corcoran recognized that local artists were a sizable and lively enough constituency to merit more exposure than they had been getting. In 1946 the

museum instituted the "area shows," which quickly became a much anticipated part of the art calendar. Second, in 1947 the now-celebrated Washington Workshop Center for the Arts opened its art school on the top floor of the former Walsh-MacLean mansion at 2020 Massachusetts Avenue. Kainen was a regular exhibitor in the area shows, and as a teacher and mentor, he helped make the workshop a magnet for the new and vital. During his tenure at the workshop, which lasted from 1947 to 1954, he was instrumental in furthering the careers of several artists. Asked by Leon Berkowitz to teach evening classes in painting and printmaking, Kainen assumed the role that more experienced artists had once fulfilled for him. Because of his links with New York, Kainen was now a magus figure for his colleagues and students at the workshop.

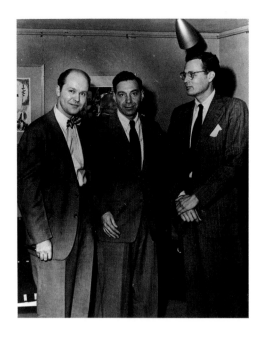

14 Kainen with Gene Davis and Robert Gates, 1952.

Kenneth Noland, who moved to Washington in 1949 to take a job at the Institute of Contemporary Arts (ICA) and then taught at the workshop and at Catholic University, said that Kainen

> told us a lot about these [New York] artists because it wasn't in magazines. There was no way that you could know about them because you couldn't see them in exhibitions either. . . . So you had to hear about it from another artist, an older artist. . . . [T]here was a kind of lore that was passed back and forth between teachers and guys. . . [who] were trying to be artists. Jacob was a good source for that.[80]

> Jacob was a pro—he wasn't just a teacher. He was a real artist, a New York artist who knew the scene because he had been there, but he didn't follow the trends. Also, he always had a fine feeling for art, a real emotional response. When you had discussions with him, they were heartfelt. He was an affirmative presence, projecting good feeling, because he felt that art was worthwhile. That was a very powerful influence, because to most people an artist was a loafer or a weirdo who didn't have a place in American culture.[81]

Kainen, who first met Noland at the ICA, respected the younger man very early in their acquaintance. He appreciated Noland's consciousness of color relationships and recognized that he was one of the few artists in town with a real background. Noland had attended Black Mountain College and studied with Bolotowsky and Albers. While at Catholic University, Noland redesigned and refurbished the school's gallery space and presented exhibitions of artists he thought should be better known, such as David Smith, Lee Krasner, and Herman Cherry. In December 1952 Noland gave Kainen his first retrospective. Kainen still considers the show, which included fifty to fifty-five paintings, to be one of the most important of his career.

In 1950 Gene Davis, then an editor working for the American Automobile Association, dropped by Kainen's classes at the Washington Workshop. Davis wanted to be an artist but had no formal training in the field. Before long, he asked Kainen to give him

private critiques. These tutorials continued every two or three weeks for seven years, until the summer of 1956. Davis was molded into a painter (fig. 14) by Kainen and Noland. Kainen brought Davis to Noland's studio, and Davis later appropriated several aspects of Noland's style and technique. After Kainen stopped teaching Davis, Noland took over for a few months.[82]

Kainen was involved in another, more crucial encounter involving the workshop. In 1953 Morris Louis, who had recently moved from Baltimore to Washington, asked Duncan Phillips for a job. Phillips had nothing to offer him but told him to see Jacob Kainen. Recalling his meeting with Louis, Kainen said:

> He looked me right in the eye and said, "I'm an abstract expressionist". . . . We exchanged a few statements, and I somehow felt a kind of integrity in him. He had a very warm look about him, very intense. I said, "Go and see Leon Berkowitz at the Washington Workshop. There might be a job open." So he went there, and Leon evidently was very much impressed. After all, without even seeing the work, he gave him a job teaching.[83]

At the workshop, Louis met Noland, and their conjunction would establish the basis for the Washington Color School. When Noland and Louis started hammering out problems together, they worked on some stain paintings jointly. They invited Kainen to collaborate on staining a canvas during a workshop open house in 1954, but he declined. "I didn't want to sacrifice mass," stated Kainen. "Pouring, soaking in the canvas, you gain something, but you lose something, too, a sense of density and body, which was part of what I had in mind."[84] As Kainen has always defined the fundamental notion of Washington Color Painting as staining, he asserts that, although present at its creation, he was never a member of the Washington Color School or a Color Field painter.

What Kainen did have in mind was an independent brand of abstraction that had been unfolding since the late 1940s. *Dock with Red Sky* (1947), *House with Black Sky* (1949; fig. 15), and *Monumental City* (1950) are jazzily patterned, semi-abstract urban scenes in the process of reforming into autonomous shapes that lock together into jigsaw-like patterns. From there, a major part of the work metamorphosed into tangles of organic forms improvised from nature. *Ritual* (1949; pl. 22) augurs what Kainen's future canvases would hold. Recognizable figurative and architectural underpinnings have been suppressed; the sense of inner strife is paramount. The forms seem agonized into ovals and rough, jagged fragments, and the canvas reverberates with despair. In their dark emotional connotations, Kainen's abstractions of the late 1940s and early 1950s share the tragic resonance of many contemporaneous Abstract Expressionist canvases. But there the similarity ends. Whereas the gestural painters of the New York School such as Pollock and de Kooning were concerned with allover mark-making, Kainen retained traditional shape-to-shape relationships more related to the work of Miró and Matta. Furthermore, in pursuing allover composition, the Action Painters worked on canvases large enough to permit them to use their entire arm, to make the broad movements that were integral to their painting process. Kainen, who moved to a smaller studio on Dupont Circle in 1950 (p. 8), did not have room to execute larger works, nor was he ready to do so. At the time he believed that "large paintings were done for biennials and salons where you competed for attention."[85] Kainen often went to New York on museum business, and he knew what Rothko, de Kooning, and Pollock were doing, but he had his own direction and hewed to it. Likewise, as the first abstract artist in Washington, Kainen found it impossible to abandon what he had done in order to commit himself to staining, which he perceived as alien to his artistic personality.

In the early 1950s, paintings such as *Unmoored I* (1950; pl. 25), *Standard Bearer* (1952; pl. 29), and *Hour of the Beast* (1953; pl. 30), which was awarded first prize in the 1954 Corcoran area show by George Grosz, represent a vision of a horrific world gone out of control. Cryptic meanings were the best meanings, Kainen believed; one dare not say too much because the enigmatic markings were a code for anguish and betrayal. He felt he had to "communicate in intangibles"[86] because to make an open statement was to court danger. (By now very aware of his subconscious, Kainen was endorsing Gorky's dictum that painting was making confession.) Aside from the titles selected—other typical ones were *The Reprieve, The Vulnerable* (pl. 32), and *Marauder*—the most obvious artistic clues to (and outlets for) Kainen's mental state [87] were the drypoint self-portraits executed in 1946 and 1947. In contrast to the confident, authoritative, integrated presentation of 1945, the subject of the subsequent portraits is no longer in charge of his world.

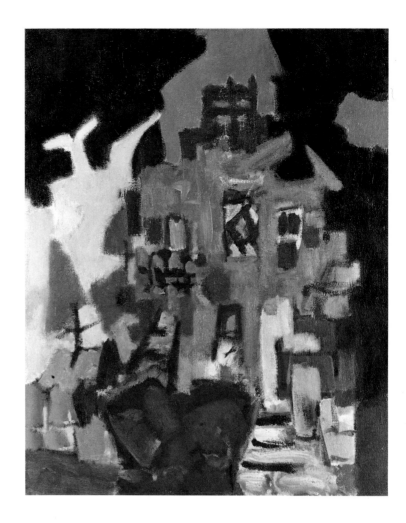

15 House with Black Sky, 1949, oil on canvas, 30 1/8 x 24 in. (76.4 x 60.9 cm). National Museum of American Art; gift of Mrs. Betty B. Ross.

In *Alter Ego*, the 1946 work, the artist splits himself in two. One is an idealized figure of light and nobility; the other is brutish and suspicious. A painful question is implied: why should an artist of large-hearted intentions and social conscience be perceived as the embodiment of evil? The 1947 image revisits the frontal portrait of two years before, but with revelatory differences. Kainen's calm demeanor has been replaced by a look of dazed fear. His jittery calligraphy—the linear equivalent of the Expressionist shriek—was the perfect vehicle for indicating instability and pressure.

These anxieties were not idle paranoia. In the mid-1940s Kainen became aware that he was under government surveillance because of his old leftist affiliations; acquaintances in the FBI and on Capitol Hill warned him to keep his head down. For this reason he stopped subscribing to magazines like *Partisan Review* and avoided showing his paintings at the A.C.A. and other New York galleries. After the war ended, all branches of the government were subjected to anti-Communist witch hunts, and each agency set up loyalty boards to superintend the housecleaning. Kainen was uncomfortably familiar with the outcome of such interrogations because one of his brothers, a meteorologist at the Department of Commerce who had never been politically active, was dismissed from his job for having signed a political petition in the early 1930s. Kainen, who had also signed it, knew that it was only a matter of time before his own future would be jeopardized. In 1948 the FBI conducted a full investigation of him and sent its findings to the Smithsonian's loyalty board. Kainen was not a Communist and had done nothing illegal or subversive, but he was called before the board in July 1948 and required to provide a detailed written explanation as to why he joined the Artists' Union and the Artists' Congress and why he wrote for *Art Front* and *The Daily Worker*.

Fortunately for Kainen, during World War II he had taught two groups of FBI

inspectors how to trace the source of Nazi propaganda documents through the identification of their printing methods and types of paper. Kainen's lectures proved so salient that he received three letters from J. Edgar Hoover thanking him for his cooperation with the FBI and for valuable service to his country. Kainen had saved these letters, which he presented, along with his rebuttals, to the loyalty board. In September 1948 the Smithsonian's tribunal made a determination in his favor, but the case was reopened in 1949 by the Civil Service's loyalty board, whose reviewing panel decided that Kainen's file was "not clearly favorable."[88] Kainen had to provide further proof of his loyalty, which was upheld by the secretary of the Smithsonian. The ordeal was still not over; his case was reviewed again in 1953 and not officially closed until 1954. The effects of being hunted down as an enemy of society inhibited Kainen for decades; well into the 1980s he became visibly perturbed when the subject came up, and he is still loath to discuss it.

Before his retrospective at Catholic University, Kainen showed eleven of his latest paintings in March 1952 at the Dupont Theatre Gallery of Art, a noncommercial venture that put on some of the city's best contemporary exhibitions. Among the pictures on view were *Unmoored I* and *Unmoored II* and *The Coming of Surprise* (1951; pl. 27), a work with lovely echoes of Kandinsky and Gorky in its pictorial vocabulary, delicately balanced composition, and mood of gentle, unfolding mystery. Kainen created surprise with dynamic movement, rhythmic structures, and vigorous brushwork, yet he insisted, "No matter how bright my colors are, how sharp the contrasts are, the effects are poised, muted and basically tender."[89] This interpretation was not universally accepted, as he was about to find out. Leslie Judd (now Leslie Judd Ahlander), art critic of the *Washington Post*, didn't review the Catholic University show. Perhaps it was just as well. When she went to the Dupont Theatre Gallery, she responded with horror. "The paintings of Jacob Kainen . . . look as though they had been shot from a cannon," she reported. "The abstract forms, with their almost brutal color, whirl in space around an invisible vortex in a state of almost unbearable tension. The color is as explosive as the composition, with the strength of the relationships pushed to the limit of violence." [90]

Kainen was taken aback by Ahlander's reaction, which he read as a savage excoriation. He showed essentially the same group of paintings in September 1953 at the Grand Central Moderns gallery in New York, to more understanding notices, but the extremism of the *Post* review and the fact that he was still under investigation led Kainen to worry about his visibility. He became apprehensive about attracting attention in Washington, where Sen. Joseph McCarthy was at the zenith of his influence and Rep. George Dondero had become notorious for his speeches vilifying modern art as a tool of Communist subversion.[91] These legislators and their henchmen were looking for victims in all areas, and one with a government job would have been a prime catch. After 1952, Kainen purposely did not have another show in Washington until 1956. He also felt that he had taken a real chance in exhibiting at Grand Central Moderns because being advertised or written about in New York exposed him to being fingered by anyone who remembered his activist past. Therefore, Kainen absented himself from the Manhattan gallery scene as well; he did not have another solo exhibition of paintings in New York until 1962.

During the time Kainen went into eclipse as an exhibiting artist, he cultivated his considerable literary and scholarly abilities.[92] He undertook a monograph on John Baptist Jackson, the eighteenth-century English woodcut artist, and the American Philosophical Society awarded him a grant for research in Europe. On his first trip abroad, during the summer of 1956, he did research in the principal libraries and

museums in the British Isles and on the Continent. Such direct exposure to the landmarks of Western art and architecture attuned Kainen to representationalism again, specifically to taking up the figure. His meditations on European art were abetted by a growing perception that Abstract Expressionism was losing its validity and vitality. It was, he saw, being adopted as *de rigueur* by college campuses, by Sunday painters, by "little old ladies."[93] If abstraction was being that widely embraced without question or rebellion, Kainen was no longer interested in it. Besides, he reasoned, since his abstractions already contained actual three-dimensional forms, they might as well be recognizable ones. Renouncing

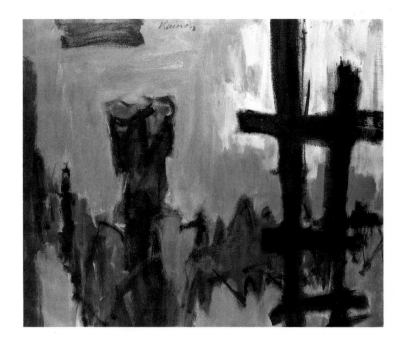

16 Stranger in the Gates, ca. 1957, oil on canvas, 40 x 49 in. (101.6 x 124.5 cm). Collection of the artist.

the dominant style deepened Kainen's estrangement from the art establishment: he was viewed as an anachronism who had shortchanged himself instead of a maverick challenging the fashion. After seeing Kainen's 1961 show at the Jefferson Place Gallery, Howard Mehring told him, "It's very *daring* to paint like that today."[94]

Kainen had observed for himself the prevailing trends when he taught at American University for a semester in 1957. Substituting for Robert Gates, who was on sabbatical, he expected to be teaching an advanced course, but the class ranged from "beginners who were afraid to squeeze the paint out of a tube to very advanced graduate students."[95] In addition, there was one person in the class who fit in neither category. A black woman in her sixties who taught at a District of Columbia junior high school, her name was Alma Thomas. Kainen had known Thomas since the 1940s because she was vicepresident of the Barnett-Aden Gallery, but her arrival in his classroom brought them into closer proximity. Thomas was not a student, but a mature artist with her own distinctive personality and outlook. Then painting dark, moody still lifes, she hired Kainen to give her private critiques outside of class. Every few weeks he would visit her at home on his lunch hour to discuss her work, color theory, and art in general. It did not take him long to discern "that a big spirit was at work"[96] and encouraged her to paint to her strength. Kainen urged her, "You have such power. Use cleaner colors. All modern art is clean color."[97] When Thomas's idiom began to change in the 1960s, Kainen was not surprised to see her flower into an original and exuberant colorist. In his introduction to Thomas's 1972 retrospective at the Corcoran, he called her the "Signac of current color painters."[98] Kainen stopped accepting money from Thomas after a few years, but their sessions continued until her death in 1978. "In later years," wrote Adelyn Breeskin, then senior curator at the National Museum of American Art, "she relied on artist Jacob Kainen and museum director Joshua Taylor as critics and guides."[99]

By the late 1950s Kainen was a figurative painter, and felt good enough about it to paint something as dramatic as *Stranger in the Gates* (ca. 1957; fig. 16). This canvas, showing a looming frontal figure close up and boldly handled in plangent reds, oranges, blues, greens, and blacks, is a forerunner of two or three arresting pictures to come, but it is also a farewell to the throbbing canvases of this troubled decade. The unavoidable impression created by the highly Expressionist figure is of a force about to overcome its restraints, and at this time Kainen was throwing off some self-imposed restraints. He underwent a change in style and started exhibiting more actively. He had solo shows

17 Ruth and Jacob Kainen at the opening of Kainen exhibition at Lunn Gallery, Washington, D.C., 1975.

in Washington in 1958 (Franz Bader Gallery), 1961 (Jefferson Place Gallery), 1963 (Corcoran Gallery of Art), and 1965 (Bader) and in New York at the Roko Gallery in 1964 and 1966.

At the Window (1960; pl. 36) and *Gene Davis* (1961; pl. 39) are further ruminations on the evocative power of color and on the question of Kainen's position as a representational and/or abstract painter. The earlier canvas, with its sidelong nod to Milton Avery, teases us with its view out the window that is simultaneously a picture within a picture, complete with its own neat frame. In his evocation of Davis, done from imagination, Kainen strokes in a backdrop of the artist's trademark stripes, demonstrating his command of figure and ground and causing us to ponder on the degree of difference between the two. The fluidity of such categories is dealt with again in *Crimson Nude* (1961; pl. 37), where scribbled brushstrokes summarize the figure and background with equally effective sketchiness. As painter Kenneth Young admiringly stated, "Jacob had such a solid background that he understood what abstraction was and what it wasn't. He could push through it so that his work became one and both."[100]

Such questions had also occurred to Richard Diebenkorn and David Park, whose work has striking affinities with Kainen's, although no interaction ever took place. All three artists were bucking what was in vogue in their reevaluations of the figure, and all three arrived at somewhat similar conclusions with regard to setting the figure solidly into the background. Kainen, who spent the mid-1960s painting single figures, usually a standing or seated woman silhouetted against light backgrounds, defined his approach as historical:

> I began thinking of treating the figure monumentally, and I remembered that Caravaggio made one of the greatest changes of direction in the history of art by painting a figure against a totally dark background. He had no accessories. You wouldn't see flowers or a window with something outside. It was a drastic conception. . . .
>
> I thought I would reverse the procedure, have dark form against a light background and have practically nothing else. I might have variations of color, maybe some stripes or something but usually it was a luminous background with a dark form against it. . . . Caravaggio's old way of doing it worked better because a light form against a dark background radiates out. The dark form against a light background just stays there. So, I would take the curse off this. I often put brighter colors on the edges of figures to give a halation of light. . . . I'll have sudden touches of color on the outside and sometimes inside . . . to give it more . . . [luminosity].[101]

Broadly blocked out and frequently painted in tones of blue, the figurative canvases are not detailed portraits. They unite the monumental quality of architecture with emotions associated with the human presence.

For Young, who arrived in Washington in 1965, Kainen was a powerful influence on several counts. Although Young was a painter, he was working full time at the

Smithsonian to make a living. He and his friends were debating "the return to the figure" as enacted by Diebenkorn, Elmer Bischoff, and Nathan Oliveira. When Young saw Kainen's work, he was intrigued to see someone tackling the same problems as the California painters, but right in town. He looked hard at Kainen's monumental figures and learned from them. "The presence of a single figure filling in a space had a mystique about it," Young said. "The message was that it had to be completely immersed in a ground as opposed to being pasted on a ground. Jacob's work had that."[102]

The two men later met through their jobs at the Smithsonian—Young was and is an exhibits designer there—and after Young mentioned that he, too, had a studio on Dupont Circle, Kainen came to see his work and told him to take it to the Franz Bader Gallery for a show. As a black artist at the beginning of his career, Young felt that the distance between himself and one of Washington's oldest galleries could not be bridged on his own. Kainen immediately agreed to speak to Bader, and in January 1968 Young had a show at the gallery, with a catalogue introduction written by Kainen. Young recalled:

> It opened the doors. I wouldn't have gotten the show at Franz Bader's if Jacob hadn't been my spokesman. Then, after the show opened, there was an awful review of my show by Paul Richard right next to a glowing one of his. Jacob called me up and said, "Don't be depressed. Don't worry about what these people say—it doesn't matter." He was in complete sympathy with me.

> Jacob was a postgraduate school for me. He continued my education and opened up my eyes to a lot of things. He was a mentor in the sense that I could have two careers and do both of them. Other people told me, "You'll never make it as an artist because you have a regular job." But Jacob showed me it was possible.[103]

By this time Kainen had had enough of two careers and attempted to retire from his museum position in September 1966. Then David Scott, director of the National Collection of Fine Arts (now the National Museum of American Art), told Kainen that if he took early retirement, he would lose his pension. Scott persuaded him to become a part-time curator of prints and drawings at his museum. However, for someone as conscientious as Kainen, half-time frequently stretched into full-time work in assembling yet a second collection of important works on paper, and he was more frustrated than ever. His paintings of the late 1960s hint of distractions, of hope being drained away. Based on photographs clipped from newspapers, they depict multiple figures in social settings, and many lack the painterly touch, engagement, or resolution that had characterized so much of the earlier work. Kainen's professional unhappiness was compounded by a separation from his wife in 1967 and a divorce a year later. Feeling bereft of inspiration and severely demoralized, he mourned that he had betrayed his talent. In his memoir of his days on the Federal Art Project, which was written during this period, Kainen revealed his state of mind. Commenting ostensibly on the plight of WPA artists in the 1930s, he concluded the essay with a veiled allusion to his own regrets by saying, "I am sure that the feeling of lost possibilities, of youth spent without cultivating our deepest talents, lies at the heart of the bitterness we all feel, despite the fond memories. 'In art,' Henry James said, 'there is no second chance.'"[104]

In February 1968 Kainen was reluctantly dragged to a luncheon at the Women's National Democratic Club by his friend and fellow artist Jack Perlmutter. The subject of Kirchner came up in conversation, and Kainen condescendingly turned to the woman

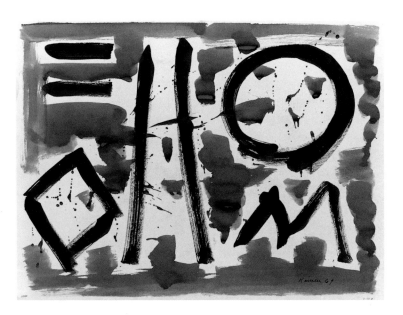

18 Untitled, 1969, gouache on paper, 21 x 30 in. (53.3 x 76.2 cm). Collection of the artist.

next to him to explain who this artist was. She replied with some annoyance that she knew very well who Kirchner was, as she had been collecting German prints and drawings for years and happened to own a Kirchner lithograph. Kainen looked with new eyes on his luncheon partner, a writer and publicist named Ruth Cole, and asked if he might see her collection. Ruth Cole and Jacob Kainen were married in February 1969, and their partnership has led to tremendous changes in Kainen's life and art (fig. 17).

In June 1969 Kainen was operated on for varicose veins, which kept him off his feet for most of the summer. To alleviate the boredom of inactivity, he began to make large, freely brushed works on paper in oil, acrylic, and gouache (fig. 18), which edged him into abstraction again. He took these ideas into the studio when he was well, and his paintings evolved accordingly. Descriptive figures were reduced to square, circular, and triangular forms, which typically were totemic structures representing a head and a thorax (fig. 19). It was a geometry with a humanist outlook; Kainen said that the combination was inspired by David Smith's sculpture, though the canvases teem with allusions to the couple's happy union (see fig. 26).

Ruth Kainen is a woman whose drive and belief in her husband make up for his tendency toward self-effacement. Soon after they were married, she resolved to do something about Kainen's neglect as a painter; she saw that despite his constant promotion of other artists, he had gotten very little for himself. He was lauded as an authority on other people's work, whereas the breadth and quality of his own achievement were unknown. Pleased with the way the painting was blossoming, Ruth Kainen persuaded her husband to take early retirement from the Smithsonian in January 1970 so that he could concentrate entirely on his own art. She was certain that her writing and his pension would support them adequately, and she was determined to give Jacob a chance to realize his creative potential to the fullest. Essential to Kainen's being reacknowledged as a painter was a permanent shedding of his duties as a curator and print expert, which "opposed his artistic exposure, growth, and survival."[105]

The new works' crisp, clean forms and flat areas of color signaled a renewal of artistic potency, and they were treated to a chorus of rapturous reviews upon being shown at the Esther Stuttman Gallery in October and November 1970. Declaring that Kainen's recent paintings were "a significant advance," Benjamin Forgey wrote in the *Star* that they were

> endowed with new energy by dint of a more forceful and enigmatic approach to subject matter. . . . the artist has entered into a more fruitful dialogue with the rich formal vocabularies of modernist art. His paintings have become more abstract, and have gained strength in the process.[106]

The *Post* was in agreement, with Paul Richard announcing,

> Something has liberated Jacob Kainen within the past 12 months. His recent oils . . . have an unexpected spark about them, a surge of sudden freedom.

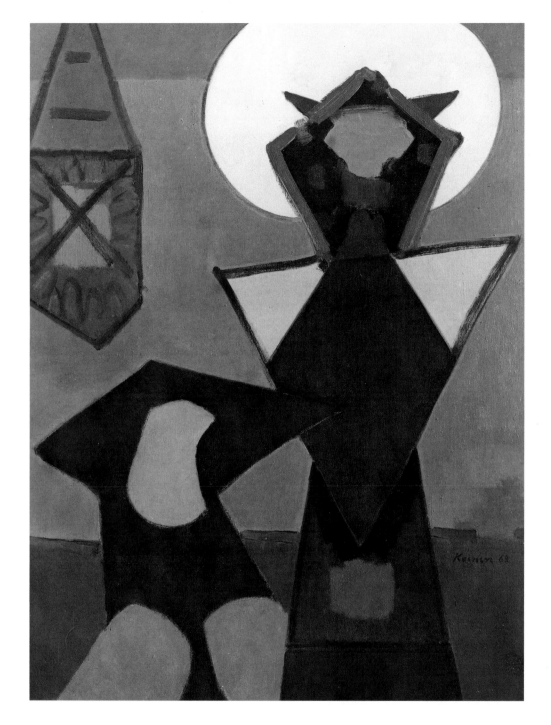

19 Figures with a Lamp I, 1969, oil on canvas, 48 x 36 in. (121.9 x 91.4 cm). Collection of the artist.

> Never has his work expressed such a confident exhilaration. . . . no viewer can mistake the sudden passion and assurance that marks [sic] his current show. . . . Jacob Kainen at age 60 has found his stride again.[107]

From this point on, as his figural forms have become more oblique, Kainen's paintings have only gained in resonance, texture, and freshness of color. Paint glows and shimmers in masterly displays of brushy overpainting; matte surfaces flicker and pulsate, setting off quivering vibrations. As Kainen wrote in 1973,

> A painting should first appear as an ensemble of harmonious but surprising shapes and colors. Colors should glow with a spiritual intensity. . . .

20 Kainen working at Landfall Press, 1975.

However abstract the forms and colors seem, they should somehow give off an aura of human experience, particularly that of the lonely Faustian thinker combining wisdom and magic. The images should seem serene at first glance, then troubling, then serene again.[108]

The emphasis on serenity may well be the result of a 1972 trip to the Soviet Union, where Kainen was deeply impressed by the spiritual purity of the Russian icon painters, especially the fifteenth-century artist Andrei Rublev. And in his invocation of the wise man or magician, Kainen conjures up the shade of John Graham and perhaps harkens back to an old debate between the two. When Kainen argued for Expressionism and the exercise of a social conscience in art, he remembered Graham replying that "art that came from orderly treatment of deeply private feelings had more enduring value than art that reflected mass psychology. . . . I would learn this, he said, when I became older and less idealistic."[109] Graham had written in a like vein: "True emotional sensitivity is not thrown at you but is hidden under poise of surface and codified in formal terms."[110] Four decades later the debate has been settled, with Graham declared the winner. More explicitly, Kainen stated in 1983 that "nothing is more deadly in art than earnest concern for one's fellow man." "Idealism," he added, was "a snare for the guileless."[111] Although remaining an Expressionist in his prints, Kainen would gravitate toward a classical statement in his paintings. Their order and balance derive from Kainen's speculative quality of mind and lifelong steadfastness of purpose. One sees them not so much as confessions in the Gorky mold but as intellectual self-examinations and chapters of a spiritual autobiography still very much in the process of being composed.

The exhibition at Esther Stuttman and Ruth Kainen's refusal to let her husband succumb to excessive modesty built up an awareness of Kainen as a painter. Since 1970 he has had at least one show of oils or works on paper a year, including an exhibition of paintings at the Pratt Manhattan Center (1972) in New York, two shows at the Phillips Collection (1973 and 1980), and two shows at the National Collection of Fine Arts (1976, 1979). During this time the Kainens formed an art collection of exceptional quality and scope, concentrating on Expressionist paintings, drawings, watercolors, and prints, particularly by Kirchner; Dutch and Italian mannerist prints (a research interest of Kainen's); and works by Kainen's friends and contemporaries, such as de Kooning, Rothko, Guston, Pollock, McNeil, Graham, Hayter, Lozowick, and Alma Thomas.[112] Extremely productive in these busy years, Kainen also worked extensively in Chicago and Paris printmaking ateliers (fig. 20). The pace of his activities was somewhat curtailed after he suffered a mild heart attack in December 1974. Kainen made a full recovery, but he is keenly aware that he is running the "final sprint"[113] of his art career. The Kainens have taken heed of an exhortation from Clement Greenberg—"Jacob's newest paintings looked to me as though he'd found his big way: Let him not be diffident about it"[114]—and Ruth vetoes most invitations for her husband to write, speak, consult, or organize exhibitions.

Kainen has never been afraid to change or question his means of expression, and by the mid-1970s he began to tire of the figurative ghosts haunting his canvases. They prevented him, he believed, "from making a stronger, more drastic artistic statement that would take into account the whole arena of the canvas and get rid of the anthropomorphic ambiguity."[115] He exorcised these remnants in severe, highly structured canvases such as *Constantine III* (1978; fig. 21) and *The Way VI* (1979; pl. 59), in which the background is not a setting for shapes or incidents. Instead, in the early paintings that constitute "The Way" series, horizontals, verticals, and diagonals slice into the rectangle of the canvas, preventing it from being perceived as a stage or vitrine

21 Constantine III, 1978, oil on canvas, 80 x 60 in. (203.1 x 152.4 cm). National Museum of American Art; gift of the artist.

with one or two shapes inside it. The spare style and comparative blankness of subject were new for Kainen, who explained his adjustment as follows: "The stoic in me must confront palpable substance, not in the sculptural sense of brute matter but in terms of painting—its tenderness, its opacities and translucencies, its reserves and contrasts, its magical charge of color."[116]

The paintings changed course, or perhaps doubled back on themselves, in the mid-1980s. Since then, Kainen has returned to richly hued, translucently layered organic abstraction in which familiar images have once more made themselves felt. In the "Dabrowsky" series, named for John Graham, shapes and symbols stand for what Kainen calls the master's "austere, magical personality."[117] The ladder form in *Dabrowsky I* (1985; pl. 86) first appeared in *Tenement Fire*, and a tremulous white form poised between a torso and a rectangle that is a constant in Kainen's "Pilot" paintings initially manifested itself in *The Vulnerable* (pl. 32) of 1954 and reoccurs throughout the 1950s and 1970s. Another dense web of associations is woven in choosing such titles as *Pilot, Isaiah*, and *The Attempt*, which recall the lonely heroics of the early 1950s. In other words, Kainen is not only not bothered by the weight of imagery but is ready to embrace it. He wrote in 1986,

> I have been moving more deeply into the area of psychological implication, while still treating broad fields of color. The movement is away from the monumental geometry of the just preceding period toward a more organic abstraction. I want to work more intuitively and less methodically.[118]

Try as Kainen might to cling to the balancing of forms, his psychological preoccupations took over. He reexplores old motifs, but with greater simplicity. An atmospheric, free-floating quality created by softly striated veils of color takes precedence over dramatic gesture or other obvious displays of skill. There is pleasure in free association, in psychic residue—witness the pentimenti of half-glimpsed shapes that register the trial and error of past experiments. The canvases are stirred by lingering presences that suggest Kainen's own largeness of feeling. That he has overcome a world of difficulties is the triumph of integrity; that his spirit has remained so tender is the miracle of art.

Acknowledgments

This essay could not have been written without the cooperation and assistance of many people. For agreeing to be interviewed and sharing their reminiscences with wit and generosity, I am grateful to Jules Halfant, George McNeil, Kenneth Noland, Jack Perlmutter, Joseph Solman, and Kenneth Young. At the National Museum of American Art, Janet Flint and Virginia Mecklenburg provided able administrative guidance, and for locating biographical and other information, I am happy to thank Lawrence Campbell, the Art Students League of New York; Marisa Keller, the Corcoran Gallery of Art; Julie Melby, the Whitney Museum of American Art; Leigh Weisblat, the Phillips Collection; and Catherine Stover, Judy Throm, Nancy Malloy, and David Dearinger, the Archives of American Art. I owe a special debt of gratitude to Francis V. O'Connor of New York and Liza Kirwin of the Archives of American Art in Washington, D.C. These loyal friends and scholars went out of their way to furnish me with documentation on Jacob Kainen and his milieu; they have greatly enlarged my understanding. I have reserved my heartiest thanks for Jacob and Ruth Kainen. Over the many hours they have devoted to this endeavor, enduring countless queries and requests, their hospitality, patience, encouragement, and good humor have been unflagging. Only they know the full extent of my appreciation.

Notes

1. Jacob Kainen, statement, May 1973, Jacob Kainen Archives (JKA), Chevy Chase, Md.
2. Joshua Taylor, "Foreword," in Janet A. Flint, *Jacob Kainen: Prints, A Retrospective* (Washington, D.C., 1976), 7. As a painter, printmaker, curator, and writer, Jacob Kainen has led several lives in one; it is beyond the scope of this essay to go into the last three in depth.
3. Jacob Kainen, interview with Avis Berman, 10 August–22 September 1982, Archives of American Art (AAA).
4. "Jacob Kainen: Outline of Activities," compiled by Ruth Cole Kainen (RCK), JKA.
5. Jules Halfant, interview with Avis Berman, 30 July 1992.
6. Norman L. Kleeblatt and Susan Chevlowe, eds., *Painting a Place in America: Jewish Artists in New York, 1900–1945* (New York, 1991), 102.
7. AAA interview, 1982.
8. Ibid.
9. Jacob Kainen, transcript of lecture given at Corcoran Gallery of Art, Washington, D.C., 8 March 1978, JKA; AAA interview, 1982.
10. Jacob Kainen, "Memories of Arshile Gorky," *Arts*, vol. 50, no. 7 (March 1976): 96.
11. "Jacob Kainen: Outline of Activities."

12. George McNeil, interview with Avis Berman, 28 August 1992.
13. Ibid. See also McNeil's interview with Irving Sandler for the AAA, 9 January 1968.
14. Katharine Metcalf Root, *The Life and Art of William Merritt Chase* (New York, 1917), 35–36.
15. Interview with Avis Berman, 17 June 1992.
16. Interview with RCK, 4 September 1975, JKA; AAA interview, 1982.
17. AAA interview, 1982. Twelve years later Kainen was awarded his degree; it was dated 1930. In a final irony, he was asked to apply for the position of dean of the School of Art and Design in 1969. (Walter Civardi, letter to Jacob Kainen, 10 December 1969, Jacob Kainen Papers, AAA.)
18. Ibid.
19. Now in the collection of the Museum of Modern Art. Kainen reviewed the Beckmann exhibition in which *Departure* appeared in the 15 January 1938 issue of *The Daily Worker*.
20. Kainen, "Memories of Arshile Gorky," 97.
21. Interview with RCK, 15 January 1980, JKA.
22. Interview with RCK, 27 March 1979.
23. Ibid.
24. Jacob Kainen, "Remembering John Graham," *Arts*, vol. 61, no. 3 (November 1986): 25.
25. AAA interview, 1982.
26. Jacob Kainen, "Posing for Gorky: A Memoir of the New York Master," *Washington Post*, 10 June 1979.
27. Ibid.
28. For a full discussion of the portrait and the trajectory of Kainen's relationship with Gorky, see "Memories of Arshile Gorky," 96–98.
29. "Memories of Arshile Gorky," 97.
30. See Kainen's "Remembering John Graham," 25–31, for an extended account of Kainen's interaction with Graham.
31. John Graham, *System and Dialectics of Art* (Baltimore and London, 1971), 140.
32. "Remembering John Graham," 29.
33. "Memories of Arshile Gorky," 98.
34. Now in the collection of the Nelson-Atkins Museum of Art.
35. "Memories of Arshile Gorky," 97.
36. McNeil, interview with Avis Berman, 28 August 1992.
37. AAA interview, 1982; Kainen, transcript of lecture given at the National Museum of American Art, 6 October 1989, JKA.
38. For a thorough history of Kainen's tenure and involvement with the Federal Art Project, see his essay, "The Graphic Arts Division of the WPA Federal Art Project," in *The New Deal Art Projects: An Anthology of Memoirs*, ed. Francis V. O'Connor (Washington, D.C., 1972), 155–75.
39. Janet A. Flint, *Jacob Kainen: Prints,*

A Retrospective, 10. As Flint has covered Kainen's work as a printmaker so ably in this publication, the subject will not be examined here.
40. Jacob Kainen, "The Whitney," *Art Front*, vol. 2, no. 11 (December 1936): 16.
41. Jacob Kainen, "American Abstract Artists," *Art Front*, vol. 3, nos. 3–4 (April–May 1937): 25.
42. Ibid., 26.
43. Jacob Kainen, "Brook and His Tradition," *Art Front*, vol. 2, no. 3 (February 1936): 7.
44. AAA interview, 1982.
45. See, for example, John R. Lane and Susan C. Larsen, eds., *Abstract Painting and Sculpture in American, 1927–1944* (Pittsburgh, 1983); *Painting a Place in America: Jewish Artists in New York, 1900–1945*; and Lucy Embick, "The Expressionist Current in New York's Avant-Garde, 1935–1940; The Paintings of 'The Ten,'" *Rutgers Art Review*, vol. 5 (Spring 1984): 56–69.
46. Jacob Kainen, "Our Expressionists," *Art Front*, vol. 3, no. 1 (February 1937): 14–15.
47. Charmion von Wiegand, "Expressionism and Social Change," *Art Front*, vol. 2, no. 10 (November 1936): 10–13.
48. "Our Expressionists," 14.
49. Jacob Kainen, "Monster Shows of Picasso and Roualt [sic] Top Art Week," *The Daily Worker*, 13 November 1937.
50. Jacob Kainen, "Art: Exhibition of New Paintings by 'The Ten' Lacks Social Themes," *The Daily Worker*, 20 May 1938.
51. Jacob Kainen, "Abstract Art Exhibit Barely Comprehensible," *The Daily Worker*, 25 February 1938.
52. Ibid.
53. Transcript of lecture given at the National Museum of American Art, 6 October 1989, JKA.
54. Exhibition announcement, the New York Group, A.C.A. Gallery, 23 May–4 June 1938, JKA.
55. AAA interview, 1982.
56. "Remembering John Graham," 29.
57. Jacob Kainen, "Social Painting and the Modern Tradition," unpublished manuscript, 10 February 1939, JKA.
58. Jacob Kainen, "Rationale of Paintings," unpublished statement, 16 November 1973, JKA.
59. Employment transcript for Jacob Kainen, 1935–1942, General Services Administration, National Personnel Records Center, St. Louis, Missouri. This document was kindly furnished to me by Francis V. O'Connor.
60. AAA interview, 1982.
61. Jacob Kainen, transcript of lecture given at the Women's National Democratic Club, 6 December 1978, JKA.
62. Ibid.
63. "Remembering John Graham," 30.
64. Jacob Kainen, draft of letter to Jean L. Cohen, 4 February 1988, JKA.
65. Harry Rand, "Jacob Kainen: Notes and Conversations," *Arts*, vol. 53, no. 4

(December 1978): 140.

66. AAA interview, 1982.

67. Jacob Kainen, unpublished draft memoir, 1984, JKA.

68. Ibid.

69. The Phillips Memorial Gallery's Christmas Sales Exhibition of Paintings, Drawings and Sculpture (29 November–27 December 1942), in which Kainen was represented by *Street Corner* and *Church Spire*. This was the first time that he showed in Washington.

70. Jacob Kainen, letter to Joseph Solman, 26 October 1942, Jacob Kainen Papers, AAA.

71. Transcript of lecture given at the National Museum of American Art, 6 October 1989, JKA.

72. AAA interview, 1982; interview with Avis Berman, 17 June 1992.

73. It ran in the 2 June 1946 issue.

74. Thomas B. Hess, *The Art Comics and Satires of Ad Reinhardt* (Düsseldorf, 1975), 32.

75. Florence S. Berryman, "One-Man Show by Washington Artist at G Place Gallery, *Washington Star*, 30 January 1944.

76. Florence S. Berryman, "Graphic Arts at Library," *Washington Star*, undated clipping, 1944, JKA. This was a lasting obsession. As late as 1956, she breathed a sigh of relief when Kainen returned to "forms which can be recognized by the layman." (See Florence Berryman, "Washington Artists in Corcoran Show," *Washington Star*, 4 November 1956.)

77. I am indebted to Francis V. O'Connor for alerting me to his theory of the frontal self-portrait as a marker of significant transitions in an artist's life and/or work. Dr. O'Connor has set forth his ideas in the fascinating essay, "The Psychodynamics of the Frontal Self-Portrait," in *Psychoanalytic Perspectives on Art*, vol. 1, ed. Mary Mathews Gedo (Hillsdale, N.J., 1985), 169–221.

78. AAA interview, 1982.

79. Flint, 12.

80. Kenneth Noland, interview with Avis Berman, 1 July 1987, AAA.

81. Kenneth Noland, telephone interview with Avis Berman, 17 July 1992.

82. Davis was reluctant to give credit to Kainen or Noland for the part they played in his development. In 1966 Kainen wrote an essay about Davis for the December issue of *Art International* ("Gene Davis and the Art of Color Interval") and let Davis see it before sending it to the magazine. Davis deleted several sentences alluding to Noland's influence on him and mailed his edited copy to *Art International* as the final version. Five years later, in an interview with Barbara Rose on his formative years in Washington ("A Conversation with Gene Davis," *Artforum*, vol. 9, no. 7 [March 1971]: 50–54), Davis avoided mentioning Kainen and misrepresented his relationship with Noland. The article drew a chastening letter from Cornelia Noland in the May 1971 issue of *Artforum* correcting Davis's version of events. After this and other complaints, Davis was more careful about what he said in print.

83. AAA interview, 1982.

84. Ibid.

85. Ibid.

86. Transcript of lecture given at the National Museum of American Art, 6 October 1989, JKA.

87. O'Connor, "The Psychodynamics of the Frontal Self-Portrait," 200.

88. Carl W. Mitman, letter to Jacob Kainen, 13 January 1949, JKA. The entire correspondence (1942–1954) between Kainen and the Smithsonian, including the letters from J. Edgar Hoover, is in the JKA. The reconstruction of events just described was based on these documents. Kainen's FBI file was requested through the Freedom of Information Act, but it has not been released yet. The dossier is said to contain 123 entries.

89. Jacob Kainen, unpublished statement, 6 January 1953, JKA.

90. Leslie Judd, "Show Points Up 'Directions' of Austrian Art," *Washington Post*, 16 March 1952.

91. For the scope of Dondero's smears of artists, abstract art, and museums (he attacked the Corcoran Gallery of Art, the Metropolitan Museum of Art, the Museum of Modern Art, and the Art Institute of Chicago, among other institutions, because they showed modern art), see William Hauptman, "The Suppression of Art in the McCarthy Era," *Artforum*, vol. 12, no. 2 (October 1973): 48–52, and Taylor D. Littleton and Maltby Sykes, *Advancing American Art: Painting, Politics, and Cultural Confrontation at Mid-Century* (Tuscaloosa, Ala., and London, 1989).

92. A critical review of the importance and impact of Kainen's writings on the history of printmaking remains to be written. His principal publications are *George Clymer and the Columbian Press* (1950); *The Halftone Screen* (1950); "John Baptist Jackson and His Chiaroscuros" (1956); "Why Bewick Succeeded: A Note in the History of Wood Engraving" (1959); *John Baptist Jackson: 18th-Century Master of the Color Woodcut* (1962); and *The Etchings of Canaletto* (1967).

93. Jacob Kainen, interview with RCK, November 1979, JKA.

94. AAA interview, 1982.

95. Jacob Kainen, interview with Judith Wilson, 1 July 1978, JKA.

96. Jacob Kainen, introductory essay, *Alma W. Thomas Retrospective Exhibition*, (Washington, D.C., 1972), unpaged.

97. AAA interview, 1982.

98. Kainen, *Alma W. Thomas Retrospective Exhibition*.

99. Adelyn Breeskin, "Alma Thomas: An Appreciation," in Merry A. Foresta, *A Life in Art: Alma Thomas, 1891–1978* (Washington, D.C., 1981), 8.

100. Kenneth Young, interview with Avis Berman, 23 July 1992.

101. Jacob Kainen, unpublished statement, 31 March 1980, JKA.

102. Young, interview with Avis Berman, 23 July 1992.

103. Ibid.

104. "The Graphic Arts Division of the WPA Federal Art Project," 175.

105. Rand, 144.

106. Benjamin Forgey, "Art: Quiet Excitement of Jacob Kainen," *Washington Star*, 25 October 1970.

107. Paul Richard, "What's Happened to the Paintings of Jacob Kainen?" *Washington Post*, 1 November 1970.

108. Jacob Kainen, unpublished statement, 16 November 1973, JKA.

109. "Remembering John Graham," 28.

110. John Graham, undated card file, John Graham Papers, AAA.

111. Jacob Kainen, unpublished statement, 1983, JKA.

112. For an excellent history and discussion of a significant portion of the Kainens' collection, see *German Expressionist Prints from the Collection of Ruth and Jacob Kainen* (Washington, D.C., 1985), a National Gallery of Art catalogue with essays by Ruth Kainen, Jacob Kainen, Andrew Robison, and Christopher With. More information on the couple's collecting activities can be gleaned from correspondence in the Kainen Papers, AAA. A brief article on the subject by Heidi L. Berry appeared in the Summer 1991 issue of *ARTnews*.

113. Quoted by Ruth Kainen in a letter to Jane Farmer, 28 February 1980, Jacob Kainen Papers, AAA.

114. Clement Greenberg, postcard to Ruth and Jacob Kainen, 13 April 1973, Jacob Kainen Papers, AAA.

115. Jacob Kainen, unpublished statement, 1983, JKA.

116. Ibid.

117. Transcript of lecture given at the National Museum of American Art, 6 October 1989, JKA.

118. Jacob Kainen, unpublished statement, November 1986, JKA.

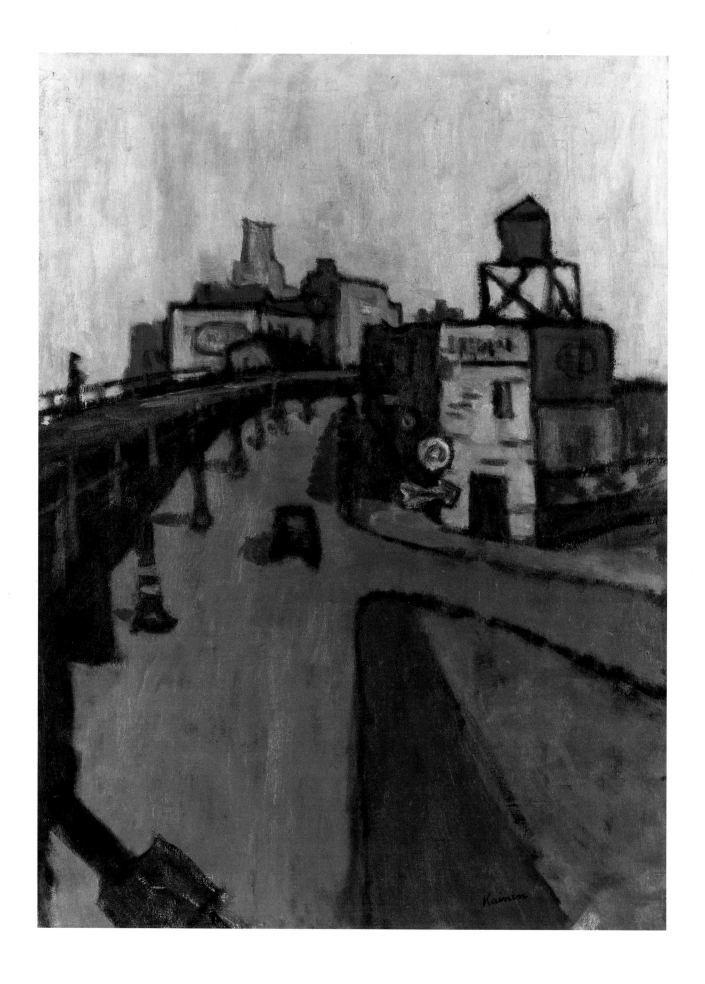

Bronx El, 1941, oil on canvas, 32 x 23 7/8 in. (81.4 x 60.8 cm). National Museum of American Art; gift of the artist.

JACOB KAINEN: POETRY IN PAINTING

WILLIAM C. AGEE

Even at this late date, the panorama of American modernism is still unfolding, and we continue to discover unknown riches. Jacob Kainen is part of that panorama. He has been a serious artist for more than sixty-five years. His artistic longevity has been remarkable. It surpasses even that achieved by Stuart Davis (1892–1964), his old friend and mentor in the 1930s, and Hans Hofmann (1880–1966), another artist Kainen has long admired. Even more remarkable has been his staying power as an artist. His painting has reached and maintained a steady, high level of accomplishment that is as rare as it is admirable. Indeed, like Davis and Hofmann, his work has only gotten better with age and experience. If he has not always shared in the formal innovations of artists such as Davis and Hofmann, through a personal, deeply felt art he has enriched the several common styles that have informed American painting. He has been on a sustained roll for twenty years, and today Jacob Kainen is painting the best pictures of his career. These are some of the most lyrical and poetic abstractions being done anywhere today.

Kainen's work contains a whole history, or even several parallel histories, of American art since the late 1920s, including Social Realism, Expressionism, Abstract Expressionism, Color Field painting, later figuration, and post-painterly abstraction. In addition, he has been a one-person history of art of the last half-century in Washington, D.C., where he moved in 1942. In fact, it may be said that Kainen inaugurated that history. These histories have been inflected by a distinctive, even contrary streak of personal and artistic independence that adds particular and unexpected twists to them.

Kainen has led an extraordinary life. Possessed of a legendary energy and work ethic as well as an iron resolve, he has simultaneously been a painter, printmaker, print curator, teacher, collector, historian, scholar, writer, and lecturer. He thought nothing of working eighteen-hour days, which he did from the early 1940s to 1968. Moreover, he is one of the most literate and widely read artists. He has made significant and lasting contributions to the arts in Washington and in America, and has done so in all of these fields.

It may be, however, that his several careers have to some extent obscured the depth and range of his painting. On the face of it, who could even have imagined that he was also a painter, given his myriad commitments? To be sure, his painting is widely known and respected in Washington, but it has been seen infrequently outside the capital. He probably has been better known beyond Washington as a printmaker and curator of

prints. (Kainen and the history of prints have a special place in American art and constitute another story altogether.) In this country we have traditionally been slow to recognize and acknowledge the fact that artists can do more than one thing well. For example, Hans Hofmann and Josef Albers were for a long time better known as teachers than as artists. We still know surprisingly little about the full range of American art, and the history of American modernism is filled with underappreciated artists whose work we simply do not know. Thus it probably should come as no surprise that only now do we have the opportunity to see the complete Jacob Kainen, to see him whole as a painter.

The fact that Washington has never been a major center for contemporary art has probably played a part in Kainen's relative obscurity as a painter. But working outside a major center has allowed his art to develop in its own way, at a slow but sure and steady pace. It has been free to assume its own character over a long period, unencumbered by the pressure to adhere to a contemporary look or stance. This distance was also important to Morris Louis and Kenneth Noland in the 1950s. For Kainen, it may be argued that the special depth of feeling, the particularly private and poetic lyricism that infuses his work, could only have matured at a distance. He has insisted on preserving the most viable traditions of the art of painting while casting them in a modern language. Jacob Kainen has a deep and abiding love for the art of painting and its venerable history and traditions. He insists that these are to be cherished and nourished with literacy and intelligence. Certainly, at a time when the "relevance" of painting has been widely questioned, he has reinforced his belief in painting as an exalted medium capable of embodying authentic emotion, even moral and spiritual grandeur. It could well be that this would have been far more difficult, if not impossible, in another kind of place.

Jacob Kainen pursued artistic interests from an early age. He was born in 1909 in Waterbury, Connecticut, to Russian immigrants who soon moved the family to New York.[1] They encouraged his interests, and by the age of twelve he was copying Howard Pyle's Art Nouveau-style illustrations in *The Story of King Arthur and His Knights*. These provided his first lessons in how a strong graphic impulse can organize and structure a surface. They were lessons he has never forgotten. He studied drawing at the Art Students League with Kimon Nicolaides in 1926–27, learning to respect the discipline that drawing demands. He continued his art studies at Pratt Institute in Brooklyn from 1927 to 1930, but was expelled shortly before graduation for his persistent displays of artistic independence, a trait that has marked his career ever since. Kainen later recalled that, all in all, he had been well trained.

His real education began when he discovered the collections of the Metropolitan Museum of Art and the Lenox Collection at the New York Public Library. They provided his most important training, fostering a deep love for Old Master painting that has been fundamental to his artistic persona to this day. From 1928 to 1933 he made more than a dozen copies of paintings by Claude, Rembrandt, Constable, Turner, Corot, and Inness, all masters of a deep, luminous light with which he has always been fascinated. He also looked hard at Copley and Church. He was later drawn to artists such as Monet and Degas, and subsequently Tintoretto and Velázquez, who also created worlds of atmospheric light and form. From the Old Masters he learned the basic elements of technique, structure, and composition. He learned to respect painting as a hard-won craft demanding discipline and long, patient study to acquire its secrets. He has never lost this respect, which still informs his painting today.

Kainen did not look only to the past. At the same time he began to explore the essential principles of a progressive, modern pictorial language. Thus his belief in a personal language of painting, imbued not only with the enduring qualities of older art but also with contemporary forms and subjects, has been fundamental to Kainen's painting from

the start. It is an approach that has parallels in the work of Arshile Gorky, with whom Kainen became friends in the 1930s, and with whom he shared a love of the Old Masters.[2] Like Gorky, Kainen began his exploration of modern art at the beginning, assimilating the tenets of Impressionism and Cézanne. In *Still Life with Apples, Pipe and Hat* of 1929 (fig. 5), Kainen used familiar studio and personal props to invoke a tentative Impressionist color and a strong internal structure we associate with Cézanne.

Little painting remains from the early thirties. His first body of paintings dates to 1934. By then he had established his first studio in New York, located at 14th Street and University Place. He had fast become a known and active member of the downtown art world, frequenting the cafés and cafeterias where much of the most vital art life in New York took place. There he met artists such as Stuart Davis, Adolf Dehn, Gorky, John Graham, Willem de Kooning, David Smith, and George McNeil, who became a close friend. In 1934 his painting *Tenement Fire* (pl. 1) was included in a group exhibition at the American Artists School gallery and won favorable notices. (From the start, Kainen exhibited regularly, and often as not his work was well received.)

By 1934 it was evident that his drive to absorb Old Master and modernist painting had been tempered by his reaction to the political, social, and economic turmoil of the Depression. It was impossible for an artist not to define how he viewed his art in relation to the pressing ills of the 1930s. Many artists, the Social Realists in particular, believed it was imperative to make a total commitment, in both their art and their life, to fighting for social justice. Other artists, Davis and Gorky among them, believed that art and politics were two separate things and should not be confused. Davis, as the leading modernist artist and spokesman, passionately committed himself to virtually every social and artistic cause through his writing, speaking, and public actions. But he steadfastly kept his art out of the political arena, pursuing it as a separate discipline subject to its own needs and demands. Davis viewed modern art as revolutionary in its own right and thus capable of effecting change. The Social Realists, on the other hand, saw the language of modernism as irrelevant formalism, an escapist and ivory-tower pursuit. The vehemence of these conflicting views reverberated through every facet of art and culture in the 1930s. Indeed, these same arguments, including the identical terminology, have been voiced throughout the social turbulence of the late 1960s and remain with us in the 1990s.

Kainen, as he has done so often, took another aesthetic position. While deeply engaged in political activism and left-wing causes, he refused to subscribe to the either/or, black-or-white rhetoric of the time. Rather, Kainen—and he was not alone in this position—attempted to reconcile the polarities of the thirties, seeking an art that would embody social and political concerns but do so through modern expressive means. It is fair to say that in this approach in the 1930s Kainen found an essential characteristic of his painting. It would later be reflected in his search for an abstract art not only able to speak its own language but also to address a specific moral, social, or political content. In the 1930s Kainen's work was not exclusively devoted to political or social themes, as is demonstrated by his landscape paintings such as *Pastorale* of 1935 (pl. 5) and *New England Vistas* of 1938 (fig. 22). Instead of depicting specific events, he often used his subject matter to speak in more general or metaphorical terms. In three of his strongest paintings of the period—*Tenement Fire* and *Disaster at Sea* of 1934 (pl. 2) and *Flood* of 1935 (pl. 4)—Kainen used imagined disasters as pointed images of a society in vast disarray.

The strong and insistent linear patterning in *Flood* and *Disaster at Sea* shows clear evidence of his close study of Baroque Old Master drawings. But in *Tenement Fire*, new concerns are also apparent. The vibrant color and drawing point to his recent absorption in German Expressionism, especially the art of Kirchner, Klee, Pechstein, and Beckmann.

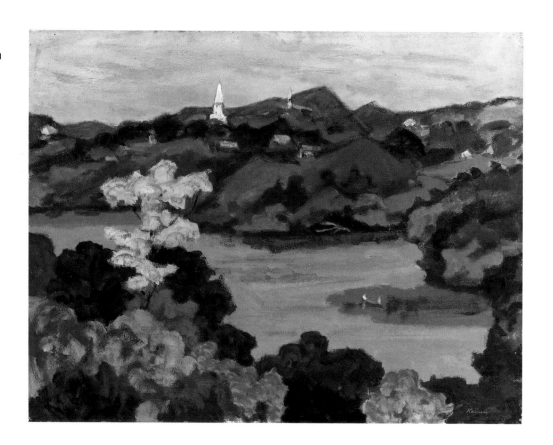

22 New England Vistas, 1938, oil on canvas, 26 x 34 in. (66.1 x 86.4 cm). Collection of the artist.

He became very familiar with the work of these artists on regular visits to J. B. Neumann's gallery, the New Art Circle, as well as to the Brummer and Nierendorf galleries and Curt Valentin's Buchholz Gallery, which opened in 1937. Pulsating line, distinctive patterning, high-keyed and intense color—all elements associated with German Expressionism—lay at the heart of his work from 1934 to 1945. Most American artists at that time gravitated to Picasso, Matisse, Miró, and the School of Paris. Kainen learned from these artists, but felt that "the Germans have the streets in them, and Matisse didn't," as he later recalled. Clearly he found in the Expressionists a mood and experience that paralleled the 1930s in America. But he also discovered that their color and line best suited his pictorial temperament, as it has continued to nourish his painting ever since. In particular, the graphic impulse in his work of those years also reflected his study of printmaking, a medium usually associated with Northern European artists. He had begun making prints in 1930, and five years later he joined the graphics section of the Works Progress Administration (WPA) at the suggestion of Davis. Thereafter Kainen became a master printmaker as well as a leading scholar in the history of prints.

Kainen also responded directly to contemporary events. Deeply stirred by the Spanish Civil War, in 1936 and 1937 he painted *Invasion* (pl. 3), *Iberia* (fig. 23), and *Spanish Museum*. However, his depictions were broad enough to transcend current events, speaking to the universality of human suffering caused by war and the profound damage inflicted on culture and civilization. We often have viewed post-1945 American art as a reaction against the social themes of the 1930s, but this was not always the case. Kainen's antiwar sentiment and his anger at the injustice done to humanity by the power-hungry did not cease after the 1930s. These feelings have stayed with him and are often at the heart of some of his strongest paintings, transformed into an abstract language.

As the thirties drew to a close, many American artists came to understand that they could not isolate themselves from the international world nor concentrate exclusively on the ills of American society. After 1937, Kainen shifted his social and political focus

to more neutral ground. *Cafeteria* (pl. 6), *Hot Dog Cart* (pl. 7), and *Oil Cloth Vendor I* (pl. 8), all of 1937, retain their street orientation, reflecting the experience of the general population, but they have a more detached, observant point of view, lacking the sense of impending doom of his earlier disaster series. Kainen chose motifs with a strong inherent order, such as the ceiling of the cafeteria and the frame of the vendor's stand, and used them to build a pronounced pictorial architecture. His use of color had also become more sophisticated and varied, evident in the black and orange contrasts of the cart's umbrella and the multicolored patterns of the oil cloth.

These paintings clearly reveal Kainen's avowed aim to be both "artistically and socially progressive" and to avail himself of the "best international traditions," as he wrote in the catalogue for the exhibition of the New York Group held at the A.C.A. Gallery in May–June 1938. Kainen was instrumental in forming the group, which included Alice Neel, Herman Rose, Joseph Vogel, and Jules Halfant, among others. Their purpose, as Kainen wrote, was to show "those aspects of contemporary life which reflect the deepest feelings of the people: their poverty, their surroundings, their desire for peace, their fight for life."[3] However, he continued, it was essential that they utilize the "living tradition of painting." They must not "talk down to the people"; their pictures "must appeal as aesthetic images which are social judgements at the same time."[4]

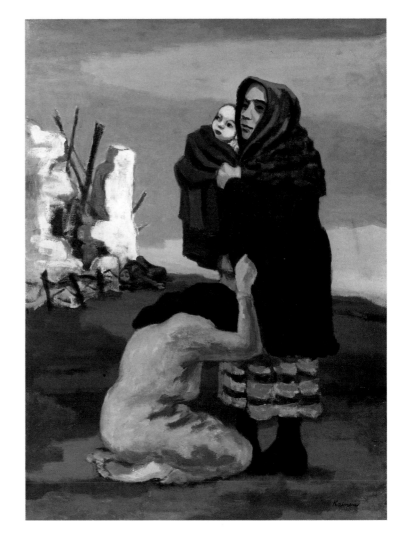

23 **Iberia**, 1936, oil on canvas, 40 x 30 in. (101.6 x 76.2 cm). Collection of the artist.

By 1940 and 1941, with America on the verge of a final break with isolationism, the urban themes in *Street Corner* (pl. 15) and *Bronx El* (see p. 42) were sought just as much for the inherent drama of their forms and patterns, as seen in the frontal planes of the former work and the dramatic diagonals of the latter. Kainen's drive to bridge a social and aesthetically advanced art culminated in the small but powerful *Street Breakers* of 1941 (pl. 17), arguably his best picture up to that time. Its theme recalls Courbet's realist masterpiece of 1849, *The Stonebreakers* (now destroyed). Kainen makes us feel the strain and wear of arduous manual labor, in great part through the power of the high-pitched color. He shows a new mastery of color that is almost Fauvist in its intensity. He gradates reds and oranges in a close range, then contrasts them with deep blues, creating a movement and architecture of color patterns that announce a new level of accomplishment. It is the work in which Kainen proclaimed he would become a serious and effective color painter.

In 1938 Kainen married and moved to the Bronx, events that removed him from the immediacy of the New York art world. It was not the last time he would put family concerns ahead of all else. Whether a result of the move or not, he began to look inward, to examine himself in a way new to his art. In paintings of 1939–40 such as *The Poet*

47

24 The Copyist,
1939, oil on
canvas, 28 x 36 in.
(71.1 x 91.4 cm).
Collection of the
artist.

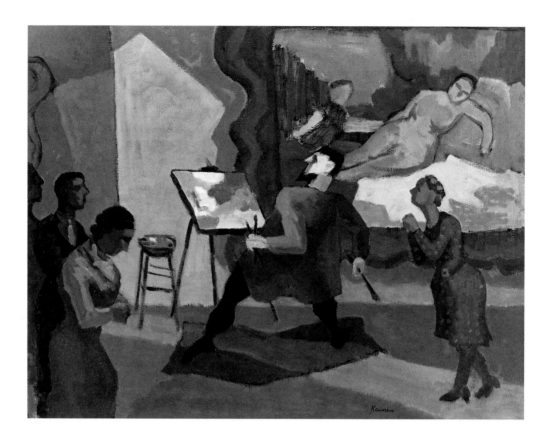

(pl. 11), *Young Man's Fancy* (pl. 13), *Blake's Angel* (pl. 16), and *The Copyist* (fig. 24), Kainen's world became not the external urban scene but one of private yearnings, embodying his own hopes and aspirations. This new mood may reflect an awareness of the explorations of Picasso and the Surrealists, but in any case these works point to the direction his art would take within a few years.

With a family to support and little or no money, Kainen was compelled to find a steady income. Always studious and inquisitive, he had immersed himself in the history of prints as well as the entire history of art. After receiving a top grade in a national Civil Service exam, in 1942 he was offered a position in Washington in the Division of Graphic Arts at the Smithsonian Institution's U.S. National Museum (now the National Museum of American History). At the time he was an established and well-respected artist in New York, an active participant in what was becoming the world center of art. He gave this up to start anew in an unfamiliar city. Kainen now recalls that the position originally was a temporary one, but it soon became a permanent appointment.

Washington could not have been farther removed from the art world. As he later remarked, the capital was a "desert," a "real wasteland" for contemporary art. That began to change with the presence of Kainen, who has been a major factor in the birth of a true contemporary art in Washington. We will have to wait for a complete history of art in Washington to assess his full impact, but there is no doubt that Kainen, as painter, printmaker, curator, writer, and teacher, has had a profound effect on the city's cultural life.

Not surprisingly, Kainen did little painting during the war years. However, one extant work stands out vividly. In *The Walk* of 1943 (pl. 19), he shows his old proclivity for urban life, but while the mood is relaxed, the street scene is laid out on a radically tilted plane. Even more dramatic is the consolidation of the painting into a few broad areas of high-pitched color that cover the entire picture plane. In turn, the surface is enlivened by pronounced, assertive brushing filled with myriad variations of touch and density. This painting has a power and directness, a sense of its physical presence, that

were new to Kainen's work. In no other painting up to that point had he felt as free to let the medium of paint speak as an autonomous expressive element. The subject of the painting could be said to be color. In retrospect, we might ask if this work does not mark the beginning of the Washington Color School.

In 1945 Kainen's continuing fascination with the city was still evident, even though the immediate social concerns of the thirties were largely behind him. His attention turned to the city's Victorian architecture, which provided an endless source of rich visual details and patterns. Kainen translated these architectural fantasies into paintings such as *Street Corner with Red Door* of 1947 (pl. 20) and *Clock Tower* of 1948 (pl. 21), in which he continued to heighten the color, letting it become still more assertive and arbitrary. The artist's linear impulse also became freer as he departed more radically than ever from observed reality, transforming the architecture into increasingly abstract patterns that activated the entire surface. Such was his journey from an external visible world to a private inner world that the city scenes became impulses for interior explorations and transformations. Indeed, the building in *Clock Tower* stands alone, totally isolated from any urban context and assuming a distinctly anthropomorphic character that recalls the theme of a single mythic figure. Configurations of this type abound in American and French painting and sculpture of the period. Here, in particular, the vertical, abstract personages of David Smith's sculptures come to mind.

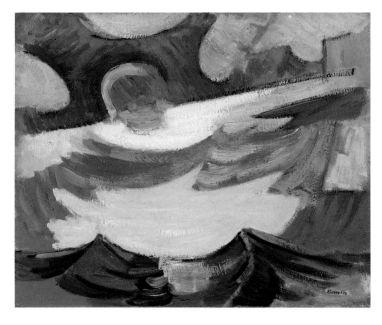

25 Sea Fantasy, 1945, oil on masonite, 16 x 20 in. (40.6 x 50.8 cm). Collection of the artist.

Kainen stayed in contact with his old friends from New York and met with artists such as George McNeil, Ad Reinhardt, and David Smith whenever they visited Washington. By 1949, undoubtedly stimulated by these contacts, Kainen's art had moved toward the type of painterly, organic abstraction associated with the New York School. In large part, his work of this period evolved from the patterning of his architectural fantasies. Also important were the examples of his old friend Arshile Gorky, as well as Picasso, and the kind of freely invented biomorphic forms that these artists used to such great effect in their painting of the late thirties and forties. Kainen's move to organic abstraction actually appeared in embryonic form as early as 1945 in a semifigurative painting entitled *Sea Fantasy* (fig. 25). The swelling curves and movement in this work, as well as in several subsequent paintings, were also inspired by the expressionistic rhythms in the seascapes of Albert Pinkham Ryder, whose work—among the treasures of Washington—he had discovered in the National Collection of Fine Arts. It is yet another example of how Kainen's love of older art has helped to shape his current painting.

Ritual, 1949 (pl. 22), is an important transitional painting. It is almost fully abstract, its forms making little or no reference to natural phenomena. In paintings of 1950 such as *Voyage* (pl. 24), the process of abstracting was completed and the entire surface set in motion by a series of independent, but sometimes interconnected, biomorphic shapes, each sharply delineated with its own distinctive profile. The dominant element, at the upper center right, is a large and looming, roughly ovoid shape. This type of element frequently appeared in Kainen's painting of that period, and it has remained a favored form to this day. At times it is roughly centered, a precise focal point for the painting; in other pictures it floats off center, as in *The Search* of 1952 (pl. 28). Such organic shapes

suggest the egg or seed, birth and germination, a search for the beginning of life. These metaphors of biomorphism, whose sources were Picasso, Miró, and Arp, became the common language of form in the late 1930s and '40s in this country.

The surface of *Voyage* and other work of the next few years is aggressive and highly charged, as opposed to the more languid mood of *Ritual* and earlier paintings. The forms seem to explode across the surface, bombarding the edges of the canvas as if the surface were a panorama of atomic and molecular life. Kainen recalled that Gorky and Graham had taught him to compose, emphasizing the importance of the pigment on the surface and the feeling it could convey. Their influence is apparent, but from them Kainen wrought a language with its own expressive tenor. We have a distinct sense of the artist attacking the painting, a mood common to much Abstract Expressionist work. It was part of a drive toward a personal and poetic kind of painting in which the artist sought to explore a cosmic world of flux, of unseen forces and drives, all caught in a rhythmic vitality born of the animating impulses of life itself. Painting became a kind of ritual, a voyage to the unknown—ideas all manifest in Kainen's titles.

The visionary world suggested in these paintings is enhanced by the indelible stamp of Kainen's color. He established a field of blue in *Voyage* and a field of red in *Magician* of 1951 (pl. 26), creating a luminous, rich veil of distinctive color in which the shapes seem to float, or to fuse with or move through the veil into an implied distance. For the first time, Kainen created worlds of enveloping light and form that parallel the luminous worlds of Claude, Turner, and Corot—masters who continued to inspire his paintings.

Into this work Kainen interjected pointed political references. In the early 1950s the country was in the grip of the McCarthy scourge. Kainen came under investigation because of his writing for *The Daily Worker* and *Art Front* in the 1930s. He was cleared, but the witch hunts left their mark. In *Standard Bearer* of 1952 (pl. 29) and *Hour of the Beast* of 1953 (pl. 30), Kainen chose titles that refer to the tyranny of McCarthyism. The aggressive collision and tension of forces in these paintings speak metaphorically of the mood of the times.

In 1953 Kainen noted a discrepancy between his vigorous, contorted brushwork and his "gentle, veiled" color. He saw himself as torn between Corot and Tintoretto, a cross between the "apocalyptic Baroque man and the pastoral classicist, musing upon serenity and luminous nuances." This tension, which is apparent in such works as *Echoes of Antiquity* of 1954 (pl. 31), has recurred in his art ever since. Although troubling, the issue finally has been resolved by knowing how to be himself, trusting his own feelings as the basis for his art.

Kainen's painterly instincts and temperament led him away from the violence and speed of gestural abstraction, and ever since he has tended to seek an art that in its various ways would embrace balance, serenity, and harmony, reconciling the expressionist and the classical. In 1954 he purged his work of the high-speed collisions of multiple and proliferating biomorphic forms. In *The Vulnerable* (pl. 32), Kainen introduced a new format, dominated by a single, centralized form and modified by a few linear elements or smaller repeating shapes. Replacing the visions of cosmic worlds was a recognition of the mundane, immediate world around him. The central shape was derived from, of all things, a glimpse of his undershirt draped over a chair as he awoke one morning; he was quick to grasp its formal possibilities, that it could be transformed into a lyrical format. Discussing the inspiration for this form, Kainen has recalled, "I was in Philadelphia in a sleazy hotel room and I used to wash my shirts and undershirts and shorts. I had my undershirt drying on a chair and I looked at it and I saw this rectangular form with the arms lopped off—by God, it was Dada's torso. And that made me think of a couple of things, not only the anthropomorphic implications of this trunk but the Argonaut's sail—the Argonauts, explorers, this wind-twisted lozenge buffeted by the

wind. You give yourself to the tempest."[5]

The single element, its basic design and shape predetermined, removed the need for constant invention. It introduced a broader, more stable, and more muted kind of painting that could focus on nuances of personal feeling rather than incessantly striving for a high-pitched emotional tenor. With a less frenetic surface, Kainen could give freer rein to his by-now singular gift for deep, rich veils and fields of color, be it the blue of *The Vulnerable* or the trademark red-salmon of *Emerge and Shine* of 1955 (pl. 34). With this move, Kainen was in the vanguard of artists reacting to the perceived formal and rhetorical excesses of Abstract Expressionism. In 1954–55, Hofmann, for example, introduced planes of color; Gottlieb's Imaginary Landscapes were a type of condensed format, leading to his distilled "Burst" pictures of 1957. By that year, even de Kooning's paintings had become broader and more open, with fewer and clearer forms.

These artists worked within painterly abstraction to correct its overworked brushing and shaping while retaining its directness, scale, and power. Such a cycle of correction had previously informed Impressionism and Cubism. By 1957–58, with the appearance of such formats as Kenneth Noland's early circles and Frank Stella's broad stripes, a younger generation, whose art became known as post-painterly abstraction, had fully defined this reaction to Abstract Expressionism. It was from the developments of 1954 that the hard-edge, cool look of much art of the 1960s later emerged.

Another alternative to Abstract Expressionism was the venerable tradition of the figure. This was the path taken by many artists, the best known being Richard Diebenkorn. Kainen, having studied the Old Masters carefully, was always close to this tradition, and its possibilities were again dramatized for him on an extended trip to Europe in 1956–57. In Italy he was struck once more by Tintoretto, at the Scuola di San Rocco, and in France by Corot. By 1957, in *Store Window* (pl. 35), the figure began to emerge from the rough rectangles floating amid veils of color, constituting his early version of post-painterly abstraction.

For the next twelve years, until 1969, Kainen worked with the figure. It diverted him from following the implications of his abstract painting and set him apart from the younger artists of the Washington Color School, whose path had in large measure been cleared by Kainen. This can partly be attributed to his well-established streak of independence, a need to go it alone; and it can partly be attributed to a distaste for the thinness of stained acrylics used by the younger artists. Kainen valued the fullness of medium that oil painting afforded, as well as the fullness of shape that the figure provided. He was seeking "noble, expressive" forms. "The figure," he said, "like a stripe or a square, is ready made, but you can modify the figure and vary the edge. I am trying to combine monumental forms with felicity of handling. . . . I am trying to get something as fundamental as architecture." These paintings usually, but not always, depict a single female figure—centered, frontal, and set in a shallow space. His largest works up to that time, they frequently display his rich color, as in the blues and blacks of *Woman in Black on a High Stool* (pl. 38). Here Kainen sought to reverse Caravaggio's technique of light figures highlighted against a dark ground, using instead a dark figure against a light ground.

The figure paintings can be compelling, but in retrospect they seem to have been a detour in the pursuit of his true gifts. Could it be that he had succumbed to the lure of the past? Or that some uncertainty had kept him from following the course he had forged by 1957? We cannot be sure, but it now appears that the dictates of representation limited, or sidetracked, the powers of lyrical invention and coloration that by 1957 had come to a point of fruition.

Kainen seems to have recognized this, for in 1967, and then more fully by 1969 in *Pale Nude* (pl. 43), abstract shapes once more began to emerge and take on a significant role

in his paintings. By the end of 1969 he had returned to full-blown abstraction, although at first the work often contained figurative references. It took him a year or two to find his way again, but by 1971–72 Kainen had hit full stride. Since then, he has continued to flourish. In no previous period has he painted as much, and never has his rate of success been higher. Age has not slowed him down; on the contrary, it has given him a well of experience that has enriched and deepened his art.

Just how and why this happened is hard to say precisely, although we can point to the confluence of several important events. Certainly his retirement from formal curatorial commitments enabled him to devote his full powers of concentration to his art. Hofmann again comes to mind, for his painting also reached a new level after he retired from teaching in 1958. For Kainen, a second marriage, in 1969 to Ruth Cole, reinvigorated him, giving him a new outlook on life. And in 1972, on a trip to Russia, his ancestral homeland, he was moved by the beauty and spirituality of Russian icon painting, which offered him new and even higher standards to aspire to in his work. There are other reasons for Kainen's flowering, reasons having solely to do with the art of painting. His art is such that it required a long period of growth and gestation, with room for experiment, false starts, and lengthy deliberation. It required time, for good abstract painting is far more difficult to make than we commonly suppose. It required time, we may speculate, for Kainen to learn, finally to know himself, to trust his painterly instincts, as he himself had long urged.

Kainen's first paintings of this new era, among them *Night Attack* of 1970 (pl. 47), are composed of a few simple, strong forms cut into a single field of high color with sharply drawn outlines. They are aggressive shapes, in keeping with the antiwar mood suggested by the title. Be it the Spanish Civil War or Vietnam thirty years later, Kainen has never lost his sense of despair and outrage over the evils of war. Now, however, he had found an abstract language to embody his feelings, a format far more comfortable for him than the painterly, gestural mode he had used in the early 1950s. This new format was a crucial discovery for him. Through it and its several variations in subsequent years, he has been able to impart to abstract painting a whole range of personal and public references.

Works such as *Night Attack* also represent his direct response to 1960s hard-edge, geometric painting. In 1971, however, he began to soften the edges and the drawing while muting and veiling the field, at the same time retaining the few large, broad shapes associated with his work of the sixties. He also introduced more varied drawing into his shapes, which keeps them from becoming predictable geometric figures. Further, he began to interject a judicious number of independent linear elements. Surface density was varied throughout. All of this enabled him to reestablish his feeling for luminous color and surface, giving the picture its particular poetic resonance. By 1974 the vocabulary of the 1960s had been transformed into a personal language that fuses the geometric with a softer, more painterly touch.

Kainen clearly felt free to incorporate whatever elements of form he needed, as well as a wide range of emotive and poetic references. Indeed, for several years, until 1974, abstracted figurative elements played a major role in his art. Typically, a roughly oval or circular shape, suggesting the head, hovers above three fused rectangles that stand for the torso, as in "The Couple" series of 1969–71—paintings that celebrated his recent marriage (fig. 26). In the 1971 *Anacharsis* (pl. 45), one of his best paintings of the time, Kainen referred to Anacharsis Klootz, an aggressive, even mad, Prussian general in the French Revolution, who had been mentioned by Melville. (Kainen is well read and loves literary references, especially to Melville.) It is a forceful picture and suggests the new level of intensity Kainen was now seeking. In *Marathon* (pl. 50) and *Orphic* of 1973, he used variants of the circular and rectangular shapes to suggest single standing figures.

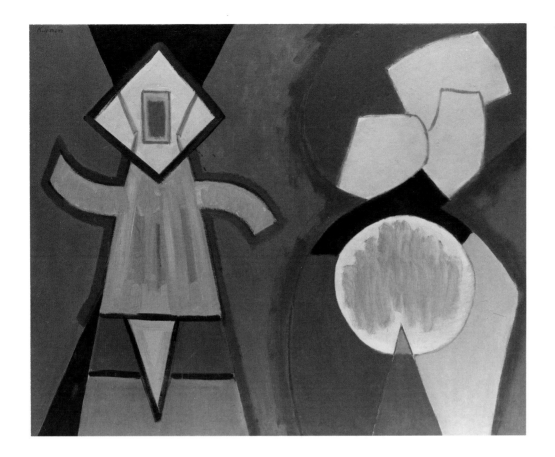

26 The Couple II, 1969, oil on canvas, 48 x 60 in. (121.9 x 152.4 cm). Collection of the artist.

Their vertical configurations, as well as the explicit titles, invoke an image of the artist as a solitary figure engaged in perilous acts of exploration, in a ritual of discovery, a poetic mood that calls to mind the tenor of Abstract Expressionism. It suggests that Kainen, in fact, wished to retain that movement's poetry within the context of a broader, more stable format, a fusion that he has successfully achieved in much of his work since then.

Indeed, the language of form developed by Kainen in his paintings of 1970–75 has as much to do with later Abstract Expressionism as it does with the 1960s. The vertically arranged figurative elements of *Anacharsis*, for example, bring to mind the standing personages that appear constantly in the sculpture of David Smith. Kainen's alternation of circular and rectangular shapes is balanced and played one against the other in ways similar to Smith's "Sentinel," "Zig," and "Voltri-Bolton" series. The large circles that Kainen began to favor at this time in turn recall the large elements in Smith's "Circle" series. Kainen became acquainted with Smith in the 1930s in New York and kept in touch with him after moving to Washington. Kainen would later state that he was the "spiritual heir of Smith, via Graham and Gorky."

By the same token, in the more condensed formats, such as the circle placed over a rectangle, for example, in *Escape Artist I* of 1973 (pl. 51), Kainen's painting could offer parallels to Gottlieb's "Burst" series, with its contrasting stable and explosive shapes. However, just how far Kainen transformed these parallels is evident in the single rectangle that, in fact, made its first appearance in 1954, metamorphosed from its guise as the artist's undershirt. It is in just such transformations that we find much of the richness of Kainen's work. In other paintings, more linear, cryptic shapes can also suggest an affinity with certain symbols in Gottlieb's pictographs of 1942 to 1950.

Kainen's love of and engagement with the history of art, so evident since the late 1920s, appeared in other ways in the paintings of this period. In *Marathon* and *Observer VI* (pl. 52), both of 1973, the circular element expands to the point where it nearly fills

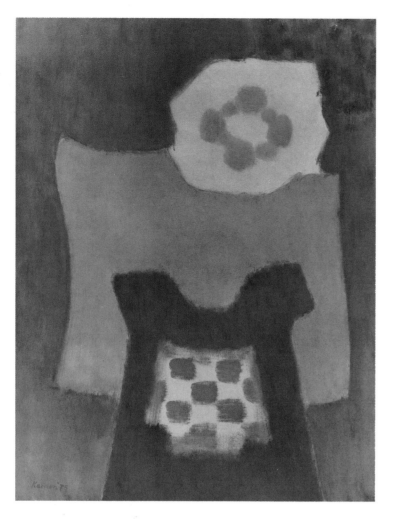

the surface. It recalls the entire vein of nature symbolism of American modernism, especially Arthur Dove's great sun and moon paintings done in the 1920s and 1930s, which are represented in depth at the Phillips Collection. In *Magellan* of 1975 (pl. 54), the circle calls to mind Matisse's tabletop pictures of 1916–17. Even more immediately, Kainen appears to have responded again to the circle format, a dominant motif used by several of the Washington Color painters, notably Kenneth Noland, whose circle paintings of 1956–63 provided an example in the mid-1960s for the work of other members of that school, including Paul Reed, Alma Thomas, Howard Mehring, and Tom Downing.

A common and recurring motif in the entire history of art, the circle has been favored in the modern age because it provides a precise and immediate focus, centering the painting and giving it maximum impact. It is a culmination of the tendency in modernist painting—from Cézanne to Pollock—to cluster and move around and to the center. Kainen, too,

above

27 Observer XVIII, 1975, oil on canvas, 36 x 28 in. (91.4 x 71.1 cm). Collection of the artist.

opposite, above

28 The Way V, 1979, oil on canvas, 60 x 80 in. (152.4 x 203.2 cm). Collection of the artist.

opposite, below

29 The Way XX, 1980, oil on canvas, 80 x 60 in. (203.2 x 152.4 cm). Collection of the artist.

can be said to have employed this phenomenon. In *Nova I* of 1977 (pl. 55), one of his most satisfying paintings, the circular element is in perfect balance, just above the center, within a surrounding six-sided star. By contrasting it with linear elements and other shapes, enhanced by his color and touch, Kainen demonstrated that circle imagery is capable of such diversity that it cannot really be called a common motif. The equilibrium he achieved in this work apparently led Kainen to feel he could go no further with the motif. He abandoned the circle for ten years, and it did not reappear until 1987.

Kainen had begun to work in series as early as 1969–71 with "The Couple" and "Voyeur," moving on in 1972 to his "Observer" series (fig. 27). In 1978, with "The Way," a series that was to number more than a hundred paintings in the next ten years, he began in earnest to explore its possibilities. He was intrigued by the idea of taking one basic format, searching and extending its potential with as many variations in shape and color as he found fruitful. This has become his standard method of working. He has worked simultaneously on more than one series, and at points has had five or six in progress at the same time. The method has suited him well, befitting his temperament and allowing him to explore in depth, and patiently, myriad formal and emotive themes. It has enabled him to create his art in a cumulative manner, enriched by cross-pollination, with the experience and implications of one painting—and one series—extending into and affecting the next. The viewer may single out individual works, but for Kainen each painting is an intrinsic part of a total and ongoing experience. The wisdom of working in series was emphasized by David Smith, who in turn passed it on to Kenneth Noland. Like Kainen, he had learned valuable lessons from Smith's example.

Kainen had rejected organic gestural abstraction because he found its marks and forms too indistinct and vague. Viewing himself as more of a "classical draftsman," he

developed through long experience a preference for the clearly formed broad shape, rendered in a straightforward and formal space with clear relationships between forms. Whereas he had once been torn between the Baroque of Tintoretto and the classical serenity of Corot, he now chose the art of harmony and balance in the tradition of Poussin and Ingres, artists whom he deeply loves.

In "The Way," a series that extended from 1978 to 1988, Kainen began with a simple form, sometimes using as few as three, often four, but never more than five shapes (fig. 28). The one most frequently used was the rectangle. Once more, we remember the humble origin of that single shape in 1954 and its several permutations in his work since then. In *The Way I*, Kainen employed three vertical rectangles, stepped upward from the left center to the upper right, in a simple progression. The colors are warm, one a deep red and the other two close-valued blues and grays. Nothing could be more straightforward. From there he would build his work, sometimes using the same format (*The Way XX*) (fig. 29), only with somewhat different colors and sharper edging to the forms; in others, rectangles of various sizes overlap or cut into one another (*LXXIX*) or are neatly joined together (*XI* [pl. 62]). Often large areas of white are used, but these function as shapes just as much as the color areas. It is not a matter of color on a white field, but shapes moving together as equals. In other paintings, all the rectangles are colored, all in Kainen's by-now familiar hues of soft, warm reds, blues, greens, grays, tans, and whites.

We are in the presence of a considered and contemplative art, in which we are invited to share with an easy openness of mind and spirit. It is an art that shuns the flashy, bravura performance. The paintings are meditative, even gentle. The shapes are clearly defined, but these are not hard-edge, geometric paintings because Kainen always softens and mutes the edges as well as the fields. In his search for an art of harmony and balance, he has always retained a predilection for painterly luminosity, which he learned to love in the Old Masters he had copied fifty years earlier at the Metropolitan Museum and the New York Public Library.

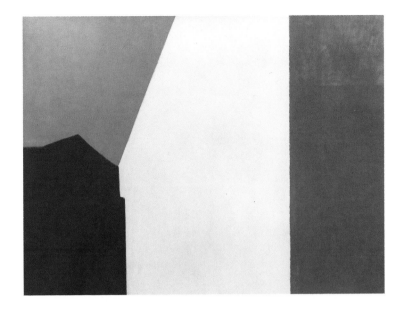

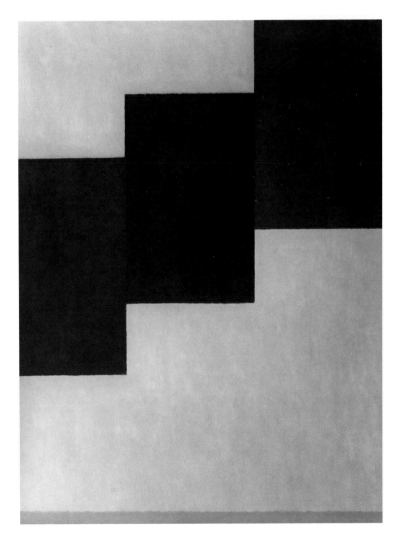

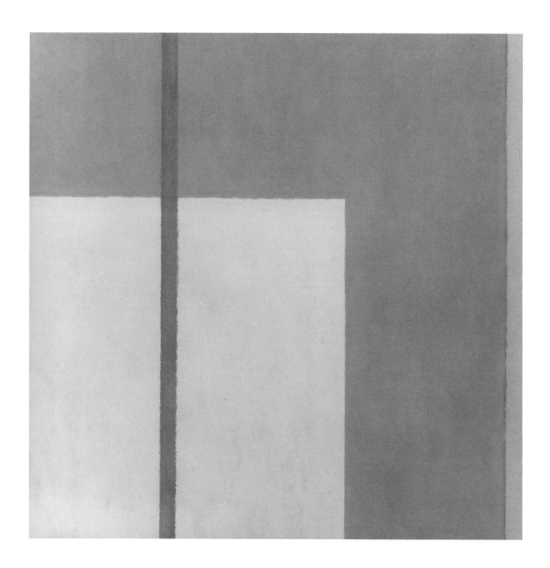

30 Aegean VIII, 1980, oil on canvas, 60 x 60 in. (152.4 x 152.4 cm.). Collection of the artist.

It is this that separates Kainen's art from the formats of Mondrian of 1917, van Doesburg from 1917 to 1930, even Ben Nicholson of the mid-1930s, all work that suggests parallels with Kainen's formats in these series. We feel these formats have more to do with the clear, sure but muted architecture and color of the planar arrangements found in Vermeer. Kainen arranges and rearranges rectangles, exploring entire formal worlds, much as Cézanne did with apples, in the pursuit of a "solitary pictorial chess," to use Meyer Schapiro's famous comparison.[6] Kainen's paintings exert great presence, due not only to their newly increased size in the late 1970s—60 by 80 inches became the preferred canvas— but also to the internal scale of the parts, which seems to expand their literal size. But more than anything, their presence is due to the enveloping fields of warm, rich color that pervade these paintings. Kainen's work since 1972 can be said to be in the great tradition of Constructivist art, which appears to use a minimum of means but achieves a maximum range of effects.

Starting from there, Kainen pursued other worlds of formal variations. In the first of the "Aegean" series of 1980–84, such as *Aegean VI*, he employed vertical elements at the left center and right edge to modify two concentric rectangles. Here, as elsewhere, we see how Kainen interjects a real ambiguity into these apparently simple structures, for we cannot be sure if the right element is meant to be read as an independent shape or the edge of a larger rectangle "hidden" behind the two visible rectangles (fig. 30). In later paintings in this series, such as *Aegean XVI* and *XIX* (pl. 78), we see how Kainen works back and forth, for here he develops the idea of overlapping rectangles begun in "The Way" series. Variations of the stepped rectangles in "The Way" reoccur in the

"Interface" series of 1982 and 1983, but now the rectangles are larger, fuller, and occupy much more of the surface.

Kainen showed the extensive range of effects that could be achieved with the simple rectangle in two other series, "Pilot" and "Argosy." In *Pilot I* (pl. 66), he began the sequence with two unevenly sized rectangles of closely gradated red-salmon color that seem to float in and across the surface. The effect is entirely different because the rectangles in the earlier series were grounded or tied to the bottom and/or at the edges. In subsequent paintings, more types and sizes of rectangles are introduced, some vertical and others emphatically horizontal. In the "Argosy" series, this is varied by placing one larger rectangle directly over a much smaller rectangle, with a vertical bar at left extending the full or nearly full height of the picture.

In the "Argosy" paintings of 1982 and 1983, the large rectangle remains, and to the left are three smaller rectangles, one or two tilted. In these paintings the field of color became fuller and stronger than ever. The "Fabrizio" series of 1983–84 introduced a new broad diagonal bar to the format of the earlier pictures, and in turn the rectangles were divided in half by the use of two distinct but related hues. The possibilities were indeed endless.

But Kainen has always pushed and questioned himself in order to stay true to his painterly aspirations. He has never allowed his art to become forced or mechanical. By 1984 he had begun to tire of regular formats and even surfaces, feeling that his art had become perhaps too austere. No doubt he missed the full evidence of hand and brush that could create luminous fields invoking the painterly worlds of light and form of Tintoretto, Rembrandt, Claude, Turner, Constable, and Corot, artists whom he had loved for so long. Kainen understood that his roots were in this tradition, where, after a long search, he would finally settle.

In the later paintings of the "Argosy" series, such as *XXXIV* of 1984 (pl. 80) and *XLV* of 1985 (pl. 84), Kainen began to mute and soften the shapes and fields. (Among contemporary painters, only Richard Diebenkorn has achieved a similar fusion of pictorial architecture and brushed surfaces and color.) In the "Stamboul" series of 1985 and 1986, Kainen introduced irregular rectangles placed at odd and variant angles, creating the sensation of a surface gently rocking in slow motion. By 1987, in *Argosy LIV*, the forms and fields of the paintings had become distinctly brushed, their painterly marks evident throughout. Evidence of the hand and of the artist's search are apparent in "ghost" images that appear to emerge from behind the surface. The artist now feels no compunction in leaving on the surface visible evidence of his work, his quest. Here the influence of Velázquez is apparent, for Kainen had developed a keen admiration for the Spanish master, particularly the naturalness of his approach and his flawless command of space relationships. (The interest of many modern artists in Velázquez—Fairfield Porter also comes to mind—is a fascinating, and separate, topic.)

Kainen reintroduced pronounced linear, hand-drawn elements in paintings of 1987, such as *Logos* (pl. 93), and then especially in the "Rublev" series of 1987–89. Linear, brushed elements now tracked throughout the painting, creating irregular surfaces and shapes that hint at the biomorphism of the late 1940s and early 1950s. Indeed, by 1989 the mood of his work was far more rooted in the poetry of Abstract Expressionism—not the violent gesturalism of the late 1940s but rather the soft lyricism associated with the later 1950s and the work of Gottlieb and Hofmann. Also evident is the feel of the sensuous color and surface of Gorky—his old friend and colleague—in his refulgent paintings of 1944–46. So, too, the velvet textures of William Baziotes come to mind, as do Clyfford Still's lustrous fields etched by sharp vertical drawing.

Nevertheless, these rich, full paintings are distinctly Kainen's by virtue of the drawing and especially the extraordinary color. These paintings are, in the memorable words of

Charles Parkhurst, enveloped by a "fog of color."[7] They are infused with a fullness of light and color, an ever-increasing intensity that makes us understand that Kainen has perpetuated, in a new and significant way, the tradition of the Washington Color School. Indeed, his paintings have continued an entire color tradition in Western painting, extending back to the seventeenth century. Nor should we forget that Kainen has also been inspired by the beauty and color of Russian icon painting, which he believes accounts for a certain oriental quality in his color after 1972, the year of his visit to Russia.

The "glow" of pigment and color, to use Kainen's own word, became even more evident in the "Pilot" series, which Kainen continued in 1989, 1990, and 1991. Here he created an almost perfect harmony between line and the familiar concentric circles and rectangles, all enveloped in a rich luminous field of light and color. So full is the color atmosphere that it readily calls to mind Degas's late pastels and Monet's symphonic pictures of the 1890s, or, as previously noted, even Arthur Dove's great sun pictures of the mid-1930s. This velvet, refined color also infers the intimate worlds of Milton Avery or of Bonnard and Vuillard, but now rendered in large-scale, abstract, equivalent terms. "It's the art of painting," Kainen says, "you do it through the paint." In the 1990 "Pilot" series, he truly achieved the "painterly ease" and kind of "orderly grandeur" that he had so long been seeking.

His search never ceases, and in his more recent work, such as *The Attempt* of 1992 (pl. 100), Kainen has again sought a more condensed type of painting. There are only a few broad shapes, and the effect is one of full clarity—the goal he had also sought in another vein in the early 1970s. Just as his drawing in 1989–91 recalls his 1950s expressionist work in that medium, so this painting brings to mind another phase of his art. Kainen apparently seeks once again to explore the amplitude and clarity of Poussin and Ingres. He is aware of how he continues to come full circle, referring to it in terms of Nietzsche's concept of "eternal recurrence." It is intrinsic to an art that values age and experience, depth and maturity, that can unabashedly make reference to virtually the entire history of art. It is an art that holds a steadfast faith in the power of painting to engage and to move us. It continues to do so, convincingly.

Notes

1. Biographical information and quotes about Kainen's ideas and work come from three primary sources: my own discussions with the artist throughout 1992, the artist's copious notes and journals dating back to 1952, and Avis Berman's extensive interviews with Kainen in August 1982. Since the information often overlaps, it would be fruitless to note each reference. Another important discussion of Kainen's art and life is in Harry Rand, "Notes and Conversations: Jacob Kainen," in *Arts* (December 1978): 135–45.
2. *Arts* (December 1978): 135–45.
3. Jacob Kainen, "The New York Group," A.C.A. Gallery, New York, 23 May–4 June 1938.
4. Ibid.
5. Interview with Michael Sundell, 18 March 1978, in Archives of American Art.
6. Meyer Schapiro, "The Apples of Cézanne: An Essay on the Meaning of Still-life," *Art News Annual*, vol. 34, 1968, "The Avant-Garde," 34–53.
7. Charles Parkhurst, "Jacob Kainen," exhibition brochure, Phillips Collection, Washington, D.C., 13 December 1980–25 January 1981, n.p.

PLATES

Unless otherwise noted, all works are oil on canvas
and in the collection of the artist; height precedes width.

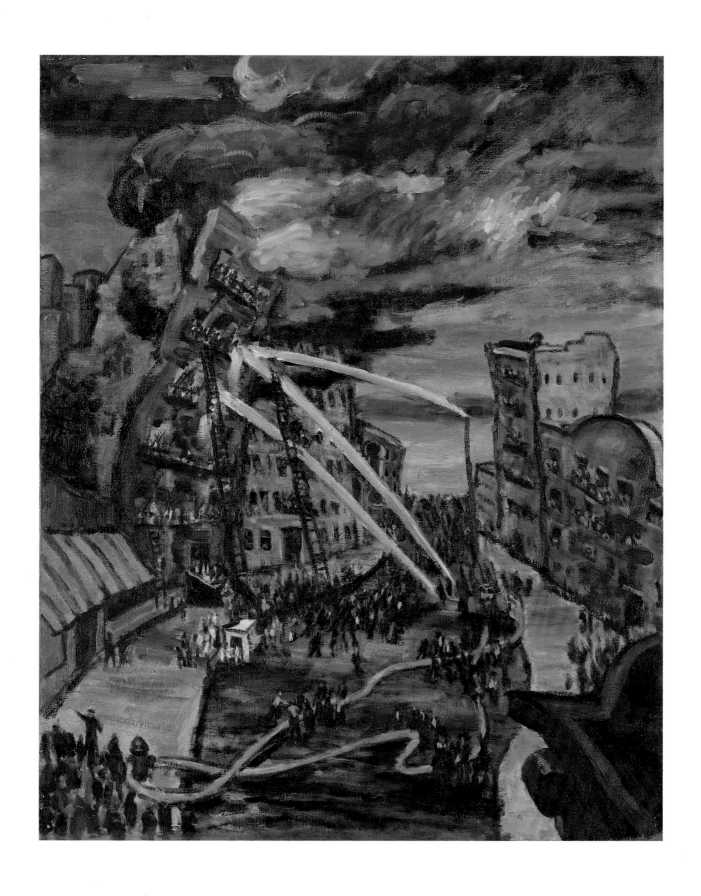

1 Tenement Fire, 1934, 28 x 23 in. (71.2 x 58.4 cm).
National Museum of American Art, gift of the artist.

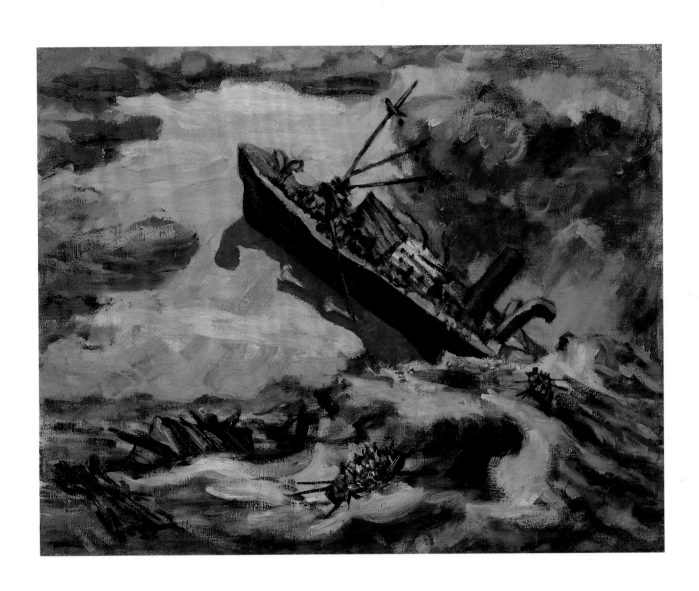

2 **Disaster at Sea**, 1934, 22 x 28 in. (55.9 x 71.1 cm).

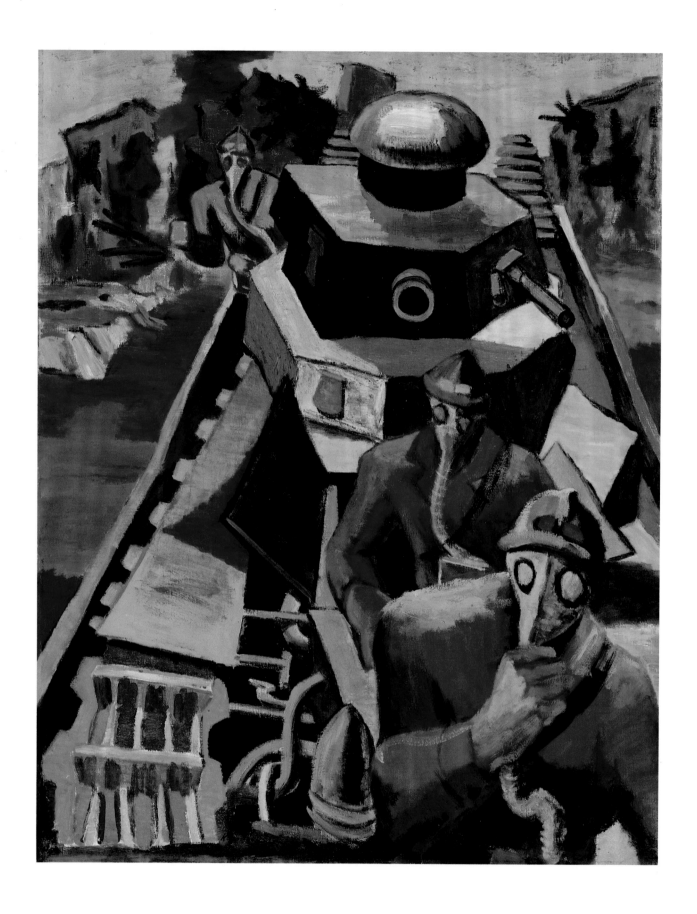

3 Invasion, 1936, 38 x 30 in. (96.5 x 76.2 cm).

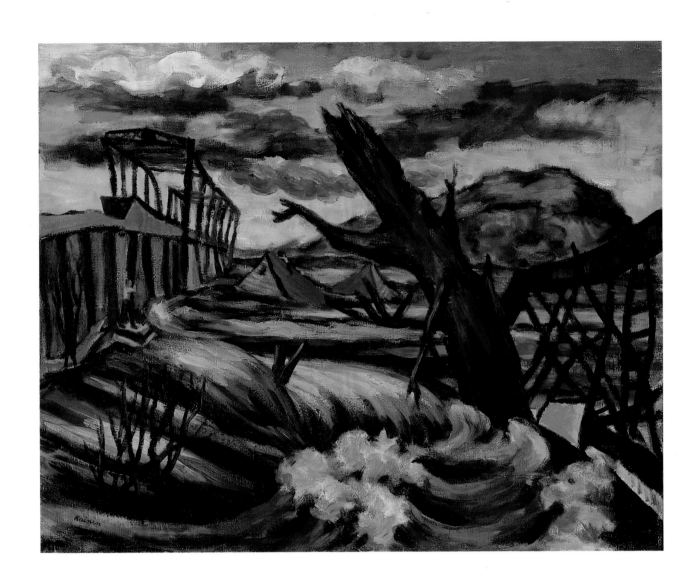

4 Flood, 1935, 22 x 28 in. (55.9 x 71.1 cm).

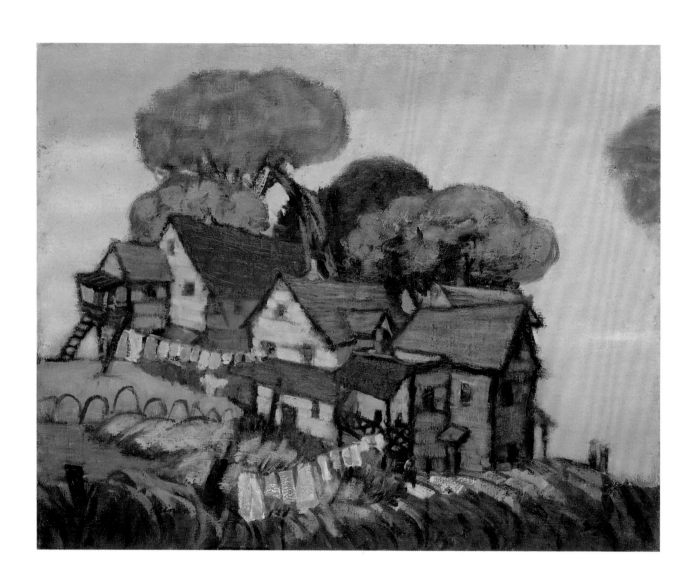

5 Pastorale, 1935, 22 x 28 in. (56 x 71.1 cm).
National Museum of American Art, gift of the artist.

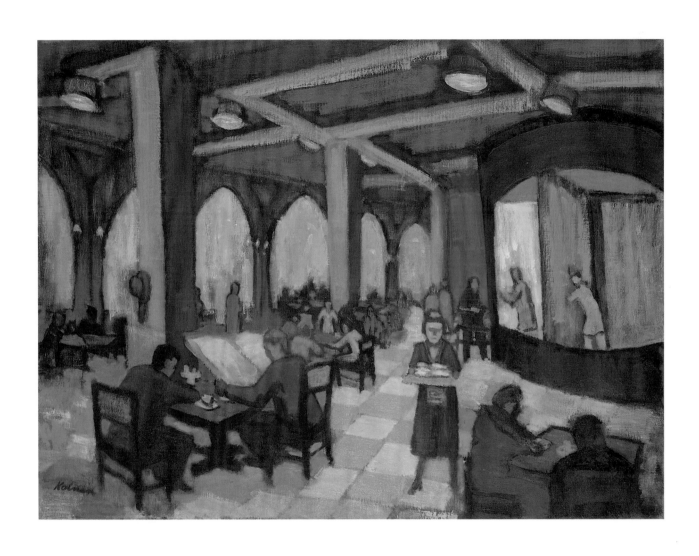

6 Cafeteria, 1937, 24 x 32 in. (60.9 x 81.3 cm).
Addison Gallery of American Art, Phillips Academy, Andover, Massachusetts, gift of the artist. All rights reserved.

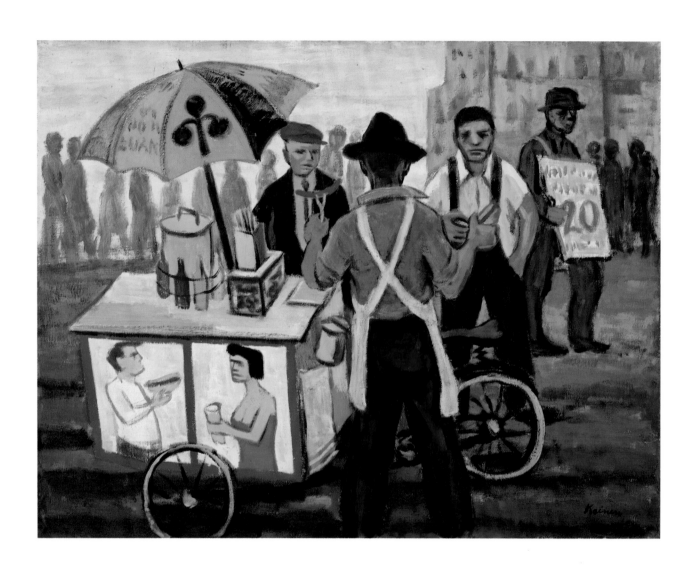

7 Hot Dog Cart, 1937, 28 x 36 in. (71.1 x 91.4 cm).

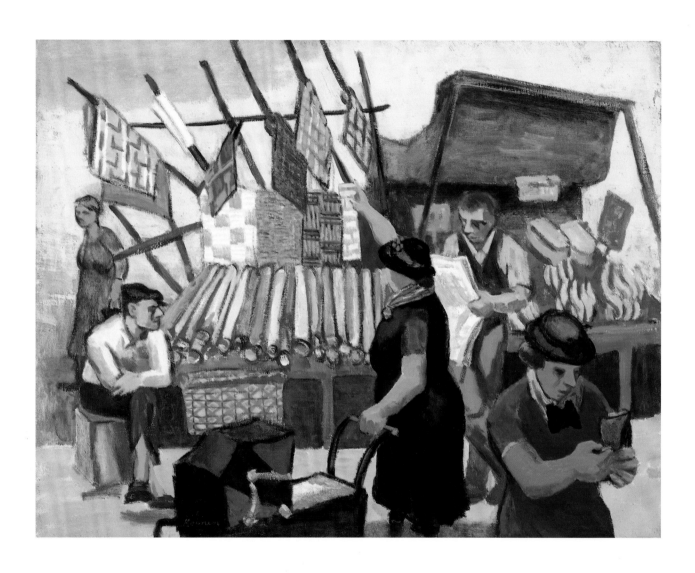

8 Oil Cloth Vendor I, 1937, 28 x 36 in. (71.1 x 91.4 cm).

9 Spanish Museum, 1937, 24 x 30 in. (60.9 x 76.2 cm).

10 Barber Shop, 1939, 30 x 24 in. (76.2 x 60.9 cm).

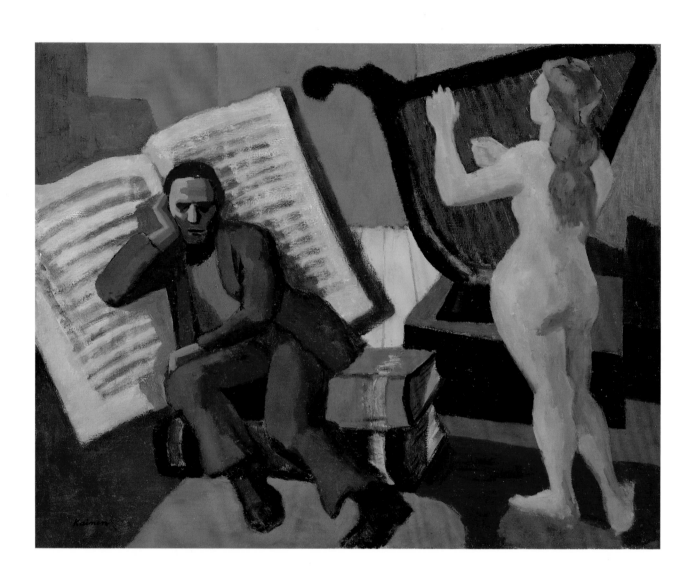

11 The Poet, 1939, 28 x 36 in. (71.1 x 91.4 cm).

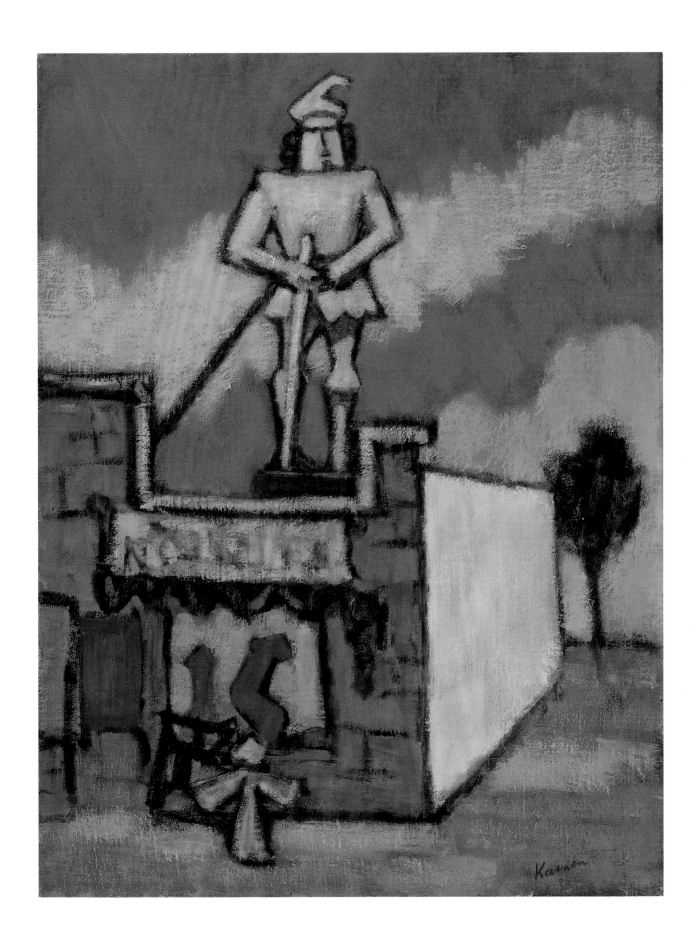

12 Tin Warrior, 1939, 26 x 20 in. (66 x 50.8 cm).

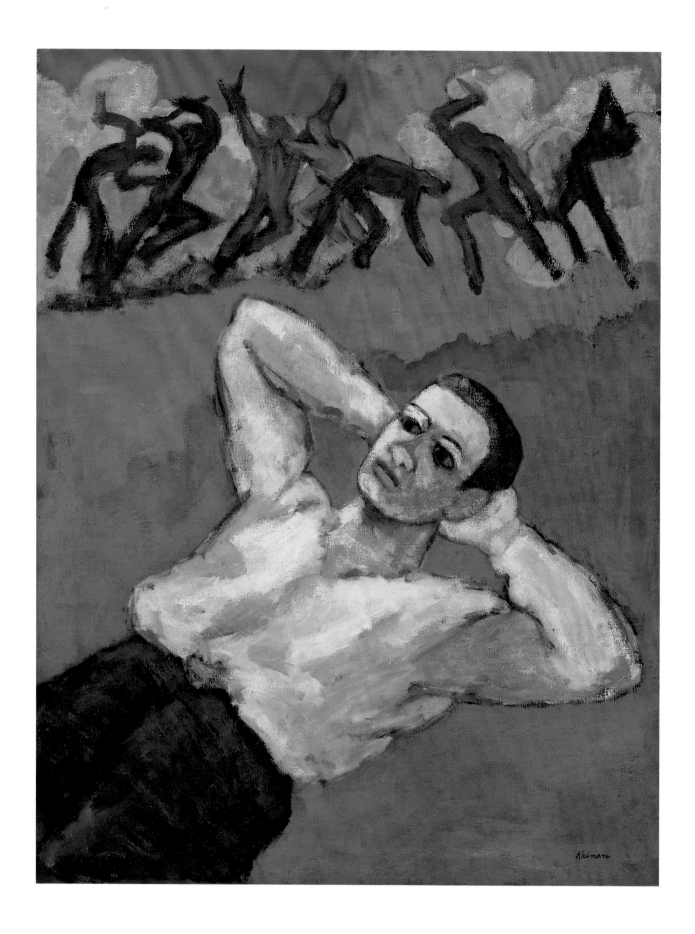

13 Young Man's Fancy, 1939, 36 x 28 in. (91.4 x 71.1 cm).

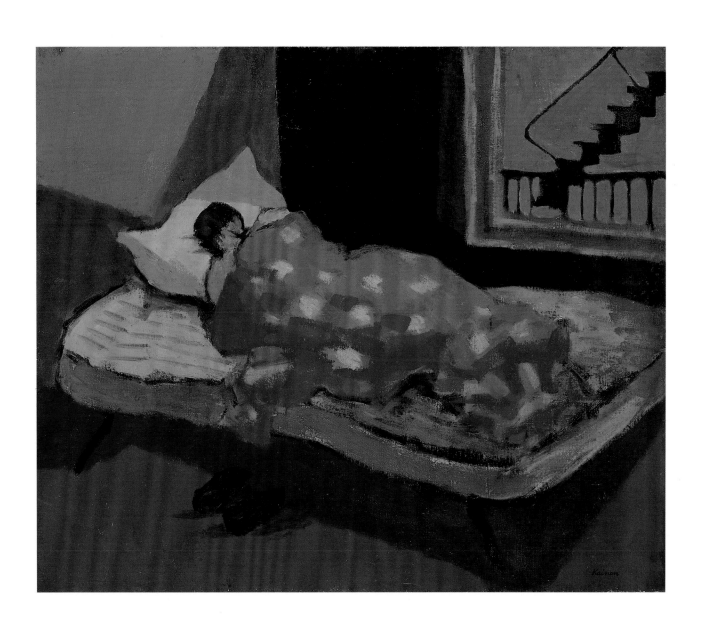

14 Unfurnished Room, 1939, 20 x 24 in. (50.8 x 60.9 cm).
Collection Ruth Cole Kainen.

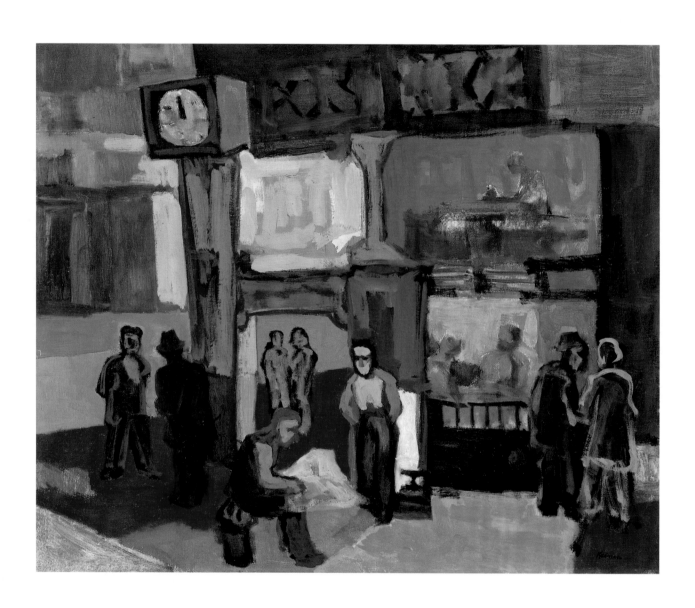

15 Street Corner, 1940, 22 x 28 in. (55.9 x 71.1 cm).
The Phillips Collection, Washington, D.C.

16 Blake's Angel, 1940, 36 x 28 in. (91.4 x 71.1 cm).

17 Street Breakers, 1941, oil on beaverboard, 12 x 20 in. (30.5 x 50.8 cm).

18 Virginia Farmhouse, 1941, 28 x 36 in. (71.1 x 91.4 cm).

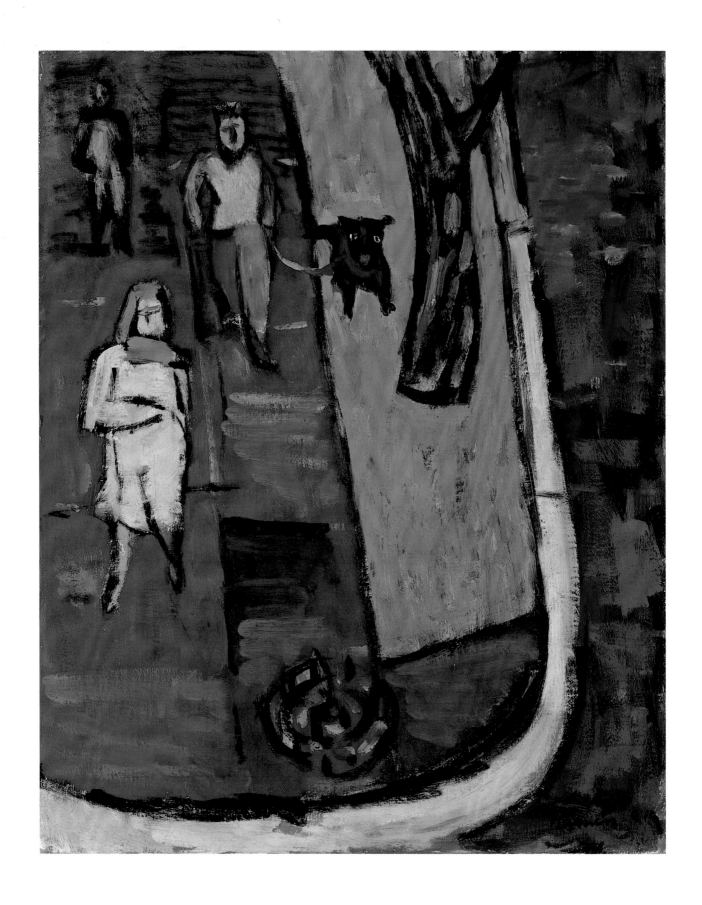

19 The Walk, 1943, 20 x 16 in. (50.8 x 40.6 cm).

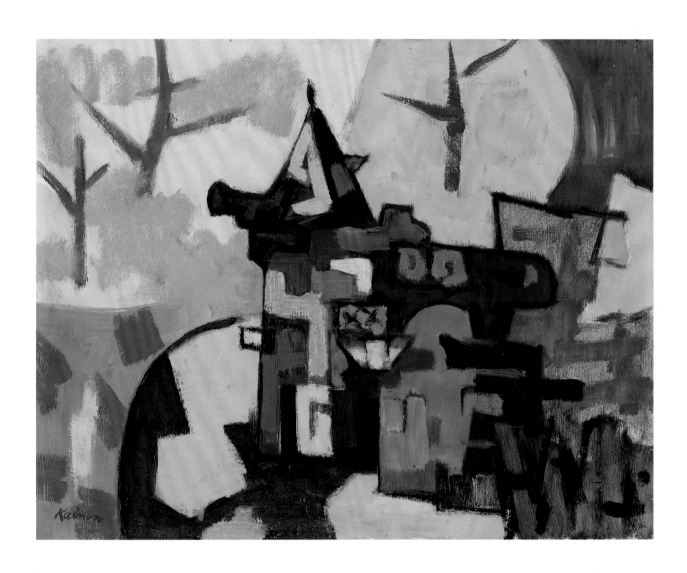

20 Street Corner with Red Door, 1947, oil on fiberboard, 14 x 18 in. (35.6 x 45.7 cm).

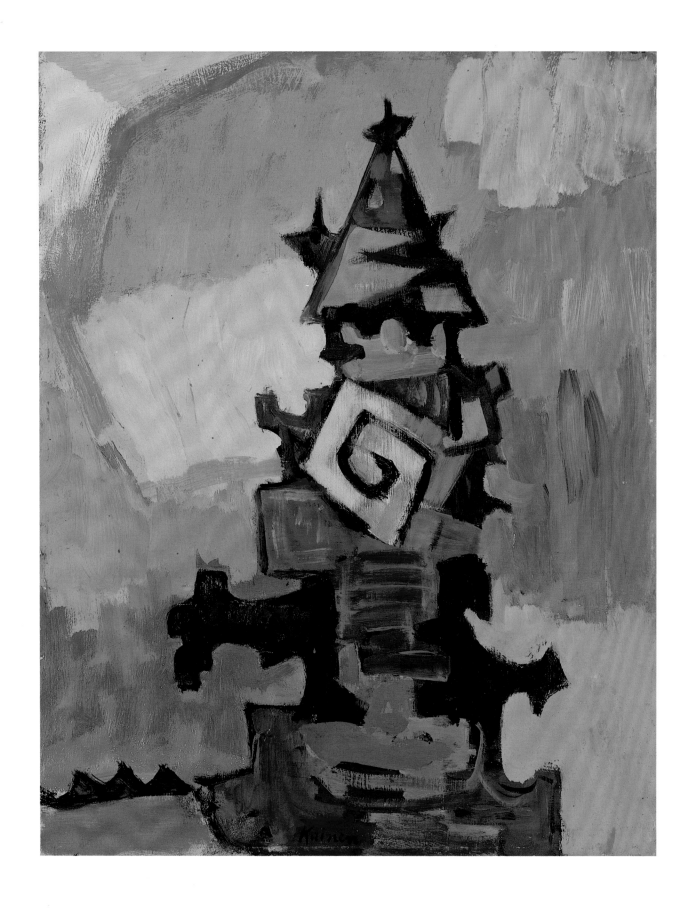

21 Clock Tower, 1948, oil on fiberboard, 20 x 16 in. (50.8 x 40.6 cm).

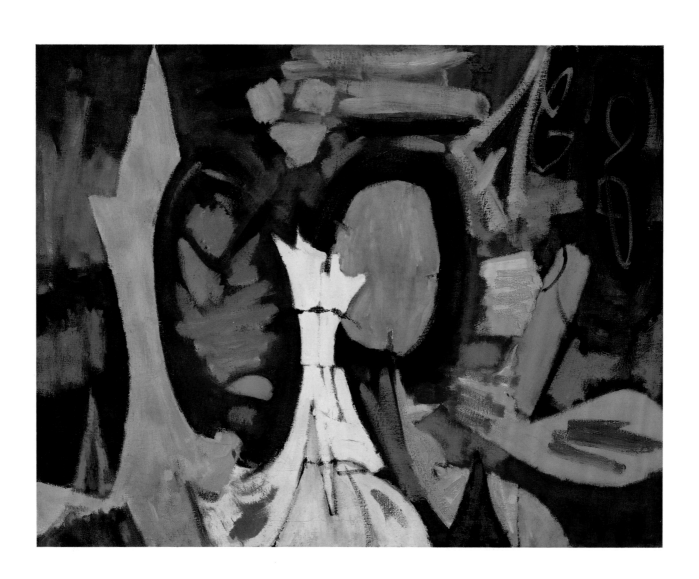

22 Ritual, 1949, 28 x 36 in. (71.1 x 91.4 cm).

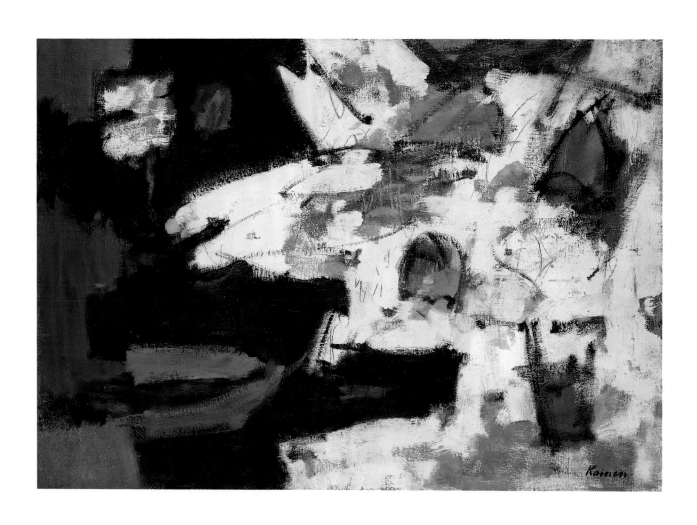

23 Shoreline, 1949, 24 x 34 in. (60.9 x 86.4 cm).
Addison Gallery of American Art, Phillips Academy, Andover, Massachusetts, gift of the artist. All rights reserved.

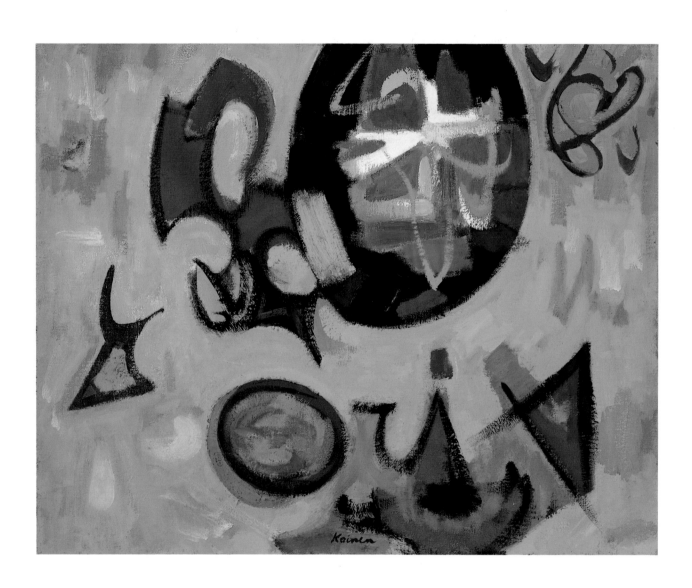

24 Voyage, 1950, 24 x 30 in. (60.9 x 76.2 cm).

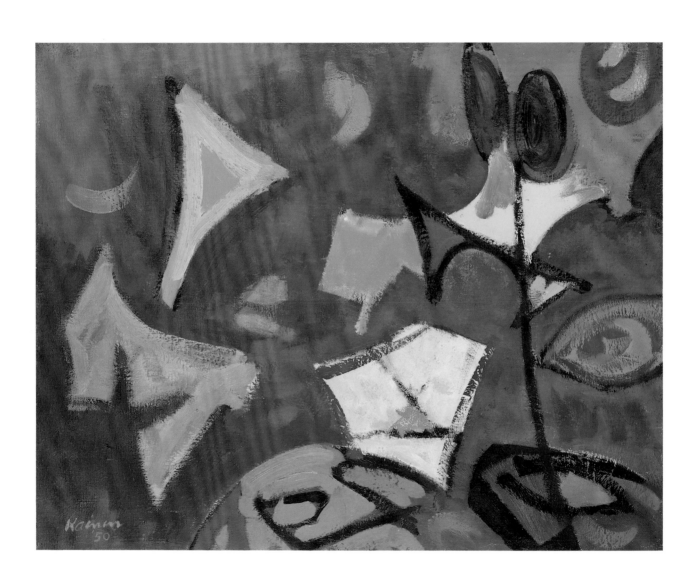

25 Unmoored I, 1950, 24 x 30 1/4 in. (60.8 x 76.8 cm).
National Museum of American Art, gift of the artist.

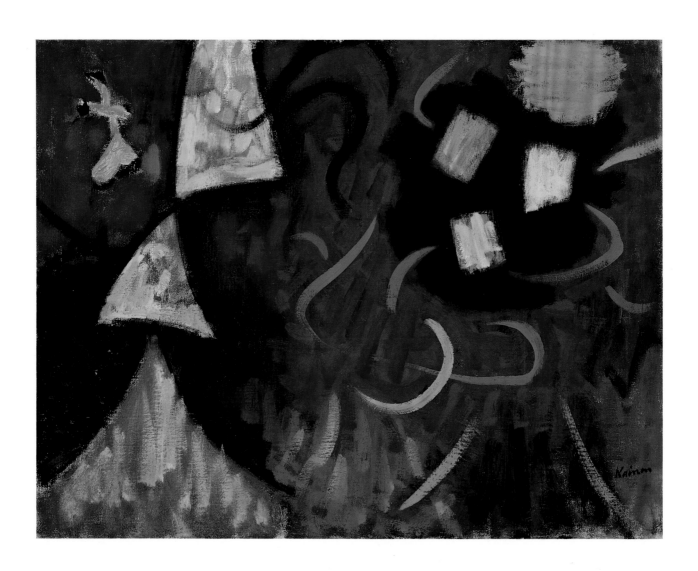

26 Magician, 1951, 20 x 28 in. (50.8 x 71.1 cm).

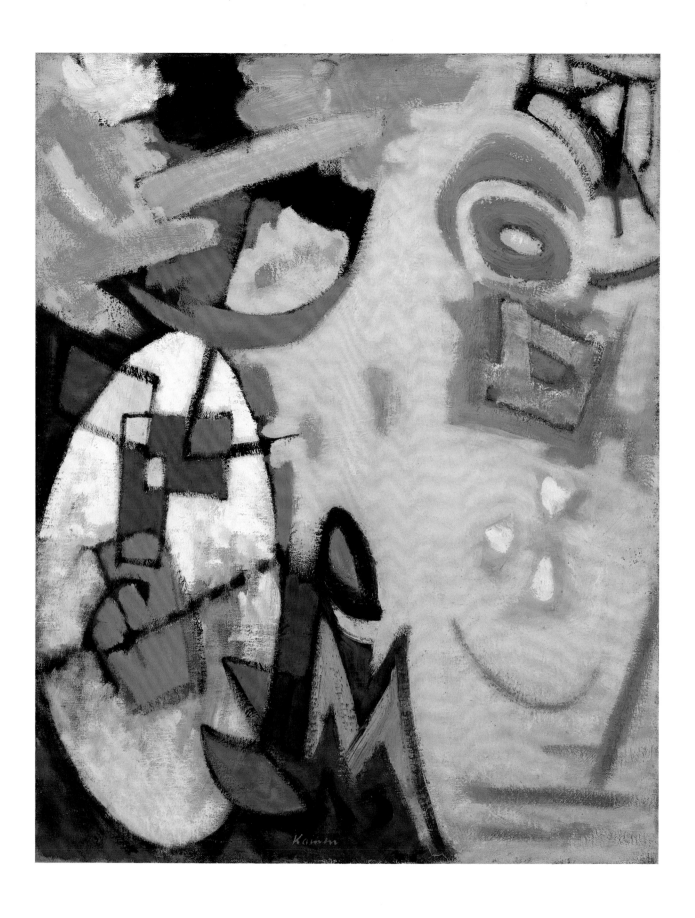

27 The Coming of Surprise, 1951, 30 x 24 in. (76.2 x 60.9 cm).
Collection Ruth Cole Kainen.

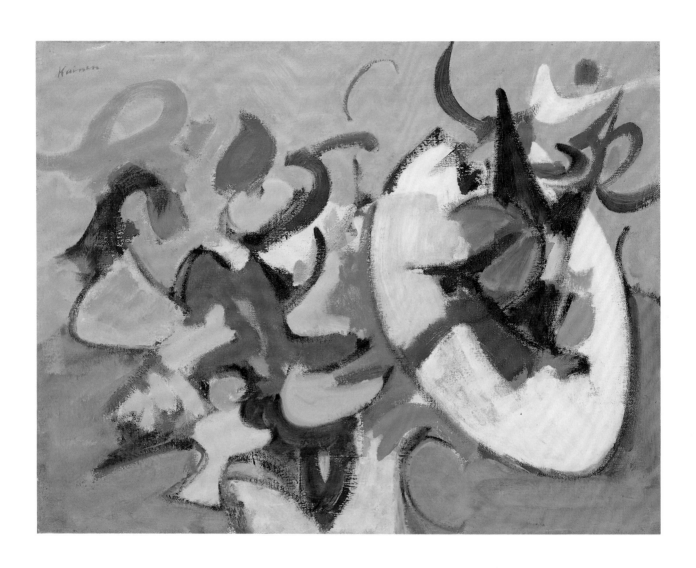

28 The Search, 1952, 20 x 26 in. (50.7 x 66.1 cm).
National Museum of American Art, gift of the artist.

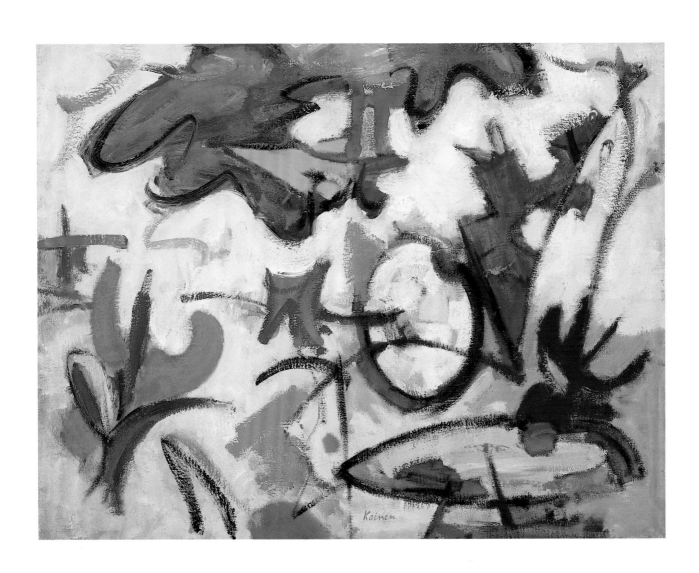

29 Standard Bearer, 1952, 28 x 36 in. (71.1 x 91.4 cm).

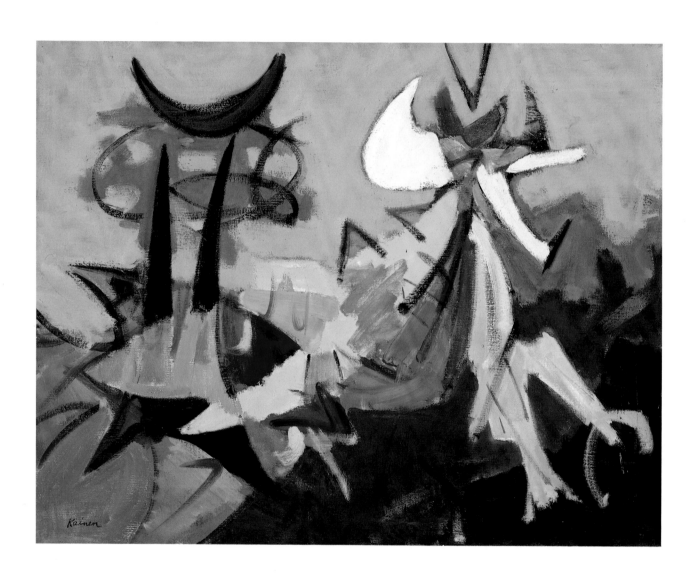

30 Hour of the Beast, 1953, 28 x 36 in. (71.1 x 91.4 cm).

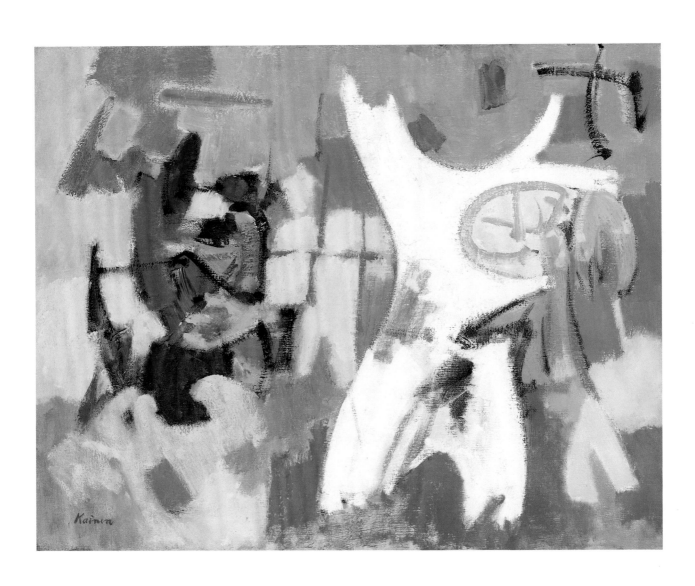

31 Echoes of Antiquity, 1954, 27 7/8 x 36 in. (70.9 x 91.3 cm).
National Museum of American Art, gift of the artist.

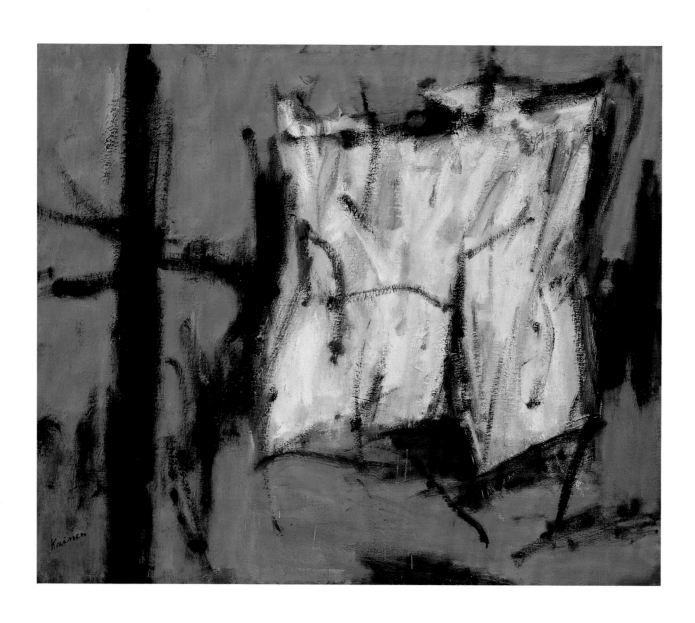

32 The Vulnerable, 1954, 42 x 50 in. (106.7 x 127 cm).
Collection Ruth Cole Kainen.

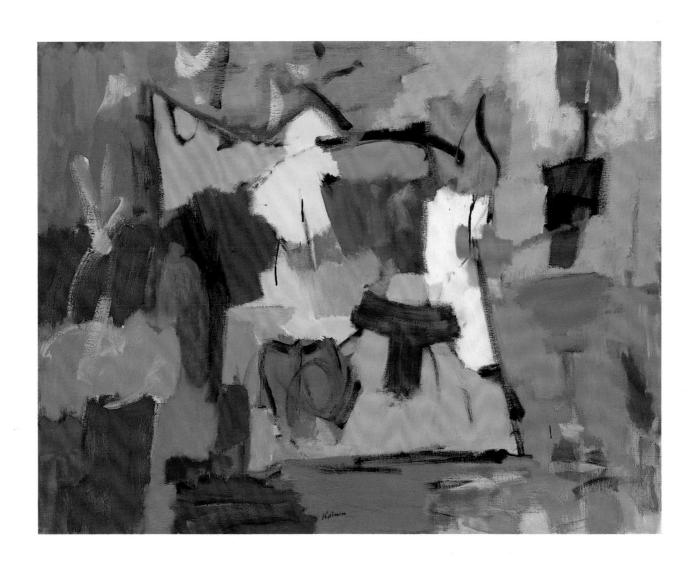

33 Only in Darkness, 1955, 34 x 44 in. (86.4 x 111.8 cm).
The Phillips Collection, Washington, D.C.

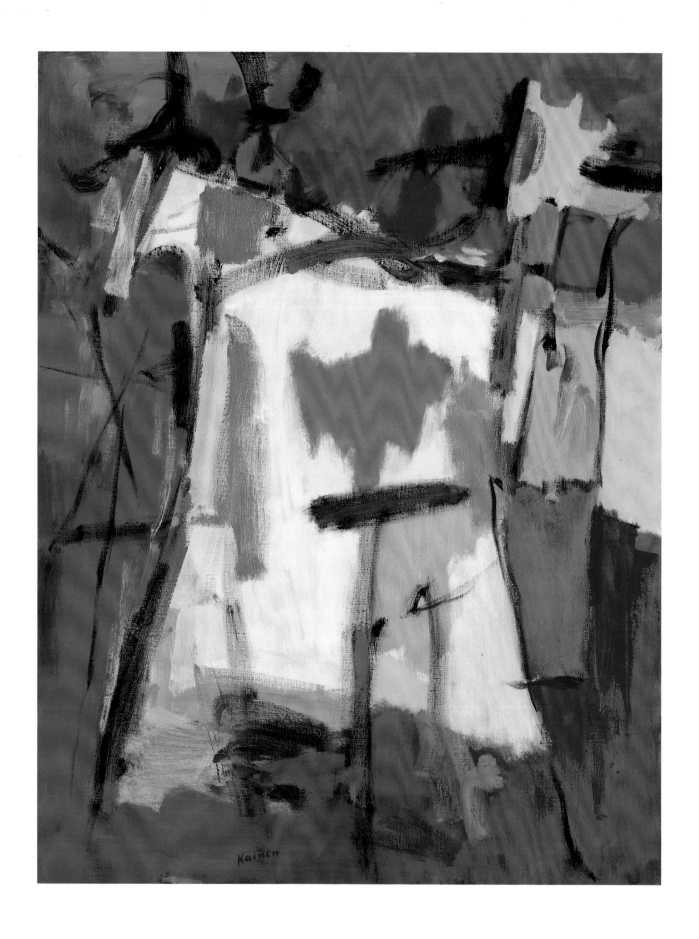

34 Emerge and Shine, 1955, 36 x 28 in. (91.4 x 71.1 cm).
Collection Mr. and Mrs. Hilbert Fefferman, Bethesda, Maryland.

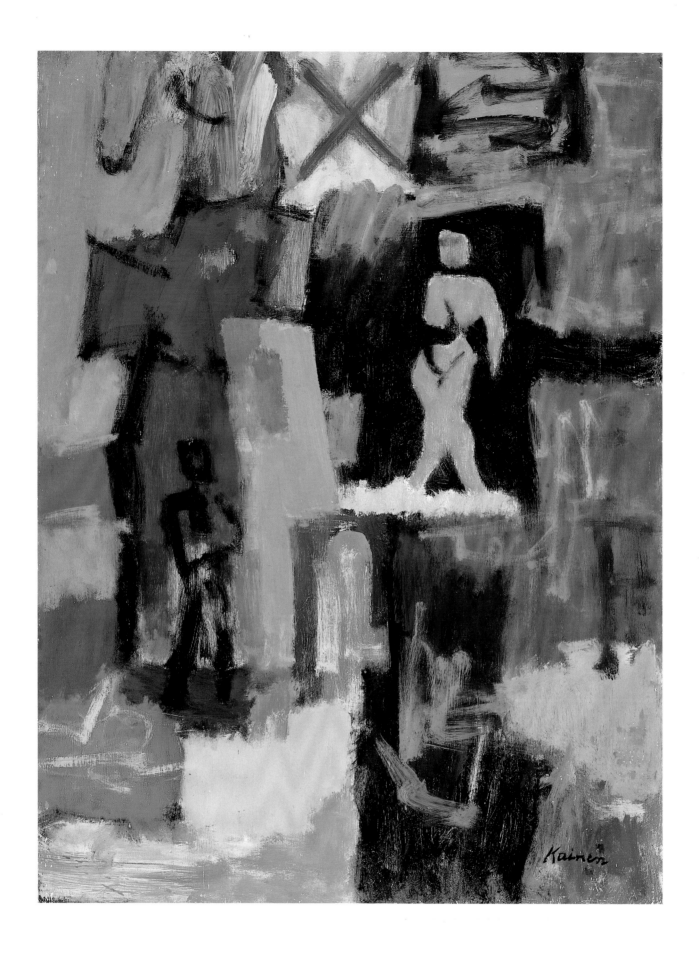

35 Store Window, 1957, magna on PresdWood, 24 x 18 in. (60.9 x 45.7 cm).

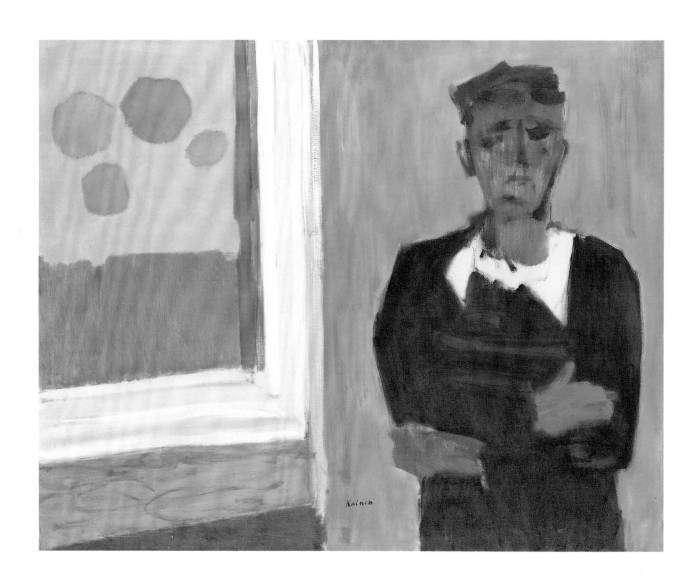

36 At the Window, 1960, 47 7/8 x 59 7/8 in. (121.6 x 152 cm).
National Museum of American Art, gift of Mr. and Mrs. Wallace F. Holladay.

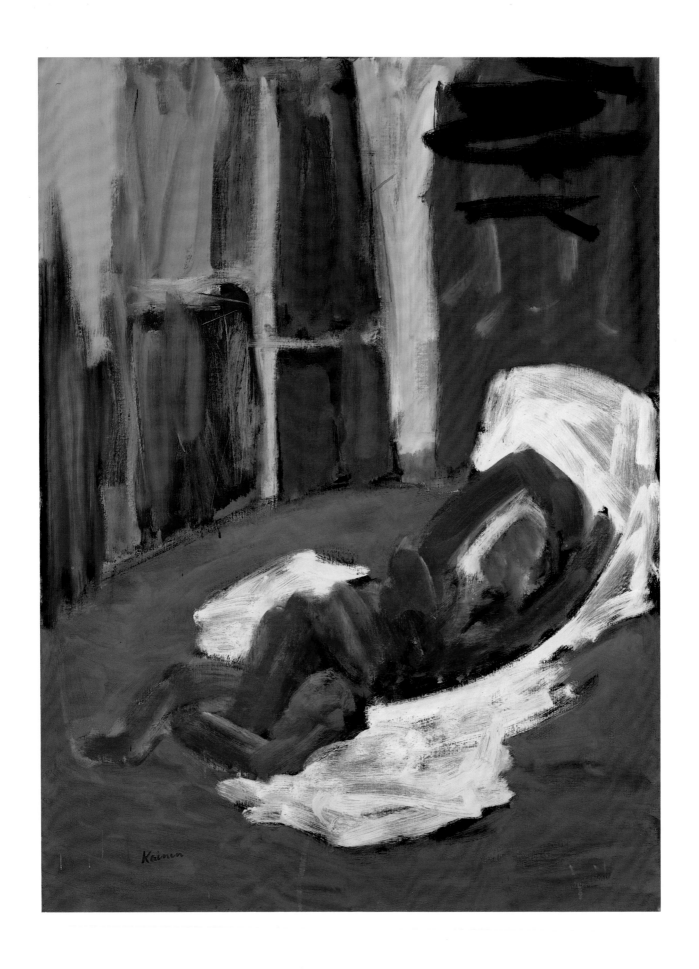

37 Crimson Nude, 1961, 48 x 36 in. (121.9 x 91.4 cm).
Collection Ruth Cole Kainen.

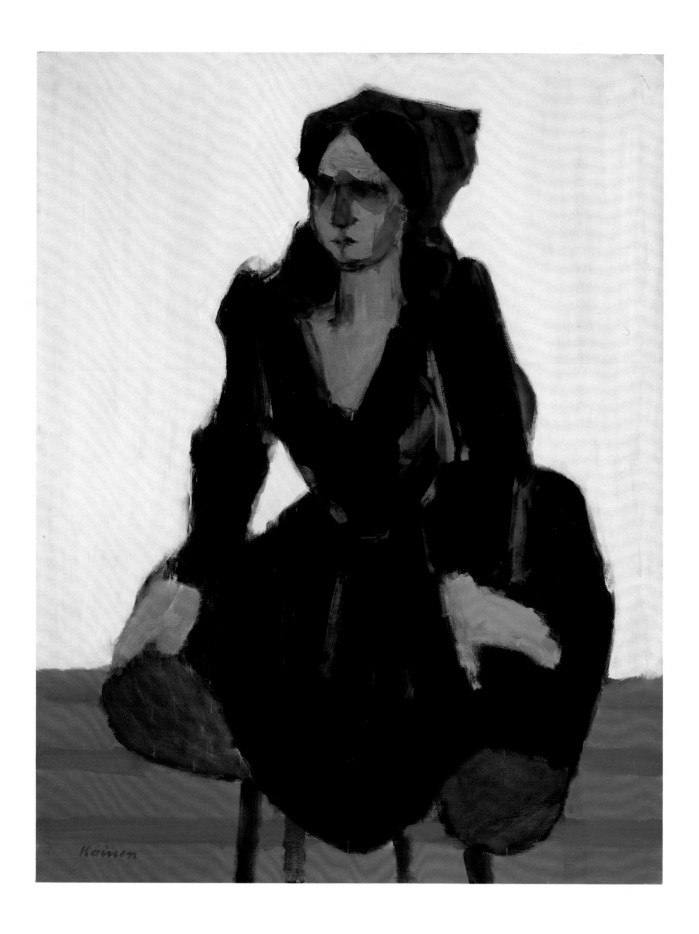

38 Woman in Black on a High Stool, 1961, 48 x 37 in. (121.9 x 93.9 cm).

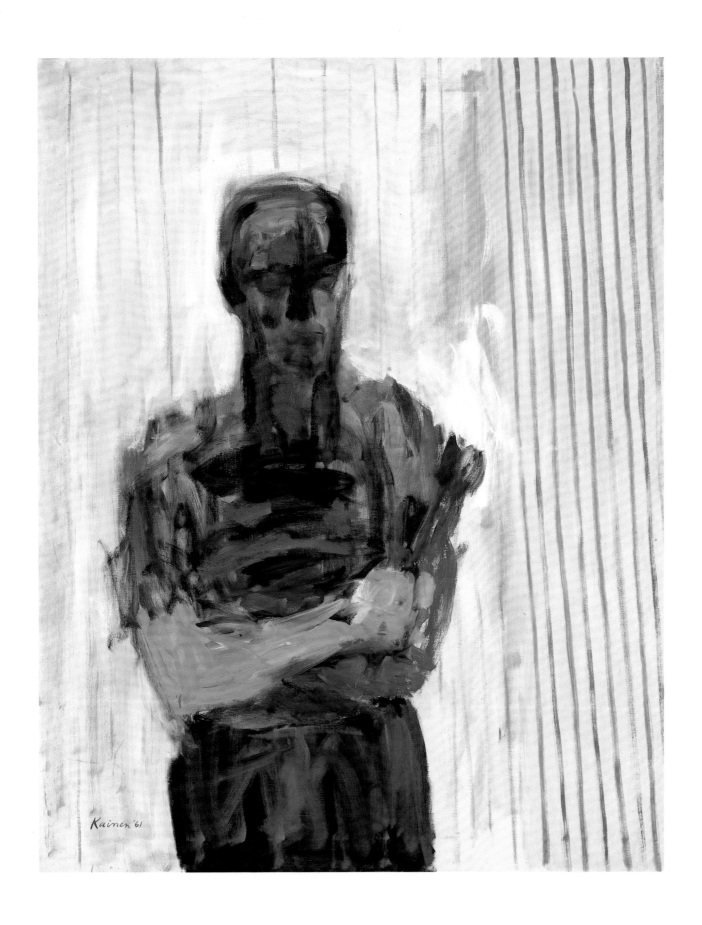

39 Gene Davis, 1961, 60 x 48 in. (152.4 x 122 cm).
National Museum of American Art, gift of the artist.

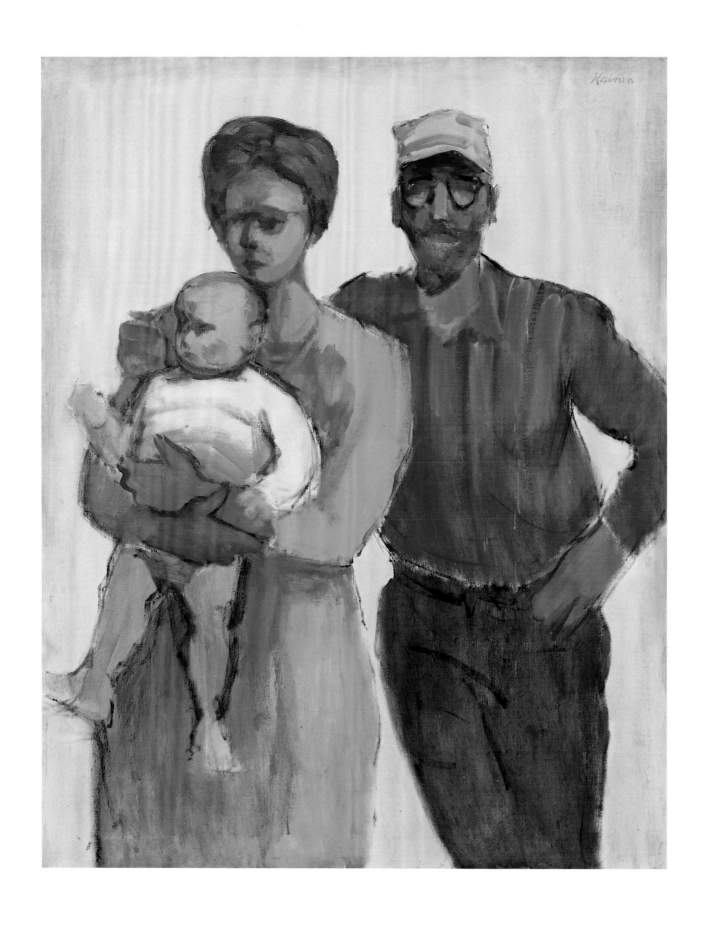

40 The Shannons, 1964, 55 x 48 in. (139.7 x 121.9 cm).
Collection Barrett M. Linde.

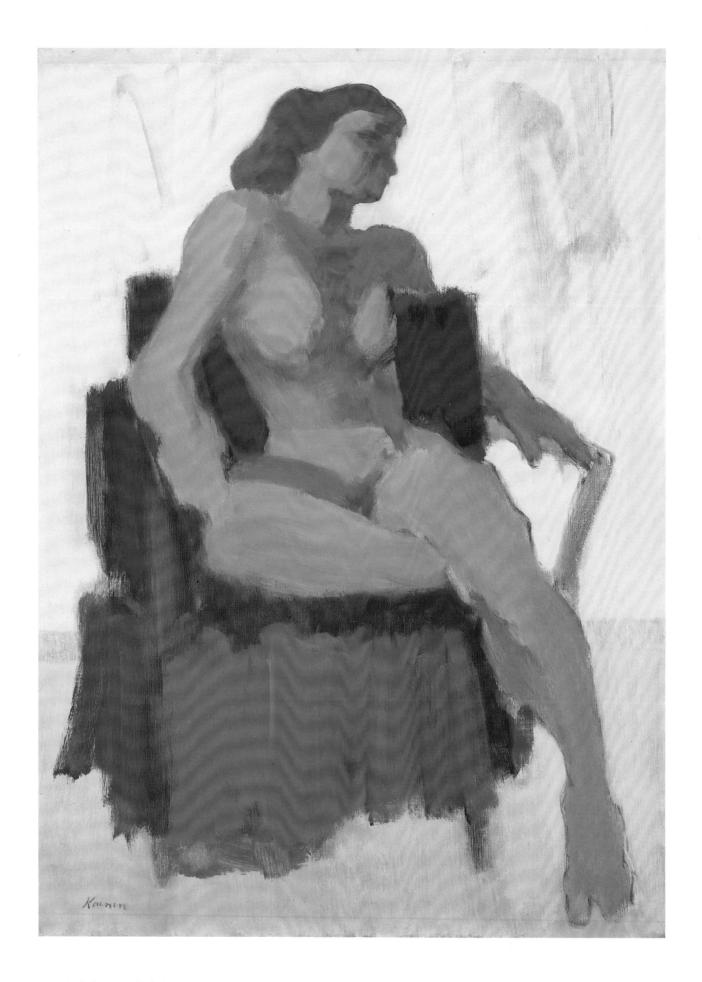

41 Nude in Red Chair, 1964, 32 1/2 x 24 in. (82.6 x 60.9 cm).
Collection Ruth Cole Kainen.

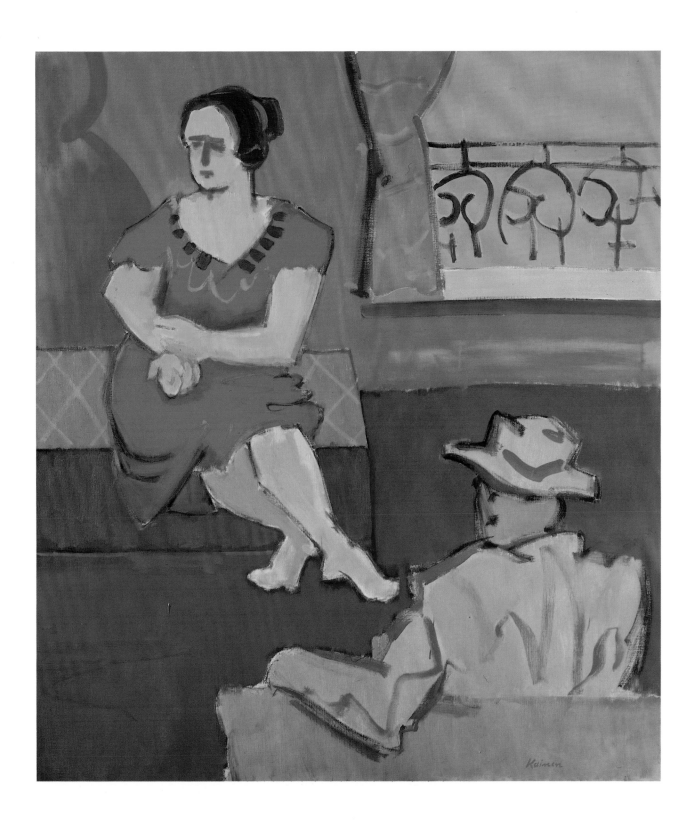

42 The Waiting Room, 1966, 50 x 44 in. (127 x 111.8 cm).
Private Collection.

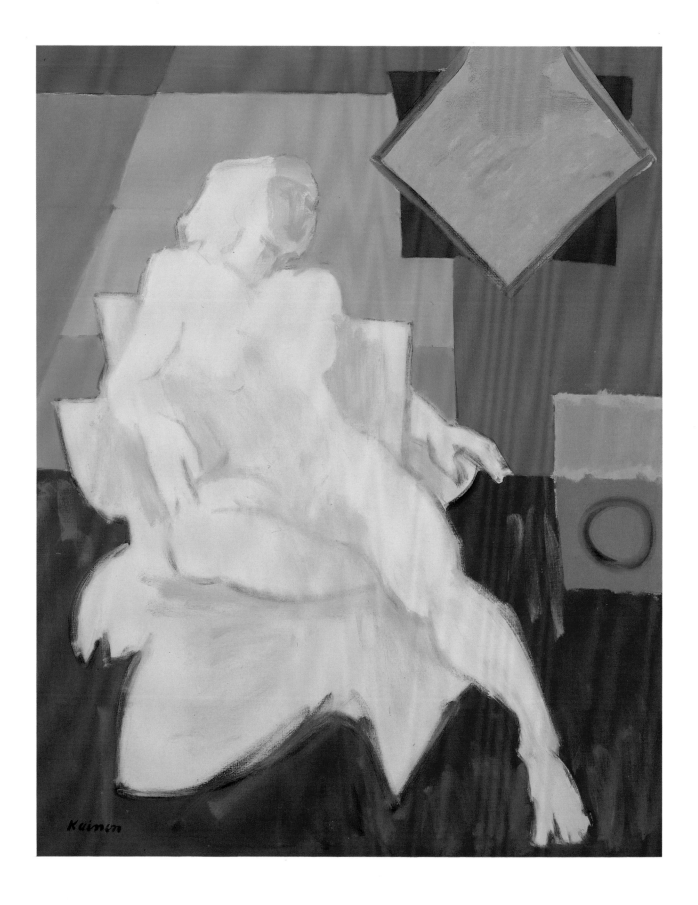

43 Pale Nude, 1969, 50 x 40 in. (127 x 101.6 cm).

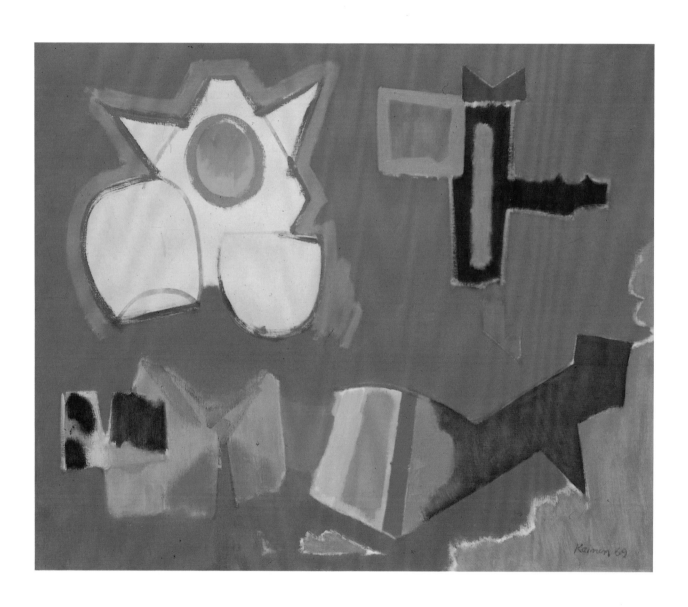

44 Dawn Attack, 1969, 36 x 44 in. (91.4 x 111.8 cm).
Collection Marion Goldin, lent in memory of Norman Goldin.

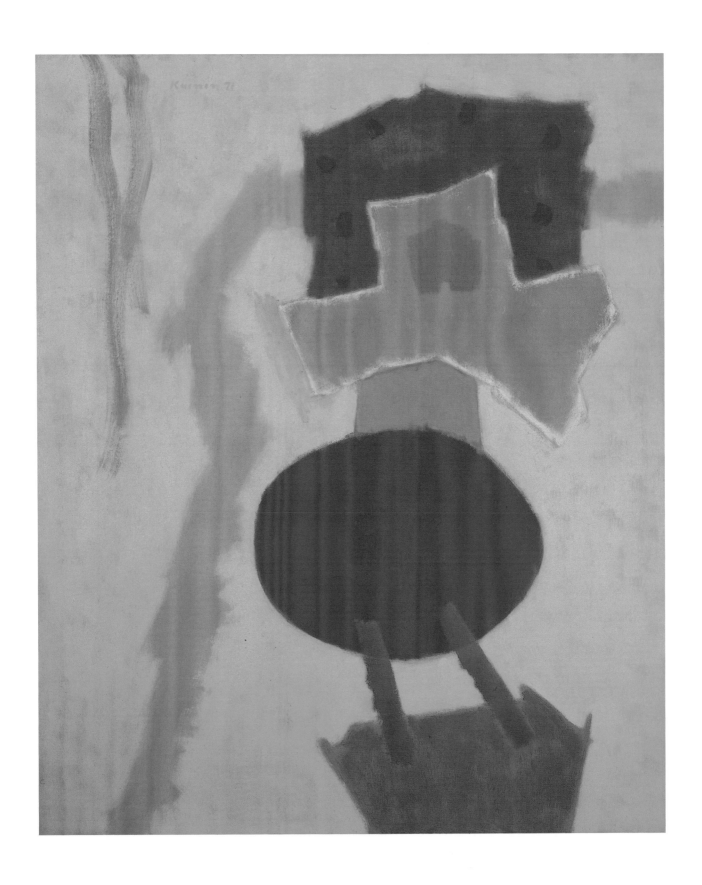

45 Anacharsis, 1971, 60 x 50 in. (152.4 x 127 cm).

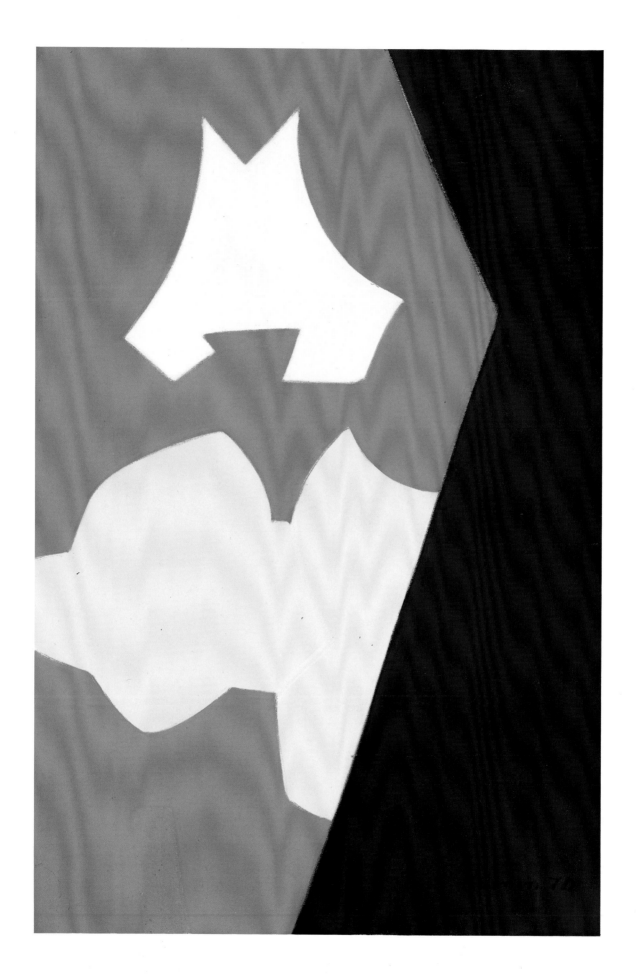

46 Gypsy Rose, 1970, 36 x 24 in. (91.4 x 60.9 cm).

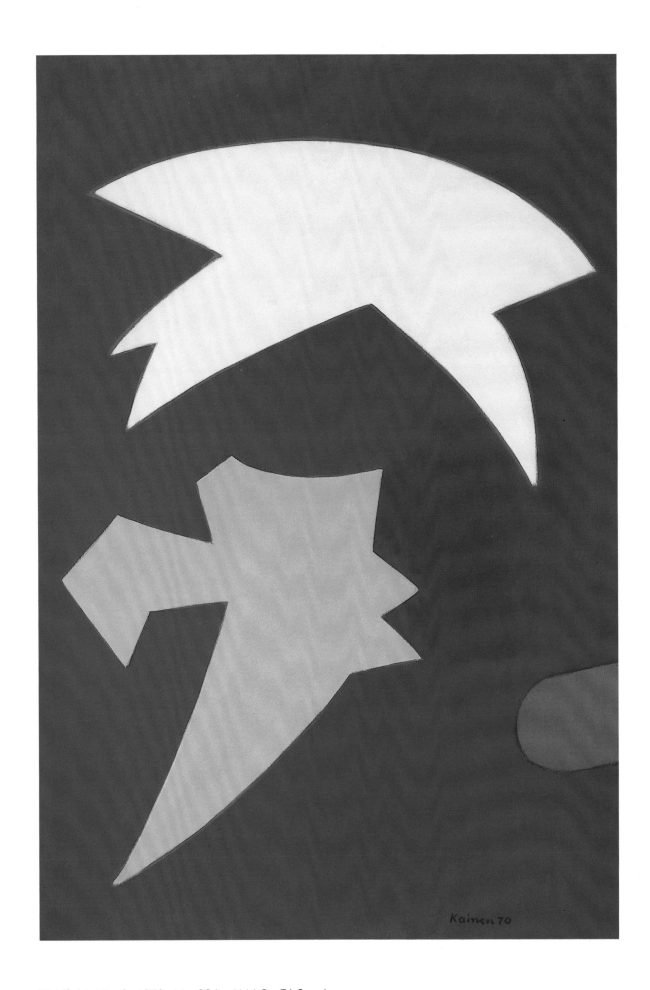

47 Night Attack, 1970, 44 x 30 in. (111.8 x 76.2 cm).

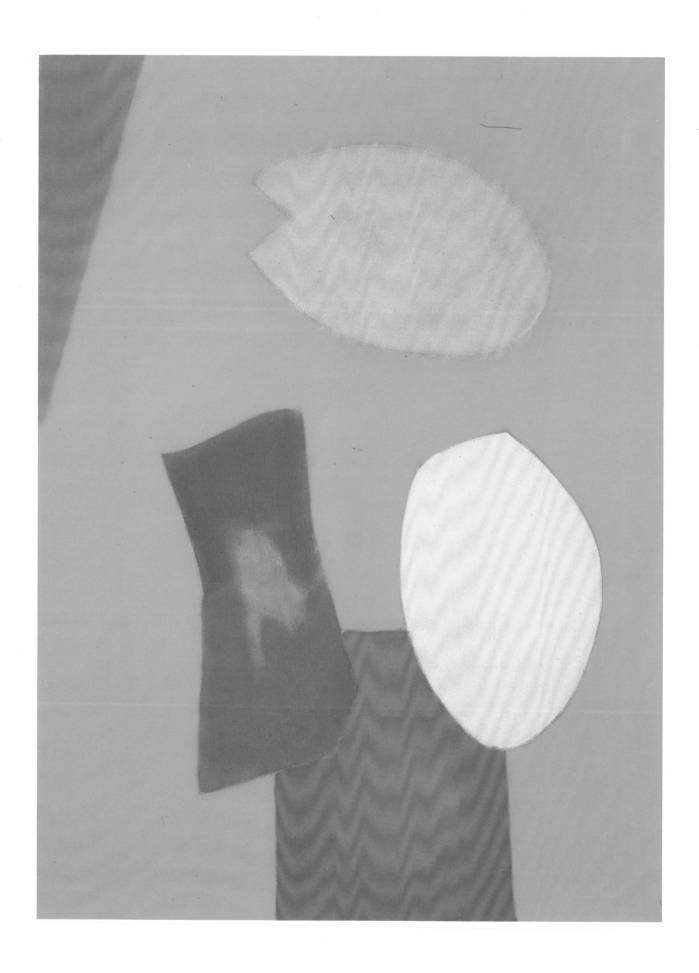

48 Macedonian, 1971, 48 x 36 in. (121.9 x 91.4 cm).

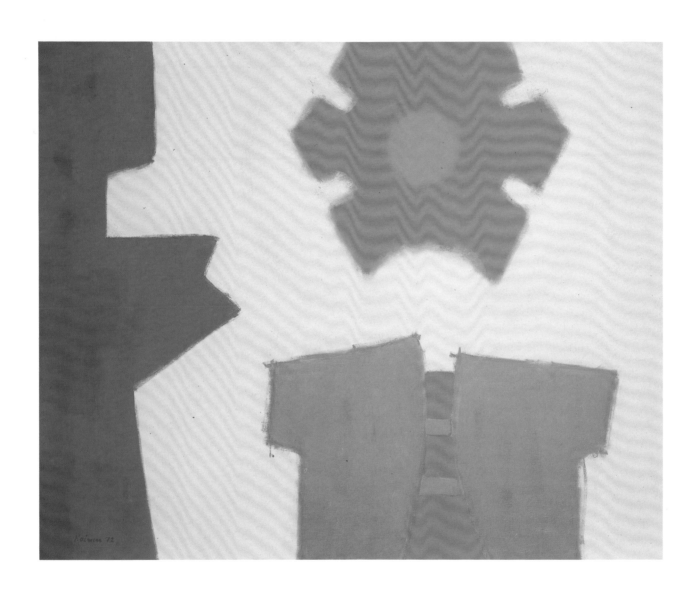

49 Elisa, 1972, 48 x 60 in. (121.9 x 152.4 cm).
Hirshhorn Museum and Sculpture Garden, Smithsonian Institution. Gift of the artist, 1976.

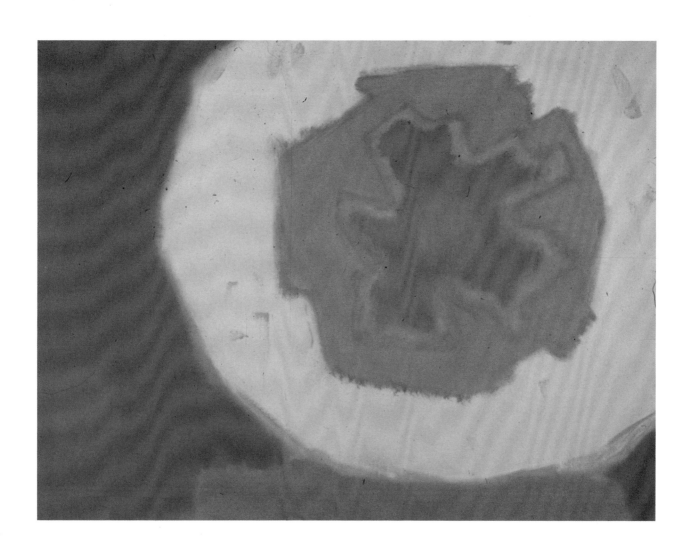

50 Marathon, 1973, 34 x 40 in. (86.4 x 101.6 cm).
Collection Mr. and Mrs. Albert Abramson.

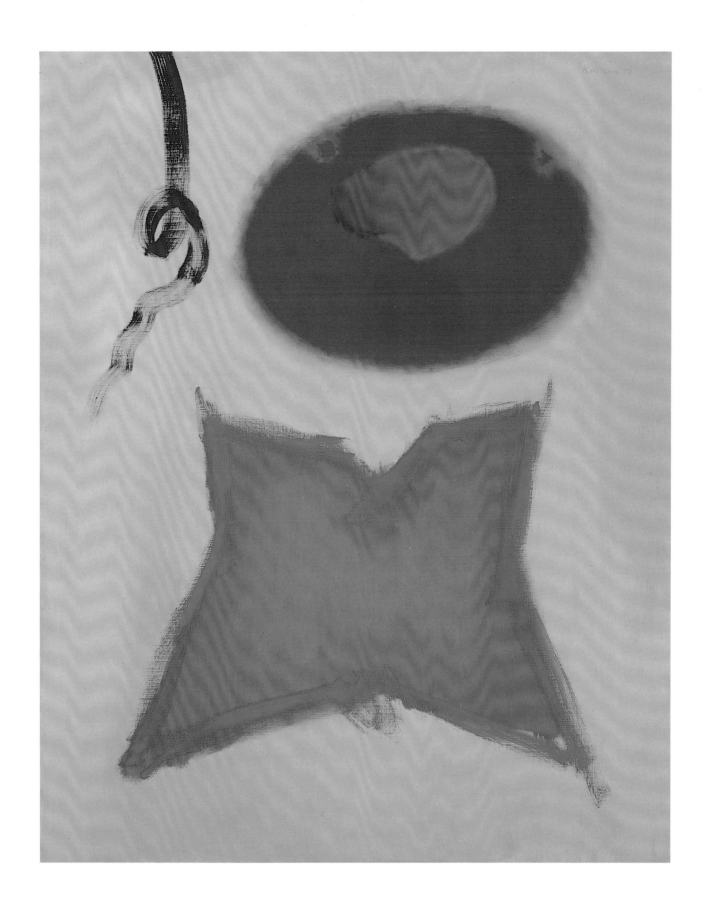

51 Escape Artist I, 1973, 60 x 48 in. (152.4 x 121.9 cm).

52 Observer VI, 1973, 48 x 60 in. (121.9 x 152.4 cm).
Collection Ruth Cole Kainen.

53 Observer XIII, 1974, 72 x 52 in. (182.9 x 132.1 cm).

54 Magellan, 1975, 72 x 52 in. (182.9 x 132.1 cm).

55 Nova I, 1977, 80 x 60 in. (203.2 x 152.4 cm).
Collection Ruth Cole Kainen.

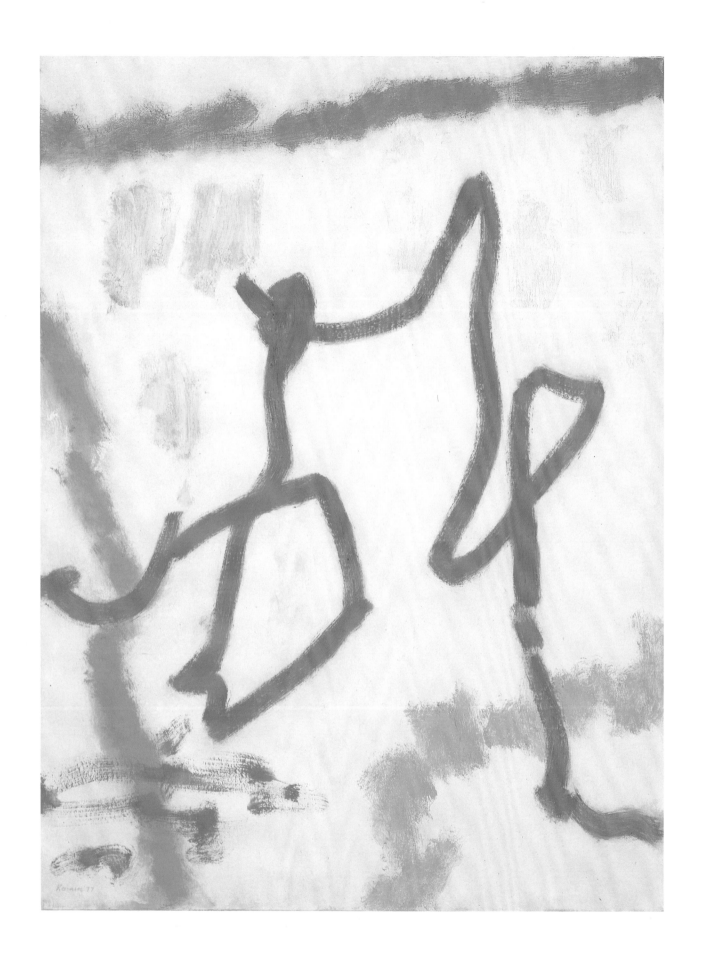

56 Wanderer, 1977, 48 x 36 in. (121.9 x 91.4 cm).

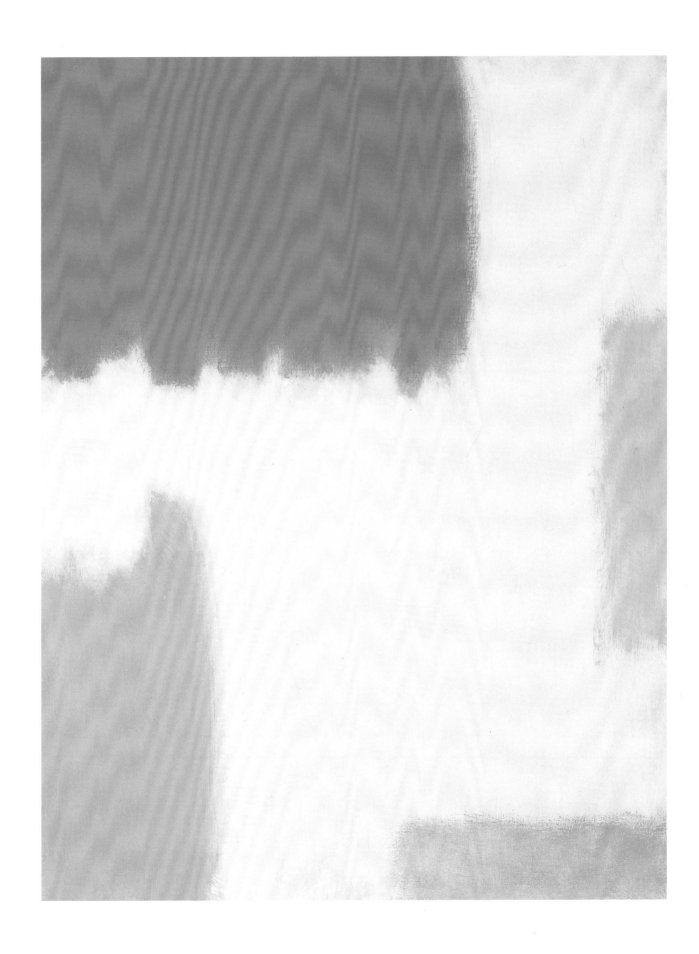

57 Sweep, 1978, 26 x 20 in. (66 x 50.8 cm).

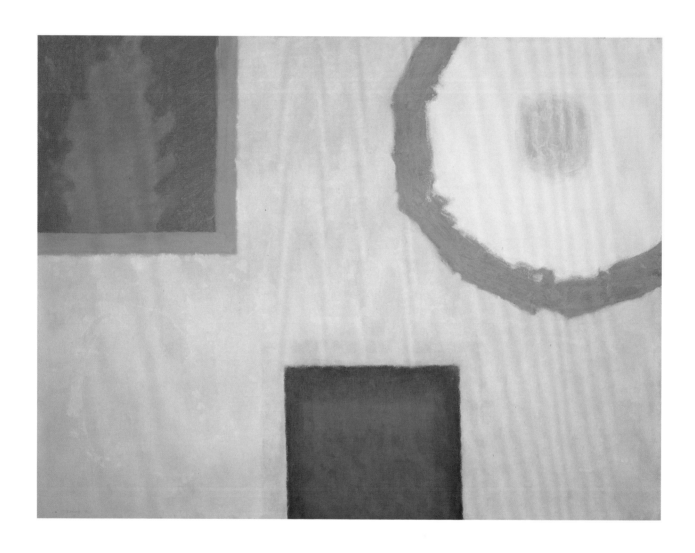

58 Goodbye Rome IV, 1979, 60 x 80 in. (152.4 x 203.2 cm).

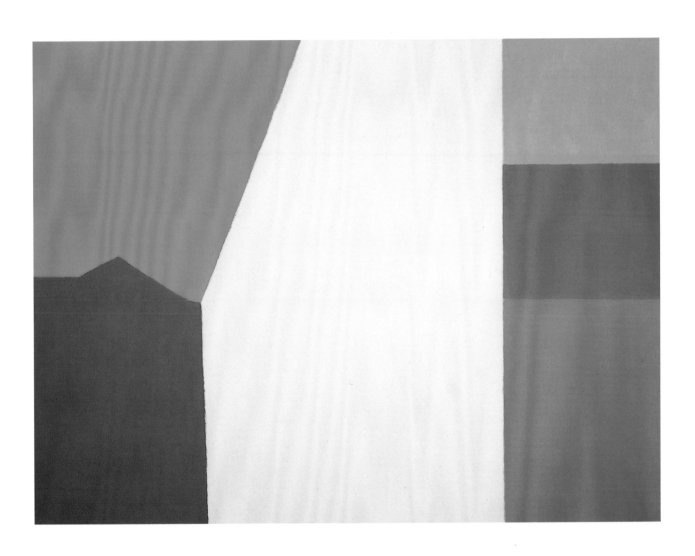

59 The Way VI, 1979, 60 x 80 in. (152.4 x 203.2 cm).

60 Aegean VI, 1980, 60 x 60 in. (152.4 x 152.4 cm).

61 Aegean VII, 1980, 48 x 60 in. (121.9 x 152.4 cm).
Collection George and Betsy Frampton.

62 The Way XI, 1979, 80 x 60 in. (203.2 x 152.4 cm).

63 Lumen II, 1980, 72 x 60 in. (182.9 x 152.4 cm).

64 The Way XXI, 1980, 30 x 36 in. (76.2 x 91.4 cm).

65 Argosy X, 1981, 48 x 60 in. (121.9 x 152.4 cm).
Collection Oliver H. Carr.

66 Pilot I, 1981, 60 x 80 in. (152.4 x 203.2 cm).
Collection Ruth Cole Kainen.

67 Pilot IV, 1981, 80 x 60 in. (203.2 x 152.4 cm).

68 The Way XLIX, 1981, 36 x 30 in. (91.4 x 76.2 cm).

69 Aegean XVI, 1982, 36 x 48 in. (91.4 x 121.9 cm).

70 Argosy XVI, 1982, 64 x 80 in. (162.6 x 203.2 cm).
The Corcoran Gallery of Art, Museum Purchase, Anna E. Clark Fund.

71 Interface I, 1982, 72 x 54 in. (182.9 x 137.2 cm).

72 Fabrizio VI, 1983, 60 x 72 in. (152.4 x 182.9 cm).

73 Interface XV, 1983, 66 x 86 in. (167.6 x 218.4 cm).

74 Interface XVI, 1983, 50 x 60 in. (127 x 152.4 cm).

75 The Way LXXIX, 1983, 60 x 80 in. (152.4 x 203.2 cm).

76 The Way LXXXI, 1983, 108 x 140 in. (274.3 x 355.6 cm).

77 The Way LXXXIV, 1983, 72 x 54 in. (182.9 x 137.2 cm).

78 Aegean XIX, 1984, 48 x 36 in. (121.9 x 91.4 cm).

79 Argosy XXXIII, 1984, 36 x 48 in. (91.4 x 121.9 cm).
Collection Kenneth and Kiyo Hitch.

80 Argosy XXXIV, 1984, 36 x 48 in. (91.4 x 121.9 cm).

81 Barrier III, 1984, 60 x 72 in. (152.4 x 182.9 cm).

82 Fabrizio X, 1984, 108 x 140 in. (274.3 x 355.6 cm).

83 The Way XC, 1984, 36 x 48 in. (91.4 x 121.9 cm).

84 Argosy XLV, 1985, 64 x 72 in. (162.6 x 182.9 cm).

85 Bright Stamboul IV, 1985, 66 x 86 in. (167.6 x 218.4 cm).

86 Dabrowsky I, 1985, 64 x 80 in. (162.6 x 203.2 cm).

87 Dabrowsky III, 1985, 108 x 140 in. (274.3 x 355.6 cm).

88 Bright Stamboul XI, 1986, 79 x 59 in. (200.7 x 149.9 cm).

89 Pilot XV, 1986, 72 x 54 in. (182.9 x 137.2 cm).

90 Rising Sign, 1986, 108 x 140 in. (274.3 x 355.6 cm).

91 Argosy LV, 1987, 72 x 60 in. (182.9 x 152.4 cm).

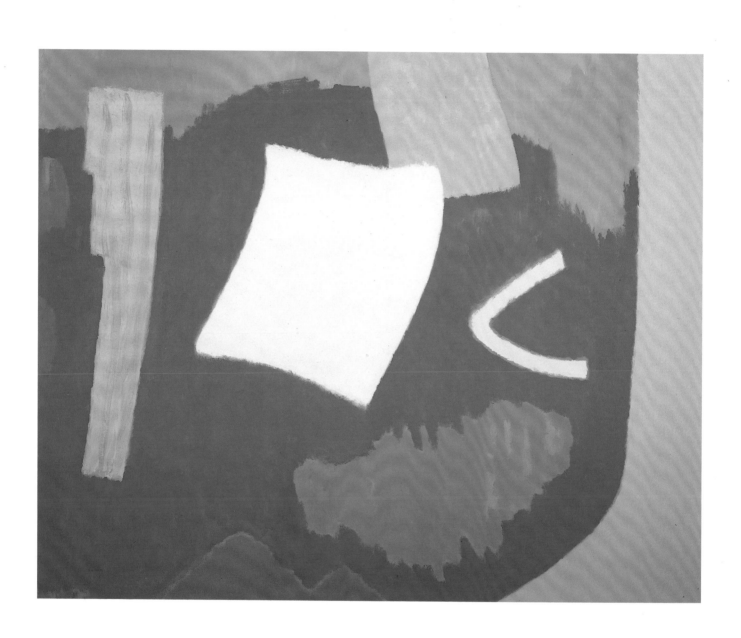

92 The Book of Days II, 1987, 80 x 100 in. (203.2 x 254 cm).

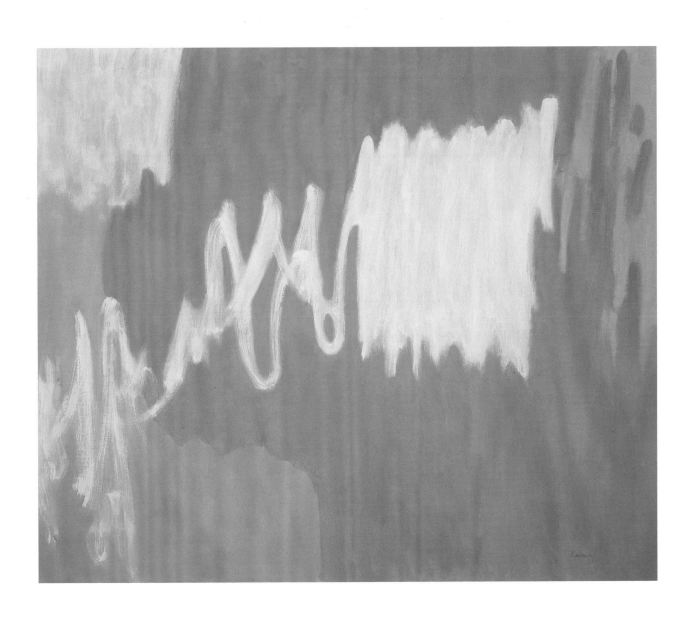

93 Logos, 1987, 50 x 60 in. (127 x 152.4 cm).

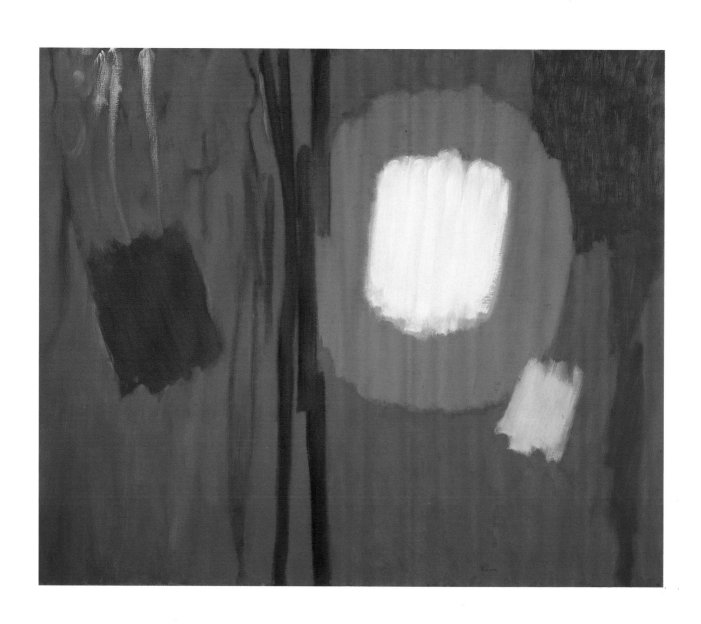

94 Pilot XXVIII, 1989, 60 x 72 in. (152.4 x 182.9 cm).

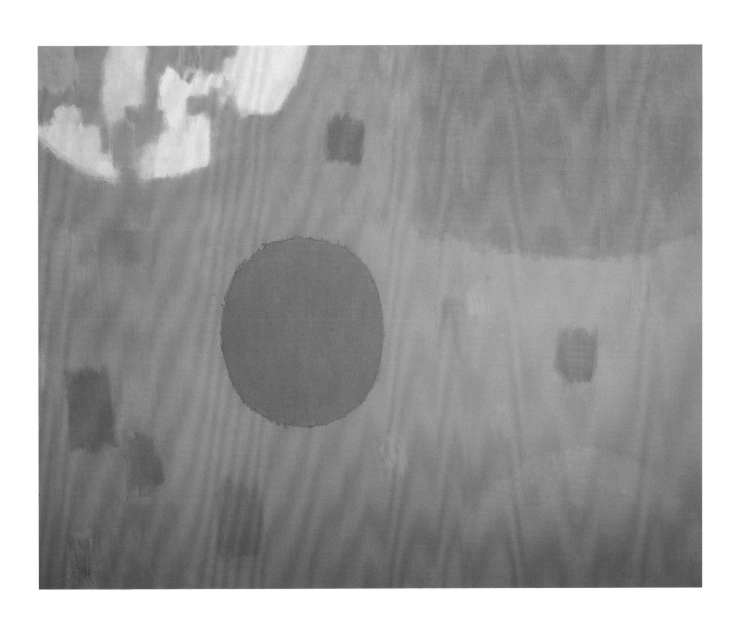

95 Red Shift, 1989, 96 x 120 in. (243.8 x 304.8 cm).

96 Isaiah I, 1990, 64 x 73 in. (162.6 x 185.4 cm).

97 Pilot XXXV, 1990, 72 x 54 in. (182.9 x 137.2 cm).
Collection Adele Lebowitz.

98 Changeling II, 1991, 50 x 60 in. (127 x 152.4 cm).

99 The Attempt, 1992, 64 x 80 in. (162.6 x 203.2 cm).

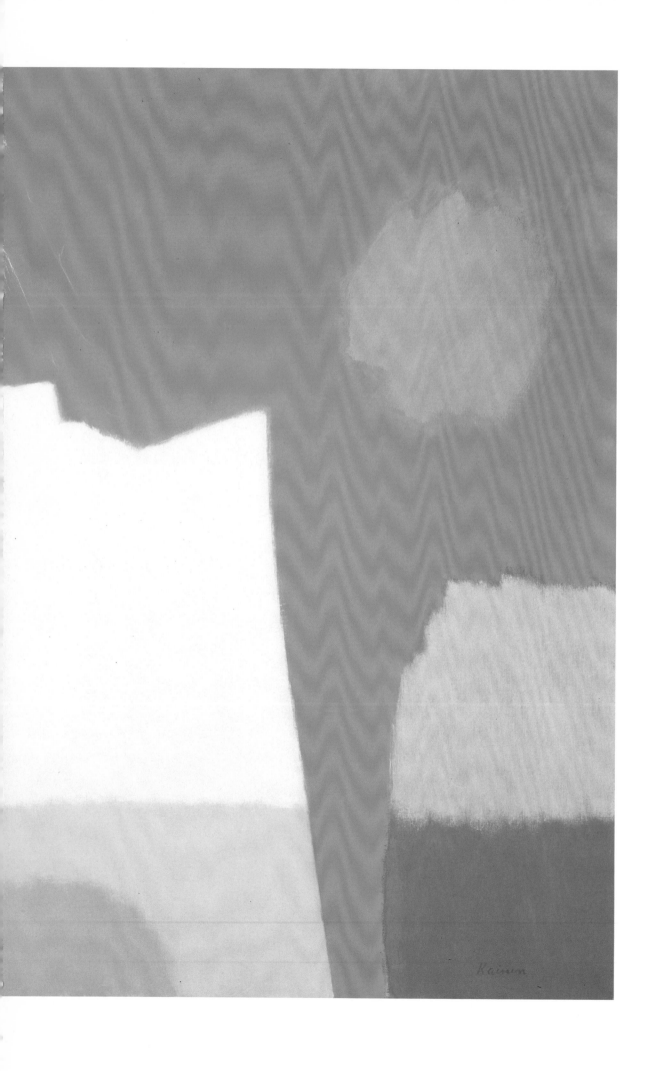

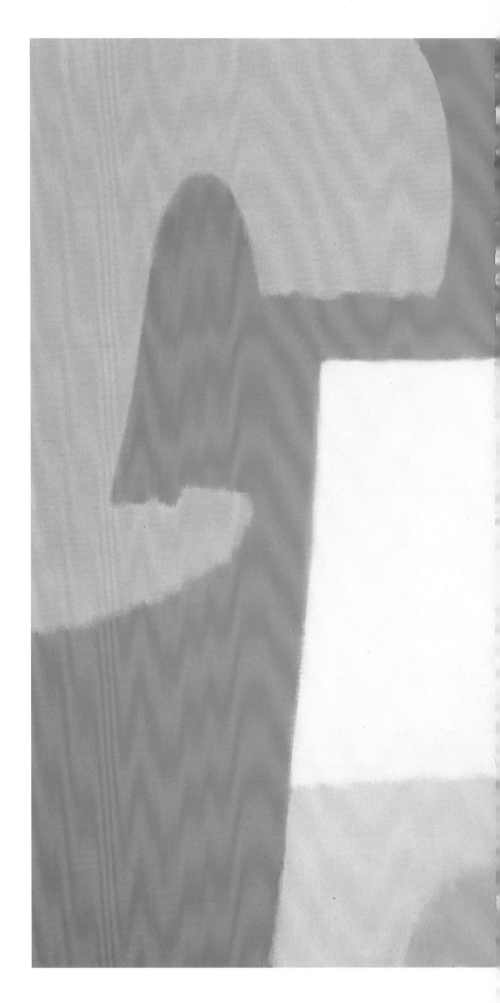

100 Argo, 1991, 50 x 60 in. (127 x 152.4 cm).

LIST OF PLATES

Unless otherwise noted, all works are oil on canvas
and in the collection of the artist; height precedes width.

1 *Tenement Fire*, 1934, 28 x 23 in. (71.2 x 58.4 cm). National Museum of American Art, gift of the artist.
2 *Disaster at Sea*, 1934, 22 x 28 in. (55.9 x 71.1 cm).
3 *Invasion*, 1936, 38 x 30 in. (96.5 x 76.2 cm).
4 *Flood*, 1935, 22 x 28 in. (55.9 x 71.1 cm).
5 *Pastorale*, 1935, 22 x 28 in. (56 x 71.1 cm). National Museum of American Art, gift of the artist.
6 *Cafeteria*, 1937, 24 x 32 in. (60.9 x 81.3 cm). Addison Gallery of American Art, Phillips Academy,
 Andover, Massachusetts, gift of the artist. All rights reserved.
7 *Hot Dog Cart*, 1937, 28 x 36 in. (71.1 x 91.4 cm).
8 *Oil Cloth Vendor I*, 1937, 28 x 36 in. (71.1 x 91.4 cm).
9 *Spanish Museum*, 1937, 24 x 30 in. (60.9 x 76.2 cm).
10 *Barber Shop*, 1939, 30 x 24 in. (76.2 x 60.9 cm).
11 *The Poet*, 1939, 28 x 36 in. (71.1 x 91.4 cm).
12 *Tin Warrior*, 1939, 26 x 20 in. (66 x 50.8 cm).
13 *Young Man's Fancy*, 1939, 36 x 28 in. (91.4 x 71.1 cm).
14 *Unfurnished Room*, 1939, 20 x 24 in. (50.8 x 60.9 cm). Collection Ruth Cole Kainen.
15 *Street Corner*, 1940, 22 x 28 in. (55.9 x 71.1 cm). ©The Phillips Collection, Washington, D.C.
16 *Blake's Angel*, 1940, 36 x 28 in. (91.4 x 71.1 cm).
17 *Street Breakers*, 1941, oil on beaverboard, 12 x 20 in. (30.5 x 50.8 cm).
18 *Virginia Farmhouse*, 1941, 28 x 36 in. (71.1 x 91.4 cm).
19 *The Walk*, 1943, 20 x 16 in. (50.8 x 40.6 cm).
20 *Street Corner with Red Door*, 1947, oil on fiberboard, 14 x 18 in. (35.6 x 45.7 cm).
21 *Clock Tower*, 1948, oil on fiberboard, 20 x 16 in. (50.8 x 40.6 cm).
22 *Ritual*, 1949, 28 x 36 in. (71.1 x 91.4 cm).
23 *Shoreline*, 1949, 24 x 34 in. (60.9 x 86.4 cm). Addison Gallery of American Art, Phillips Academy,
 Andover, Massachusetts, gift of the artist. All rights reserved.
24 *Voyage*, 1950, 24 x 30 in. (60.9 x 76.2 cm).
25 *Unmoored I*, 1950, 24 x 30 1/4 in. (60.8 x 76.8 cm).
 National Museum of American Art, gift of the artist.
26 *Magician*, 1951, 20 x 28 in. (50.8 x 71.1 cm).
27 *The Coming of Surprise*, 1951, 30 x 24 in. (76.2 x 60.9 cm). Collection Ruth Cole Kainen.
28 *The Search*, 1952, 20 x 26 in. (50.7 x 66.1 cm). National Museum of American Art, gift of the artist.
29 *Standard Bearer*, 1952, 28 x 36 in. (71.1 x 91.4 cm).
30 *Hour of the Beast*, 1953, 28 x 36 in. (71.1 x 91.4 cm).
31 *Echoes of Antiquity*, 1954, 27 7/8 x 36 in. (70.9 x 91.3 cm). National Museum of American Art, gift of the artist.
32 *The Vulnerable*, 1954, 42 x 50 in. (106.7 x 127 cm). Collection Ruth Cole Kainen.
33 *Only in Darkness*, 1955, 34 x 44 in. (86.4 x 111.8 cm). ©The Phillips Collection, Washington, D.C.
34 *Emerge and Shine*, 1955, 36 x 28 in. (91.4 x 71.1 cm).
 Collection Mr. and Mrs. Hilbert Fefferman, Bethesda, Maryland.
35 *Store Window*, 1957, magna on PresdWood, 24 x 18 in. (60.9 x 45.7 cm).
36 *At the Window*, 1960, 47 7/8 x 59 7/8 in. (121.6 x 152 cm). National Museum of American Art,
 gift of Mr. and Mrs. Wallace F. Holladay.
37 *Crimson Nude*, 1961, 48 x 36 in. (121.9 x 91.4 cm). Collection Ruth Cole Kainen.
38 *Woman in Black on a High Stool*, 1961, 48 x 37 in. (121.9 x 93.9 cm).
39 *Gene Davis*, 1961, 60 x 48 in. (152.4 x 122 cm). National Museum of American Art, gift of the artist.
40 *The Shannons*, 1964, 55 x 48 in. (139.7 x 121.9 cm). Collection Barrett M. Linde.
41 *Nude in Red Chair*, 1964, 32 1/2 x 24 in. (82.6 x 60.9 cm). Collection Ruth Cole Kainen.
42 *The Waiting Room*, 1966, 50 x 44 in. (127 x 111.8 cm). Private Collection.
43 *Pale Nude*, 1969, 50 x 40 in. (127 x 101.6 cm).
44 *Dawn Attack*, 1969, 36 x 44 in. (91.4 x 111.8 cm). Collection Marion Goldin,
 lent in memory of Norman Goldin.
45 *Anacharsis*, 1971, 60 x 50 in. (152.4 x 127 cm).

46 *Gypsy Rose*, 1970, 36 x 24 in. (91.4 x 60.9 cm).

47 *Night Attack*, 1970, 44 x 30 in. (111.8 x 76.2 cm).

48 *Macedonian*, 1971, 48 x 36 in. (121.9 x 91.4 cm).

49 *Elisa*, 1972, 48 x 60 in. (121.9 x 152.4 cm). Hirshhorn Museum and Sculpture Garden, Smithsonian Institution. Gift of the artist, 1976.

50 *Marathon*, 1973, 34 x 40 in. (86.4 x 101.6 cm). Collection Mr. and Mrs. Albert Abramson.

51 *Escape Artist I*, 1973, 60 x 48 in. (152.4 x 121.9 cm).

52 *Observer VI*, 1973, 48 x 60 in. (121.9 x 152.4 cm). Collection Ruth Cole Kainen.

53 *Observer XIII*, 1974, 72 x 52 in. (182.9 x 132.1 cm).

54 *Magellan*, 1975, 72 x 52 in. (182.9 x 132.1 cm).

55 *Nova I*, 1977, 80 x 60 in. (203.2 x 152.4 cm). Collection Ruth Cole Kainen.

56 *Wanderer*, 1977, 48 x 36 in. (121.9 x 91.4 cm).

57 *Sweep*, 1978, 26 x 20 in. (66 x 50.8 cm).

58 *Goodbye Rome IV*, 1979, 60 x 80 in. (152.4 x 203.2 cm).

59 *The Way VI*, 1979, 60 x 80 in. (152.4 x 203.2 cm).

60 *Aegean VI*, 1980, 60 x 60 in. (152.4 x 152.4 cm).

61 *Aegean VII*, 1980, 48 x 60 in. (121.9 x 152.4 cm). Collection George and Betsy Frampton.

62 *The Way XI*, 1979, 80 x 60 in. (203.2 x 152.4 cm).

63 *Lumen II*, 1980, 72 x 60 in. (182.9 x 152.4 cm).

64 *The Way XXI*, 1980, 30 x 36 in. (76.2 x 91.4 cm).

65 *Argosy X*, 1981, 48 x 60 in. (121.9 x 152.4 cm). Collection Oliver H. Carr.

66 *Pilot I*, 1981, 60 x 80 in. (152.4 x 203.2 cm). Collection Ruth Cole Kainen.

67 *Pilot IV*, 1981, 80 x 60 in. (203.2 x 152.4 cm).

68 *The Way XLIX*, 1981, 36 x 30 in. (91.4 x 76.2 cm).

69 *Aegean XVI*, 1982, 36 x 48 in. (91.4 x 121.9 cm).

70 *Argosy XVI*, 1982, 64 x 80 in. (162.6 x 203.2 cm). The Corcoran Gallery of Art, Museum Purchase, Anna E. Clark Fund.

71 *Interface I*, 1982, 72 x 54 in. (182.9 x 137.2 cm).

72 *Fabrizio VI*, 1983, 60 x 72 in. (152.4 x 182.9 cm).

73 *Interface XV*, 1983, 66 x 86 in. (167.6 x 218.4 cm).

74 *Interface XVI*, 1983, 50 x 60 in. (127 x 152.4 cm).

75 *The Way LXXIX*, 1983, 60 x 80 in. (152.4 x 203.2 cm).

76 *The Way LXXXI*, 1983, 108 x 140 in. (274.3 x 355.6 cm).

77 *The Way LXXXIV*, 1983, 72 x 54 in. (182.9 x 137.2 cm).

78 *Aegean XIX*, 1984, 48 x 36 in. (121.9 x 91.4 cm).

79 *Argosy XXXIII*, 1984, 36 x 48 in. (91.4 x 121.9 cm). Collection Kenneth and Kiyo Hitch.

80 *Argosy XXXIV*, 1984, 36 x 48 in. (91.4 x 121.9 cm).

81 *Barrier III*, 1984, 60 x 72 in. (152.4 x 182.9 cm).

82 *Fabrizio X*, 1984, 108 x 140 in. (274.3 x 355.6 cm).

83 *The Way XC*, 1984, 36 x 48 in. (91.4 x 121.9 cm).

84 *Argosy XLV*, 1985, 64 x 72 in. (162.6 x 182.9 cm).

85 *Bright Stamboul IV*, 1985, 66 x 86 in. (167.6 x 218.4 cm).

86 *Dabrowsky I*, 1985, 64 x 80 in. (162.6 x 203.2 cm).

87 *Dabrowsky III*, 1985, 108 x 140 in. (274.3 x 355.6 cm).

88 *Bright Stamboul XI*, 1986, 79 x 59 in. (200.7 x 149.9 cm).

89 *Pilot XV*, 1986, 72 x 54 in. (182.9 x 137.2 cm).

90 *Rising Sign*, 1986, 108 x 140 in. (274.3 x 355.6 cm).

91 *Argosy LV*, 1987, 72 x 60 in. (182.9 x 152.4 cm).

92 *The Book of Days II*, 1987, 80 x 100 in. (203.2 x 254 cm).

93 *Logos*, 1987, 50 x 60 in. (127 x 152.4 cm).

94 *Pilot XXVIII*, 1989, 60 x 72 in. (152.4 x 182.9 cm).

95 *Red Shift*, 1989, 96 x 120 in. (243.8 x 304.8 cm).

96 *Isaiah I*, 1990, 64 x 73 in. (162.6 x 185.4 cm).

97 *Pilot XXXV*, 1990, 72 x 54 in. (182.9 x 137.2 cm). Collection Adele Lebowitz.

98 *Changeling II*, 1991, 50 x 60 in. (127 x 152.4 cm).

99 *The Attempt*, 1992, 64 x 80 in. (162.6 x 203.2 cm).

100 *Argo*, 1991, 50 x 60 in. (127 x 152.4 cm).

CHRONOLOGY

1909 Born Dec. 7 in Waterbury, Connecticut, the second of three sons, to Russian immigrants Fannie Levin Kainen and Joseph Kainen, a machinist-inventor.

ca. 1918–25 Moves to New York with family, settling in the Bronx. Enters DeWitt Clinton High School at age twelve. Frequents the Metropolitan Museum of Art and fills sketchbooks. Begins to visit commercial galleries on Saturdays.

1926 Graduates from high school. Takes life drawing classes with Abbo Ostrowsky at the Educational Alliance, a settlement house on the Lower East Side; at the Art Students League begins evening drawing classes under Kimon Nicolaides. Works as stock boy at Brentano's bookstore.

1927 Enters Pratt Institute as art major; meets fellow student George McNeil. Also studies life drawing with A. J. Bogdanove at the New York Evening School of Industrial Art and with Frank Leonard Allen in Brooklyn on Sundays.

Jules Halfant, a friend from high school, introduces Kainen to the work of Velázquez and Hals. In the next five years he copies over a dozen paintings by Claude, Rembrandt, Corot, and others at the Metropolitan Museum of Art and the Lenox Collection of the New York Public Library. Works in shop as sign painter.

1930 Expelled from Pratt three weeks before graduation for rebelling against revamped curriculum emphasizing commercial art.

1934 Rents studio at corner of University Place and Fourteenth Street, just north of Greenwich Village. Meets Stuart Davis, Willem de Kooning, Adolf Dehn, John Graham, and Arshile Gorky, who paints Kainen's portrait. Joins the John Reed Club. Begins to use disaster subjects as metaphors for society in disarray in paintings such as *Tenement Fire* and *Flood* (1935).

1935 Employed by the Graphic Arts division of the WPA Federal Art Project. Joins the Artists' Union; becomes a contributing writer for *Art Front* and two years later joins its editorial board. Publishes occasional cartoons and reviews in *The Daily Worker* and *The New Masses*.

1936 Paints *Invasion* and *Spanish Museum* in reaction to the Spanish Civil War.

1937 Joins the A.C.A. Gallery. Becomes a member of the American Artists' Congress.

1938 Organizes the New York Group with Jules Halfant and Herbert Kruckman; they invite Alice Neel, Louis Nisonoff, Herman Rose, Max Schnitzler, and Joseph Vogel to join. The group exhibits at the A.C.A. Gallery in May and June.

Marries Bertha Friedman and moves to the Bronx.

1939 Second exhibition of the New York Group at A.C.A. Gallery, after which the group disbands.

1940 First solo exhibition, at A.C.A. Gallery, includes twenty canvases and is well received by reviewers.

1942 Receives diploma (dated 1930) from Pratt Institute. Accepts temporary position as aide with the Division of Graphic Arts at the Smithsonian Institution's U.S. National Museum (now the National Museum of American History) and moves to Washington, D.C.

Duncan Phillips buys *Street Corner* (1940) for the Phillips Memorial Gallery (now the Phillips Collection), Kainen's first painting to be acquired by a museum.

1943 Joins In Transit, a progressive artists' group in Washington, and the Artists Guild of Washington. Kainen's first son, Paul, is born.

1944 First exhibition in Washington held at David Porter's G Place Gallery. Rents a studio at 3140 M Street, where he works in the evenings.

Promoted to assistant curator. Smithsonian position becomes permanent.

1946 Promoted to curator of the Division of Graphic Arts. Presents monthly print exhibitions, including work of modern printmakers and Old Masters. Launches efforts to augment the division's collection by acquiring wide-ranging selection of prints, from Dürer and Rembrandt to Picasso.

1947 Begins to teach evening classes at the newly opened Washington Workshop Center for the Arts; continues until 1954. Kainen's second son, Daniel, is born.

1948 FBI sends findings of an investigation of Kainen's background to the Smithsonian's Loyalty Board; questioned about his earlier membership in the Artists' Union and American Artists' Congress and his involvement with *Art Front* and *The Daily Worker*. Although case is determined in his favor, it is reopened in 1949, reviewed again in 1953, and not closed officially until 1954. Paintings such as *Hour of the Beast* (1953) and *The Vulnerable* (1954) reflect the McCarthy period.

1949 Turns to organic abstraction in drawing; paints *Ritual* and *All-Worshipped-Shrine* (now lost), his first totally nonrepresentational paintings. Meets Kenneth Noland.

1950 His abstractions become more gestural, with emphasis on shape-making and spatial ambiguity. Begins giving weekly tutorials to Gene Davis, which continue until 1957.

1952 Recent abstract paintings exhibited at the Dupont Theatre Gallery of Art. Retrospective of Kainen's work presented at Catholic University art gallery, organized by Noland.

Exhibition at Grand Central Moderns gallery in New York.

1956 Obtains a grant from the American Philosophical Society and travels to Europe for the first time, where he does research for a book on John Baptist Jackson and also studies European art for three months.

1957 Reintroduces the figure into his work in an Expressionist manner in such paintings as *Impresario* and *The Initiate*. During a semester of teaching at American University meets Alma Thomas and begins to give private critiques of her work, which continue until the mid-1970s.

1960s Paints monumental figures silhouetted against light backgrounds, such as *Gene Davis* and *Woman in Black on a High Stool*.

1966 Resigns from the U.S. National Museum and accepts a part-time position as curator of prints and drawings at the Smithsonian's National Collection of Fine Arts (now National Museum of American Art), where he begins to assemble a collection of American prints and drawings.

1968 Kainen and his wife are divorced.

Meets Ruth Cole, a writer, publicist, and collector, whom he marries a year later.

1969 Undergoes surgery and during prolonged recuperation turns from figurative subjects to loosely brushed abstract works on paper. By the year's end, paints abstract compositions based on the figure, such as *The Couple I* and *II*.

1970 Takes early retirement from the Smithsonian and concentrates full time on his own work. Exhibits new paintings at Esther Stuttman Gallery; some of these works, such as *Dawn Attack* and *Night Attack*, obliquely reflect his outrage over the Vietnam War.

1972 Travels to the Soviet Union and is deeply impressed by the spiritual purity of Russian icon painting, especially the work of fifteenth-century artist Andrei Rublev. Moves toward a more classical statement in his paintings.

1974 Suffers a mild heart attack in December, but by February 1975 is painting again.

1979–81 Paints both geometric and lyrical abstractions.

1980–85 Focuses on geometric abstraction in series such as "The Way," "Interface," and "Fabrizio."

Mid-1980s Begins to allow "ghost" images to emerge from behind the surfaces, due partly to his fascination with Velázquez. Painterly marks and loosely brushed edges become dominant concerns in such paintings as *Pilot XV*.

1989 Celebrates eightieth birthday at a National Gallery of Art reception and exhibition of his prints and drawings in the collection and also at a reception at the Washington Project for the Arts.

SELECTED EXHIBITIONS

Solo Exhibitions

1940 *Paintings*, A.C.A. Gallery, New York, 28 October–9 November.

1944 G Place Gallery, Washington, D.C., 24 January–13 February.

1945 *Drawings and Lithographs*, Central Public Library, Washington, D.C., July–5 August.

1949 *Retrospective Exhibition of Prints: Contemporary American Artists Series*, No. 7, Corcoran Gallery of Art, Washington, D.C., 21 May–30 September.

1950 *Recent Paintings by Jacob Kainen*, Whyte Gallery, Washington, D.C., 11 Februay–7 March.

1952 *Paintings by Jacob Kainen*, Dupont Theatre Gallery of Art, Washington, D.C., March–April.

Retrospective Exhibition of Paintings, Catholic University, Washington, D.C., November–December.

1953 *Jacob Kainen: Guest Exhibition*, Grand Central Moderns, New York, 14–28 September.

1958 *Recent Paintings*, Franz Bader Gallery, Washington, D.C., September–October.

1961 *Drawings*, Dupont Theatre Gallery of Art, Washington, D.C., 11 October–27 November.

Jacob Kainen: Paintings, Jefferson Place Gallery, Washington, D.C., 8–25 November.

1963 *Paintings: Washington Artists Exhibition Series*, No. 17, Corcoran Gallery of Art, Washington, D.C., 26 February–24 March.

1964 *Jacob Kainen: Recent Paintings*, Roko Gallery, New York, 6–29 January.

Jacob Kainen: Drawings in Various Media, Jewish Community Center of Greater Washington, Washington, D.C., October.

1965 *Recent Paintings*, Franz Bader Gallery, Washington, D.C., 3–21 April.

1966 *Paintings*, Roko Gallery, New York, 28 February–23 March.

1967 *Recent Paintings*, Franz Bader Gallery, Washington, D.C., 15 February–4 March.

1968 *Prints and Drawings*, Emerson Gallery, McLean, Va., 2–27 January.

1970 *Jacob Kainen's Recent Work*, Esther Stuttman Gallery, Washington, D.C., 26 October–30 November.

1971 *Jacob Kainen: Works on Paper*, Hom Gallery, Bethesda, Md., 27 November–31 December.

1972 *Paintings*, Pratt Manhattan Center, New York, 28 March–19 April.

Jacob Kainen: Figure Paintings, 1960-1969, Northern Virginia Community College, 8 May–10 June.

1973 *Jacob Kainen: Recent Lithographs*, Angus Whyte Gallery, Provincetown, Mass., August.

Recent Paintings, Phillips Collection, Washington, D.C., 6–28 October.

1975 *Works on Paper*, Procter Art Center, Bard College, Annandale-on-Hudson, N.Y., March.

Jacob Kainen: Paintings, Lunn Gallery/Graphics International, Ltd., Washington, D.C., 14 May–25 June.

1976 *Jacob Kainen, Prints: A Retrospective*, National Collection of Fine Arts (now National Museum of American Art), Smithsonian Institution, Washington, D.C., 19 November–16 January. Also shown at Baltimore Museum of Art, University of Pittsburgh Art Gallery, and University of Oregon, in 1977.

1977 *Recent Paintings*, Mattatuck Museum, Waterbury, Conn., 5–31 May.

1978 *Jacob Kainen: Forty Years of Printmaking*, Associated American Artists, New York, 29 April–26 May.

Recent Works, Lunn Gallery/Graphics International, Ltd., Washington, D.C., 20 May–7 July.

Jacob Kainen, Four Decades: Paintings, New Gallery of Contemporary Art, Cleveland, Ohio, 23 May–24 June.

1979 *Monotypes*, Lunn Gallery, Washington, D.C., 8 December–5 January 1980.

Jacob Kainen: Five Decades as a Painter, National Museum of American Art, Smithsonian Institution, Washington, D.C., 7 December–5 January 1980 (paintings from the collection).

1980 *Jacob Kainen: New Works*, Phillips Collection, Washington, D.C., 13 December–25 January 1981.

1983 *Recent Paintings*, Martha White Gallery, Louisville, Ky., 3 March–2 April.

Recent Paintings, Sid Deutsch Gallery, New York, 5 March–2 April.

Jacob Kainen: American Printmaker, Marilyn Pink Gallery, Los Angeles, Calif., 15 November–17 December.

1984 *Monotypes*, Hom Gallery, Washington, D.C., 27 October–17 November.

Paintings, Baumgartner Galleries, Washington, D.C., 27 October–17 November.

1986 Middendorf Gallery, Washington, D.C., 12 April–10 May.

1987 *Color Woodcuts*, Hom Gallery, Washington, D.C., 28 March–25 April.

1988 *Recent Paintings*, Middendorf Gallery, Washington, D.C., 9 April–7 May.

1989 *Recent Paintings*, Middendorf Gallery, Washington, D.C., 26 October–2 December.

Jacob Kainen: Drawings and Prints, National Gallery of Art, Washington, D.C., 7–31 December.

1990 Reynolds/Minor Gallery, Richmond, Va., 5 January–10 February.

1991 *Recent Paintings*, Nancy Drysdale Gallery, Washington, D.C., 5 December–4 January 1992.

Group Exhibitions

1936 American Artists' Congress, first exhibition.

1937 *4 Out of 500: Artists Dismissed from W.P.A.*, A.C.A. Gallery, New York, 30 August–11 September.

1938 *The New York Group*, A.C.A. Gallery, New York, 23 May–4 June.

1939 *Ninety-Nine Prints by WPA*, Federal Art Gallery, January.

The New York Group, A.C.A. Gallery, New York, 5–18 February.

1941 *Tenth Anniversary of A.C.A. Gallery*

1942 Tenth Annual Exhibition of Watercolors, Pastels, Drawings, and Prints, Oakland Art Gallery, Oakland, Calif., 27 September–1 November.

1943 Artists Guild of Washington, 2nd Annual Exhibit, Corcoran Gallery of Art, 2–17 January.

1947 *Paintings by Jack Berkman, William Calfee, Jacob Kainen, Pietro Lazzari, Jack Perlmutter and John Robinson*, Barnett-Aden Gallery, Washington, D.C., May–June.

1948 *Third Annual Exhibition of Work by Artists of Washing-*

ton and Vicinity, Corcoran Gallery of Art, Washington, D.C., December.

1953 *The Eighth Annual Area Exhibition*, Corcoran Gallery of Art, Washington, D.C. *Hour of the Beast* given first prize by George Grosz.

1956 Four-person exhibition, Corcoran Gallery of Art, Washington, D.C., October–November.

Tenth Annual Area Exhibition, Corcoran Gallery of Art, Washington, D.C., 4 December–5 February 1957.

1959 *The 26th Biennial Exhibition of Contemporary American Painting*, Corcoran Gallery of Art, Washington, D.C., 17 January–8 March.

1961 *New Vistas in American Art*, Howard University, Washington, D.C., March–April.

Four Washington Printmakers, Cornell University, Ithaca, N.Y., 17 September–17 October.

1969 *Ten Years*, Jefferson Place Gallery, Washington, D.C.

1970 *Washington: Twenty Years*, Baltimore Museum of Art, Baltimore, Md., 12 May–21 June.

1973 *Three Contemporary Printmakers*, National Collection of Fine Arts, Washington, D.C., 1 June–1 July.

1974 *The Barnett-Aden Collection*, Anacostia Neighborhood Museum, Smithsonian Institution, Washington, D.C., 20 January–6 May.

Lithographs from Landfall Press, Illinois State University, Normal, Ill., October–November.

Contemporary Graphic Protest and the Grand Tradition, Pratt Graphics Center, New York, October–November.

1975 *The Barnett-Aden Collection*, Corcoran Gallery of Art, Washington, D.C., 10 January–9 February.

Works on Twinrocker Handmade Paper, Indianapolis Museum of Art, Ind., 15 April–25 May.

1976 *30 Years of American Printmaking*, Brooklyn Museum, N.Y., 20 November–30 January 1977.

1977 *Grafica contemporanea americana, tendenze e ricerche techniche*, Galleria Bevilacqua la Masa, Venice, Italy, 21 September–5 October.

1979 *In Homage to*, Washington Project for the Arts, 4–28 September.

1980 *Works on Paper by Gallery Artists*, Meredith Long Gallery, New York, June–July.

American Drawing in Black and White: 1970-1980, Brooklyn Museum, New York, 20 November–20 December.

Distinguished Mid-Atlantic Artists: Four Decades of Growth, University of Delaware, Newark, May–June.

1981 *Contemporary American Prints and Drawings 1940-1980*, National Gallery of Art, Washington, D.C., 22 March–19 July.

Jacob Kainen/George McNeil, Lunn Gallery, Washington, D.C., 5 December–16 January 1982.

1990 *Back from the Future: Maryland Artists 1950s-1980s*, Maryland Art Place, Baltimore, 1 November–22 December.

New Abstract Paintings, Middendorf Gallery, Washington, D.C., 15 September–20 October.

1991 *American Abstraction at the Addison*, Addison Gallery of American Art, Phillips Academy, Andover, Mass., 18 April–31 July.

WORKS IN PUBLIC COLLECTIONS

Achenbach Foundation for the Graphic Arts, The Fine Arts Museums of San Francisco, California

Addison Gallery of American Art, Phillips Academy, Andover, Massachusetts

The Art Institute of Chicago, Illinois

The Baltimore Museum of Art, Maryland

British Museum, London

The Brooklyn Museum, New York

Carnegie Museum of Art, Pittsburgh, Pennsylvania

The Cleveland Museum of Art, Ohio

The Corcoran Gallery of Art, Washington, D.C.

Grunwald Center for the Graphic Arts, University of California, Los Angeles, California

Hirshhorn Museum and Sculpture Garden, Smithsonian Institution, Washington, D.C.

Indianapolis Museum of Art, Indiana

Hamburger Kunsthalle, Hamburg, Germany

Kunstverein, Frechen, Germany

Library of Congress, Washington, D.C.

The Metropolitan Museum of Art, New York City

The Museum of Modern Art, New York City

National Gallery of Art, Washington, D.C.

Australian National Gallery, Canberra

National Museum of American Art, Smithsonian Institution, Washington, D.C.

The New York Public Library, New York City

New York University, New York City

Philadelphia Museum of Art, Pennsylvania

The Phillips Collection, Washington, D. C.

Portland Art Museum, Oregon

Walker Art Center, Minneapolis, Minnesota

Whitney Museum of American Art, New York City

Yale University Art Gallery, New Haven, Connecticut

BIBLIOGRAPHY

Books and Monographs by Jacob Kainen

George Clymer and the Columbian Press. New York: The Typophiles, 1950; San Francisco: Book Club of California, 1950 (separate editions).

The Halftone Screen. Chicago: Lakeside Press, 1950.

"The Development of the Halftone Screen." In *Smithsonian Report for 1951*. Washington, D.C.: U.S. Printing Office, 1952, 409–25. Also published as separate brochure, 1952.

Why Bewick Succeeded: A Note in the History of Wood Engraving. Washington, D.C.: Smithsonian Institution, U.S. National Museum Bulletin 218, 1959, 185–201.

John Baptist Jackson: 18th-Century Master of the Color Woodcut. Washington, D.C.: Smithsonian Institution, U.S. National Museum Bulletin 222, 1962.

The Etchings of Canaletto. Washington, D.C.: Smithsonian Institution Press, 1967.

Selected Articles by Jacob Kainen

Art Front:

"Revolutionary Art at the John Reed Club," January 1935, 6.

Letter to the editors concerning Thomas Hart Benton, May 1935, 7.

"Brook and His Tradition," February 1936, 6.

"The Project Graphic Show," April 1936, 14.

"The Independents XXth Annual," June 1936, 14.

"Judson Briggs," December 1936, 17–18.

"Our Expressionists," February 1937, 14–15.

"American Abstract Artists," May 1937, 25–26.

"Art as a Function of Government." Book review. Supervisors Association of the Federal Art Project, October 1937, 18–19.

The Daily Worker:

"Joe Jones' One-Man Exhibition," 27 January 1936.

"The Voice of the Sacrificed" [Käthe Kollwitz], 19 April 1937.

"Dismissed Artists Give 'Pink Slip' Exhibition," 14 July 1937.

"A Century of Lithography," 9 October 1937.

"Vincent Spagna," 9 October 1937.

"Whitney Museum Opens Doors to Varied Artists," 20 November 1937.

"Anti Fascist Painting on Display by Guggenheim Winner" [Peter Blume], 2 December 1937.

"Ribak's Works at ACA Galleries," 7 December 1937.

"2nd Artists' Congress Show Is Dedicated to Spain and China," 19 December 1937.

"Abstract Art Barely Comprehensible," 25 February 1938.

"Man of the Renaissance" [Michelangelo], 7 March 1938.

"Disasters of War" [Goya], 30 March 1938.

"Exhibition of New Paintings by 'The Ten' Lacks Social Themes," 20 May 1938.

"'New York Realists' Depict Social Themes" [under Kainen pseudonym Ray King], December 1939.

"Dream World Art." Review of *After Picasso*, by James Thrall Soby. *New Masses*, 12 November 1936.

"Drawings by Gene Davis." Introduction to Dupont Theatre Gallery exhibition catalogue. Washington, D.C., 1952.

"How Mass and Plane Are Used in the Arts." *Journal of the American Association of University Women* (May 1956): 211–13.

Encyclopaedia Britannica. Entries on Collotype, Lithography, Electrotyping, Sepia, Silk Screen Printing, Gravure. 1963, 1967.

"Gene Davis and the Art of Color Interval." *Art International* (December 1966): 31–33.

Foreword to *Raphael Soyer, Fifty Years of Printmaking 1917–1967*, ed. Sylvan Cole, Jr. New York: Da Capo Press, 1967.

"The Woodcuts of Werner Drewes." In *Werner Drewes Woodcuts*, 7–9. National Collection of Fine Arts. Washington, D.C.: Smithsonian Institution Press, 1969.

Foreword to *John Sloan's Prints*, by Peter Morse. New Haven: Yale University Press, 1969.

Introduction to reprint of *The Art of Graveing and Etching*, by William Faithorne. New York: Da Capo Press, 1970, originally published in 1662.

"Rothko: Perhaps the noblest and most moving colorist America has produced." *Washington Post, Potomac Magazine*, 4 April 1971, 44.

"Philip Guston's work goes deeply against the grain of current art practice." *Washington Post, Potomac Magazine*, 23 May 1971, 36–37.

"Gorky, A Student of the Masters, Old and New." *Washington Post, Potomac Magazine*, 15 August 1971, 24.

Velasquez: "A look at the real value of a $5.4 million painting," and "There's good reason to consider Velasquez the first modern painter." Parts 1, 2. *Washington Post, Potomac Magazine*, 25 July 1971, 1 August 1971, 29, 22.

"The Graphic Arts Division of the WPA Federal Art Project." In *The New Deal Art Projects: An Anthology of Memoirs*, ed. Francis V. O'Connor, 155–75. Washington, D.C.: Smithsonian Institution Press, 1972.

Introduction to catalogue for *Alma W. Thomas Retrospective Exhibition*. Washington, D.C.: Corcoran Gallery of Art, 1972.

Stanley William Hayter. Paintings, Drawings and Prints 1928–1950. Washington, D.C.: Corcoran Gallery of Art, 1973.

"The Monumental Achievement of Ernst Kirchner." *ARTnews* (March 1973): 37–40.

"Memories of Arshile Gorky." *Arts* (March 1976): 96–98.

"Self-destruction, the final tragic act of a principled man driven into a corner" [Mark Rothko]. *Washington Post, Potomac Magazine*, 11 April 1977, 28.

"Posing for Gorky, A Memoir of the N.Y. Master." *Washington Post*, 10 June 1979, L1, L4.

"Art from a Stone." Reviews of *American Lithographers 1900–1960: The Artists and Their Printers*, by Clinton Adams, and *Lithography, 200 Years of Art, History and Technique*, ed. Domenico Porzio with Rosalba and Marcello Tabanelli. *New York Times Book Review*, 8 January 1984, 9–10.

"The Art of the American Print." Review of *A Century of American Printmaking 1880–1980*, by James Watrous. *Washington Post Book World*, 21 October 1984, 3–4. Republished by *Manchester Guardian Weekly*, 28 October 1984.

"E. L. Kirchner as Printmaker." In *German Expressionist Prints from the Collection of Ruth and Jacob Kainen*, 31–49. Washington, D.C.: National Gallery of Art, 1985.

"An Interview with Stanley William Hayter" (with Ruth C. Kainen). *Arts* (January 1986): 64–67.

"Remembering John Graham." *Arts* (November 1986): 25–31.

"Appreciation." In *James Lesesne Wells, Sixty Years in Art*, by Richard Powell and Jock Reynolds. Washington, D.C.: Washington Project for the Arts, 1986.

"Stanley William Hayter: An Introduction." In *The Prints of Stanley William Hayter, A Complete Catalogue*, by Peter Black and Desiree Moorhead, 8–17. London: Phaidon Press, Ltd., 1992.

Articles About Jacob Kainen

Monograph

Holladay, Winton Smoot. "Jacob Kainen—Paintings: The Evolution of Abstraction." Master's thesis, George Washington University, 1980. With 70 color and seven black-and-white photographs. Copy in Archives of American Art.

Articles and Exhibition Reviews

Ahlander, Leslie Judd. "Gallery Notes." *Washington Post*, 16 March 1952.

———. "Busy Kainen in Three Shows Here." *Washington Post*, 12 November 1961.

———. "An Artist Speaks: Jacob Kainen." *Washington Post*, 5 August 1962.

———. [Review] *Washington Post*, 3 March 1963.

Allen, Jane Addams. "Jacob Kainen at Middendorf Gallery and the National Gallery of Art." *New Art Examiner* (February 1990): 46.

Ashton, Dore. Review of Grand Central Moderns exhibition. *Art Digest* (15 September 1953): 21.

Baro, Gene. "The Blindfolded Calligrapher: The Graphic Art of Jacob Kainen." *Arts* (November 1976): 94–95.

Baron, Herman (unsigned). "Jacob Kainen's Work on Exhibit at ACA." *Daily Worker*, 1940.

Benedict, Ruth. "On a Washington Institution." *Washington Print Club Newsletter* (March/April 1973): 11–13.

Berry, Heidi L. "Living with Art, Jacob and Ruth Kainen: The House of Expressionism." *ARTnews* (Summer 1992): 75–77.

Berryman, Florence. "One-Man Show by Washington Artist at G Place Gallery." *Washington Star*, 30 January 1944.

———. "Graphic Arts at [Central Public] Library." *Washington Star*, 30 January 1944.

———. "Art and Artists: Kainen Moves from Natural and Factual to Composed Expression of Inner Struggle." *Sunday Star*, 29 May 1949.

———. "Victorian Kaleidoscope." *Sunday Star*, 19 February 1950.

———. "Suspended in Space." *Evening Star*, 30 March 1952.

———. "Art News—Kainen Retrospective." *Evening Star*, 7 December 1952.

———. "New Approach." *Sunday Star*, 4 November 1956.

———. "Kainen's Latest." *Sunday Star*, 5 October 1958.

Brown, Gordon. Review of Pratt Manhattan Center exhibition. *Arts* (May 1972): 76–78.

Browne, Rosalind. Review of Roko Gallery exhibition. *Art News* (April 1966): 17.

Burroughs, Carlyle. "Jacob Kainen." *New York Herald Tribune*, 3 November 1940.

———. Review of Grand Central Moderns exhibition. *New York Herald Tribune*, 20 September 1953.

Campbell, Lawrence. "Jacob Kainen at Sid Deutsch." *Art in America* (October 1983): 182.

Cohen, Jean Lawlor. "The Old Guard: Washington Artists in the 1940s." *Museum & Arts Washington* (May/June 1988): 55–59, 64–71.

———. "Washington Art History: The Making of the Color School Stars." *Museum & Arts Washington* (November/December 1988): 55–61, 84.

Conroy, Sarah Booth. "Cake to Please the Palette, at the NGA, Celebrating Jacob Kainen's 80th." *Washington Post*, 8 December 1989.

Coutu, Marie. "Jacob Kainen's Career: From Waterbury to Smithsonian." *Waterbury [Conn.] American*, 12 May 1977.

Crane, Jane Watson. "Kainen's Own." *Washington Post*, 29 May 1949.

Cullinan, Helen. "Kainen: A radiant image emerges in new exposure." *Cleveland Plain Dealer*, 28 May 1978.

Davis, Gene. "Starting out in the `50s." *Art in America* (July/August 1978): 91.

Devree, Howard. "Jacob Kainen." *New York Times*, 3 November 1940.

———. Review of Grand Central Moderns exhibition. *New York Times*, 19 September 1953.

Dobson, Gwen. "Luncheon with Jacob Kainen." *Evening Star*, 11 December 1970.

Farmer, Jane. "Kainen Retrospective." *Washington Print Club Newsletter* (November/December 1976).

———. "Jacob Kainen's Monotypes." *Washington Print Club Newsletter* (Spring 1980).

Fleming, Lee. "Jacob Kainen, The Phillips Collection." *New Art Examiner* (March 1981): 15.

———. "Washington, D.C.: Jacob Kainen." *ARTnews* (September 1986): 42.

Forgey, Benjamin. "Two Area Galleries." Review of Franz Bader Gallery exhibition. *Sunday Star*, 19 February 1967.

———. "Art: Quiet Excitement of Jacob Kainen." *Sunday Star*, 25 October 1970.

———. "ART: Jacob Kainen." *Sunday Star*, 5 December 1971.

———. "The Art Scene: Jacob Kainen." *Evening Star*, 17 April 1972.

———. "Jacob Kainen's Cup of Good Cheer." *Washington Star-News*, 7 October 1973.

———. "Going Modern." *ARTnews* (December 1973): 70–72.

———. "Paintings out of Love for a Park—Kainen." *Evening Star*, 30 May 1975.

———. "Focusing on the Surface." *ARTnews* (September 1975): 86–88.

———. "Jacob Kainen responds to his sensibilities." *Sunday Star*, 28 November 1976.

———. "Jacob Kainen: Vision and Technique." *ARTnews* (February 1977): 86–87.

———. "Kainen: Art, Time and Place." *Evening Star*, 16 December 1979.

———. "Art: Recent Jacob Kainen." *Evening Star*, 4 January 1981.

Genauer, Emily. "Solo Show at A.C.A." *New York World-Telegram*, 2 November 1940.

Getlein, Frank. "Jefferson Place." *Sunday Star*, 12 November 1961.

———. "Great Show." *Sunday Star*, 11 April 1965.

———. "Jacob Kainen Show at Corcoran Gallery." *Sunday Star*, 3 March 1963.

———. "New York Note." *Evening Star*, 5 January 1964.

Gibson, Eric. "Driven to Abstraction." *Washington Times*, 15 December 1991.

———. "Kainen 'tunes' colors to abstract harmony." *Washington Times*, 2 January 1992.

Gold, Barbara. "The joy of printmaking evident in Kainen show." *The Sun* (Baltimore), 26 May 1977.

Griffiths, Harriet S. "Impressions of an Expressionist." *Sunday Star Magazine*, 19 February 1961, 16–17.

Harney, Tom. "An Animated Show, Omit the Clutter and Get the Life." *Washington Daily News*, 3 March 1967.

Henry, Gerrit. "Jacob Kainen—Sid Deutsch." *ARTnews* (May 1983): 158.

Hood, Richard. "An Interview with Jacob Kainen." Parts 1, 2. *Washington Print Club Newsletter* (Autumn 1984, Winter 1984–85): 8–13, 3–4.

Hudson, Andrew. Review of Franz Bader Gallery exhibition. *Washington Post*, 26 February 1967.

Johnson, Lincoln F. "Innovation, fine technique in exhibits." *The Sun* (Baltimore), 26 May 1977.

Kramer, Hilton. Review of Roko Gallery exhibition. *New York Times*, March 1966.

Krasnow, Iris. "Jacob's Ladder." *Museum & Arts Washington* (January/February 1990): 48–56, 141, 158.

LaFarge, Henry A. Review of Grand Central Moderns exhibition. *Art News* (September 1953): 55–56.

Laget, Mokha. "Jacob Kainen: Recent Paintings." *Washington Review* (June/July 1988): 21.

Laisy, Emily. "Jacob Kainen." *Print Club of Cleveland*, 1978.

Landsell, Sarah. "Right Mix of Order and Feeling Equals Art, Painter Kainen Says." *Louisville [Ky.] Courier-Journal Sun*, 5 March 1983.

Lane, James. "Kainen's First Exhibition of Oils." *The Art News* (2 November 1940): 12.

Lawrence, Leonce. "Jacob Kainen, Baumgartner Galleries." *New Art Examiner* (February 1985).

Lewis, Jo Ann. "Uncovering a Master." *Washington Post*, 26 November 1976.

———. Review of Lunn Gallery exhibition. *Washington Post*, 24 June 1978.

———. "A Cake for Kainen." *Washington Post*, 11 December 1979.

Mahoney, J. W. "Jacob Kainen at Nancy Drysdale." *Art in America* (July 1992): 113.

Martin-Johnson, Barbara. "Jacob Kainen." *Washington Review* (August/September 1978): 22.

Merritt, Robert. *Richmond Times-Dispatch*, 6 January 1990.

Noland, Cornelia. "Jacob Kainen." *Washingtonian* (October 1970): 101–2.

Parmelee, Terry. "Jacob Kainen's Monotypes." *Washington Print Club Newsletter* (Winter 1984–85): 5.

Perlmutter, Jack. "Jacob Kainen." *Art Voices South* (May/June 1980): 71.

Portner, Leslie Judd. "New Approach." *Washington Post and Times Herald*, 21 October 1956.

———. Review of Franz Bader Gallery exhibition. *Washington Post*, 5 October 1958.

Power, Mark. "Kainen, Showing His Colors." *Washington Post*, 1 May 1986.

Preston, Stuart. Review of Roko Gallery exhibition. *New York Times*, 11 January 1964.

Proctor, Roy. "Reynolds/Minor Offers a Fascinating Contrast." *Richmond News Leader*, 6 January 1990.

Rand, Harry. "Notes and Conversations: Jacob Kainen." *Arts* (December 1978): 135–45.

———. "Jacob Kainen." *Arts* (March 1983): 19.

Reinhardt, Ad. "How to Look at Modern Art," cartoon. *P.M.*, 2 June 1946.

Richard, Paul. "Beauty Sneaks in Kainen Art." *Washington Post*, 7 January 1968.

———. "What's Happened to the Paintings of Jacob Kainen?" *Washington Post*, 1 November 1970.

———. "Art as Synthesis." *Washington Post*, 6 October 1973.

———. "Galleries: One Glance Isn't Enough." *Washington Post*, 29 May 1975.

———. [Review]. *Washington Post*, 27 November 1976.

———. "Jacob Kainen's Stirring Abstractions." *Washington Post*, 15 December 1980.

———. "Kainen and McNeil." *Washington Post*, 17 December 1981.

———. "Prismatic Painter." *Washington Post*, 3 October 1984.

Rose, Barbara. "Jacob Kainen (Pratt Manhattan Center)." *New York Magazine*, 10 April 1973.

Rubenfeld, Florence. "Jacob Kainen." *Museum & Arts Washington* (May/June 1988): 22.

Ruffin, Cordelia. "One Thing You Can Say for Girls: They Have Shape." *Washington Daily News*, 16 October 1964.

Stevens, Elizabeth. Review of Franz Bader Gallery exhibition. *Washington Post*, 11 April 1965.

Sweeney, Louise. "Applauding Kainen: the Art and the Man, Famed Painter's 80th Birthday." *Christian Science Monitor*, 11 January 1990.

Swift, Mary. "Kainen and McNeil," *Washington Review* (February/March 1982).

———. "Jacob Kainen: Washington Printmaker." *Washington Review* (June/July 1992): 3–4.

Tannous, David. "Those Who Stay" and "Capital Art: In the Major Leagues?" *Art in America* (July/August 1978): 78–87, 135.

———. "Washington, D.C.: Jacob Kainen at the N.C.F.A., the Phillips and Lunn." *Art in America* (September 1980): 135.

Thompson, Toby. "The Way of Jacob Kainen." *Washington Post, Potomac Magazine*, 14 December 1980, 32–34.

Thorson, Alice. "Jacob Kainen." *Washington Times*, 16 April 1987.

Tillim, Sidney. Review of Roko Gallery exhibition, *Arts* (February 1964): 29.

Welzenbach, Michael. "Jacob Kainen, Abstractly." *Washington Post*, 28 November 1989.

Wilson, Janet. "Kainen's Celebrations of Color." *Washington Post*, 7 December 1991.

Withers, Josephine. "Jacob Kainen." *Arts* (September 1975): 30.

Unsigned (Melville Upton?). Review of first solo exhibition. *New York Sun*, 9 November 1940.

Unsigned. "New York Reviews, Jacob Kainen." *ARTnews* (September 1978): 164–65.

———. "Jacob Kainen." In *Current Biography*, vol. 48, no. 2, 20–24. New York: H. W. Wilson Company, 1987.

Exhibition Catalogues and Brochures

A.C.A. Gallery. *New York Group.* Unsigned foreword by Jacob Kainen. New York, 1938.

A.C.A. Gallery. *New York Group.* Foreword by Kenneth Fearing. New York, 1939.

Associated American Artists. *Jacob Kainen: Forty Years of Printmaking.* New York, 1978.

Corcoran Gallery of Art. *Retrospective Exhibition of Prints: Contemporary American Artists Series, No. 7: Jacob Kainen.* Introduction by Prentiss Taylor. Washington, D.C., 1949.

Corcoran Gallery of Art. *Paintings: Washington Artists Exhibition Series, No. 17: Jacob Kainen.* Washington, D.C., 1963.

G Place Gallery. Foreword by Martha Davidson. Washington, D.C., 1944.

Lunn Gallery/Graphics International Ltd. *Recent Works.* Foreword by Joshua Taylor. Washington, D.C., 1978.

Middendorf Gallery. *Jacob Kainen—Recent Paintings.* Washington, D.C., 1988.

National Collection of Fine Arts (now National Museum of American Art), Smithsonian Institution. *Jacob Kainen: Prints, A Retrospective.* Foreword by Joshua Taylor, essay and checklist by Janet A. Flint. Washington, D.C., 1976.

New Gallery of Contemporary Art. *Jacob Kainen, Four Decades: Paintings.* Essay by Michael G. Sundell. Cleveland, 1978.

Phillips Collection. *Recent Paintings by Jacob Kainen.* Washington, D.C., 1973.

Phillips Collection. *Jacob Kainen: New Works.* Introduction by Charles Parkhurst. Washington, D.C., 1981.

Esther Stuttman Gallery. *Jacob Kainen's Recent Work.* Foreword by Gene Davis. Washington, D.C., 1970.

Video

National Museum of American Art. "Jacob Kainen." 30 minutes. Washington, D.C., 1982.

Archives of American Art Transcripts

On deposit at the Archives of American Art are interviews with Jacob Kainen conducted in the 1970s and 1980s. In addition to Avis Berman's extensive interviews specifically conducted for the Archives in 1982, there are transcripts of radio, television, and newspaper interviews by more than a dozen art historians, journalists, and critics.

INDEX

PHOTO CREDITS

Courtesy of Jacob Kainen: figs. 1, 3, 8, 9, 14, 17
Michael Fisher: fig. 7, p. 42; pls. 1, 5, 25, 28, 31, 36, 39
Lawrence Gichner: p. 8
Ruth Cole Kainen: frontispiece, fig. 20
Nathan Rabin: fig. 6
Gregory R. Staley: pl. 79
Gene Young: figs. 2, 4, 5, 18, 22–25, 27–30; pls. 2–4, 7–13, 16–22, 24, 26, 29, 30, 34, 35, 38, 40, 43, 45–48, 51, 53, 54, 56–60, 62–64, 67–69, 71–78, 80–96, 98–100